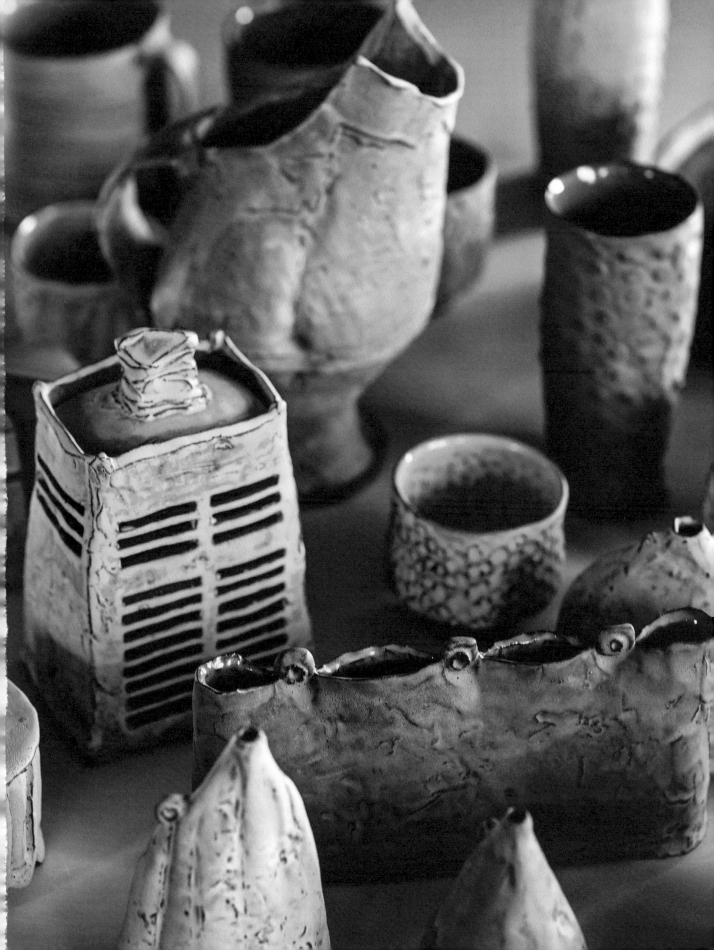

Brimming with creative inspiration, how-to projects, and useful information to enrich your everyday life, Quarto Knows is a favorite destination for those pursuing their interests and passions. Visit our site and dig deeper with our books into your area of interest: Quarto Creates, Quarto Cooks, Quarto Homes, Quarto Lives, Quarto Drives, Quarto Explores, Quarto Gifts, or Quarto Kids.

© 2017 Quarto Publishing Group USA Inc.
Text © 2017 Sunshine Cobb
Photography by Tim Robison, except where otherwise noted

First published in 2017 by Voyageur Press, an imprint of The Quarto Group, 401 Second Avenue North, Suite 310, Minneapolis, MN 55401 USA. T (612) 344-8100 F (612) 344-8692 www.QuartoKnows.com

Voyageur Press titles are also available at discount for retail, wholesale, promotional, and bulk purchase. For details, contact the Special Sales Manager by email at specialsales@quarto.com or by mail at The Quarto Group, Attn: Special Sales Manager, 401 Second Avenue North, Suite 310, Minneapolis, MN 55401 USA.

10 9 8 7 6 5 4 3 2 1

ISBN: 978-0-7603-5273-1

Library of Congress Cataloging-in-Publication Data

Names: Cobb, Sunshine, author.
Title: Mastering hand building : techniques, tips, and tricks for slabs,
 coils, and more / Sunshine Cobb.
Description: Minneapolis, MN : Voyageur Press, 2018.
Identifiers: LCCN 2017030473 | ISBN 9780760352731 (hardback)
Subjects: LCSH: Pottery craft. | BISAC: CRAFTS & HOBBIES / Pottery &
 Ceramics. | CRAFTS & HOBBIES / Reference.
Classification: LCC TT920 .C626 2018 | DDC 738.1/2—dc23
LC record available at https://lccn.loc.gov/2017030473

Acquiring Editor: Thom O'Hearn
Project Manager: Alyssa Lochner
Art Director: Cindy Samargia Laun
Cover and Page Design: Laura Shaw Design

Printed in China

MASTERING HAND BUILDING

TECHNIQUES, TIPS, AND TRICKS FOR SLABS, COILS, AND MORE

SUNSHINE COBB

FOREWORD BY ANDREA GILL

VOYAGEUR PRESS

CONTENTS

FOREWORD

Handbuilders Unite!

A short, unprecise history of a way of working.

The Kansas City Art Institute was a hotbed of ceramics when I arrived in the fall of 1972. Jacquie Rice had joined the faculty to add a new point of view, including a variety of hand building and decorating techniques. We were charged up by the challenge she brought to the strong high-fire throwing culture championed by Ken Ferguson and Victor Babu. While they focused on Asian pottery, Jacquie taught us to use low-fire commercial glazes, decals, lusters, and china paints on hand-built vessels. This entirely different aesthetic was infectious and led to what seemed like a revolution.

At some point that year, a student printed bumper stickers. They were bright orange, about 5 x 6 inches, and read: **Handbuilders Unite!** I wonder sometimes what people thought when they saw the bumper sticker. What was a *hand builder* and why did they need to unite? The politics of the day led to many diverse manifestos on car bumpers. Ours was a Declaration of the Freedom of Ceramic Art.

We did not invent that phrase, but it felt like we were on the cutting edge of a new way of working. John Gill was a senior, and already showing his work. His soft-slab teapots, jars, and cups influenced other students, including me. (I was so impressed, I married him!) Another curious connection was the one we made with Mark Pharis, who visited KCAI with Warren MacKenzie and a group of students from the University of Minnesota. I don't know if he had already experimented with soft slabs, but he soon added hand building to his body of work and has since made magnificent pots using the technique. About the same time, Victor Babu demonstrated how to use very large, stiff slabs to make a box. This is how I make all my work. One demo: a life is changed.

When I first came to ceramics, I was a painter and form seemed alien to me (which was only reinforced by a bad grade in Freshman 3D Design). However, from the start I found building with slabs was different; it was very much like drawing. I could invent line with a knife and volume by pressing slabs into molds. This system made it possible to create well-rendered generic shapes quickly, then combine them to make work as large as my kiln would accommodate. It was like stretching a canvas, giving me the freedom to play with two-dimensional shape, color, and pattern. I had found my voice, and was then able to experiment and play.

I still love how clay feels as a perfect leather-hard slab, and I usually have at least two hundred pounds rolled before beginning a series. I enter the studio with few expectations other than an approximate number of works I will make. The making stage is divorced from decorating: I learned early on that the fewer clues I left on the surface, the more I could invent the shapes of color. Sometimes I coat the pot with a thick, white glaze known as Majolica, from the Italian Renaissance technique. Other work is decorated with layers of engobe. Over the years, I have found particular cultural and historic patterns to use as a starting point. The forms, although not planned specifically, are in response to the shapes I see in the images. From Japanese prints and Turkish robes to a particular image of a basket of flowers on a Chinese plate, I am always looking, seeing possibilities for making when I least expect it.

I have taught Introductory Hand Building at Alfred University for about thirty years. The course has evolved over time from one that emphasized vessel making to one that is heavily sculptural and

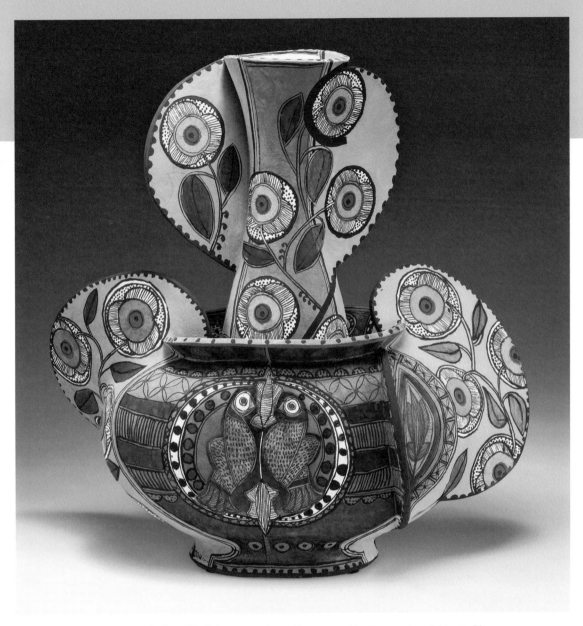

Basin and Vase Series: Parrots. Andrea Gill. Slab construction with press molds. *Photo courtesy of Brian Ogelsbee.*

includes slip casting and press molding. Yet we did not want to change the course name to "Ceramic Sculpture." Hand building does not indicate a type of object, only a way of working, and that is how we want to think about it—by questioning ways of making, ways of using materials outside the typical beginning assignments of coil/slab/press mold then glaze. Clay can be bone dry, already fired, the

consistency of mud, or, of course, the plastic clay that now comes in convenient square blocks in plastic bags. Hand building has never been so easy or as challenging as it is today. ***Handbuilders Unite!***

—ANDREA GILL, Professor Emeritus of Ceramic Art at Alfred University

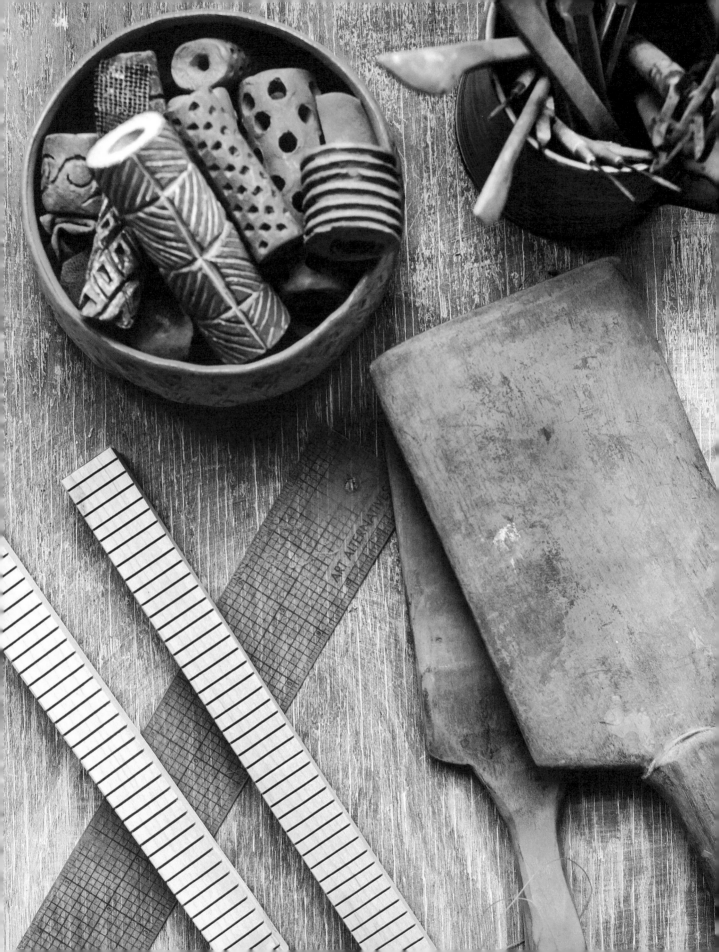

1 THE BASICS

I BELIEVE IN KEEPING THINGS SIMPLE.

It is easy to complicate your studio life by thinking you need certain things to get started. Maybe it's a special tool or that perfect clay. There will always be something you want or you think will make all the difference. However, over the past two decades, I have learned that the most important tool is one you always have: it's you! If you're in the studio, you can make great work.

That said, your studio, tools, and clay are important when it comes to hand building. Where you work and what you work with will affect your journey. I will cover all of this on the pages that follow. In this chapter, I'll also introduce some key terms and techniques used throughout the book. These will be especially useful if you're new to clay and just might help you over those initial hurdles to get going strong in the studio.

One last note before we begin: throughout this book I advocate doing things a certain way. If you're a more experienced potter, my way may be similar to yours or it may be quite different. As you no doubt know, at some point you stop thinking about how you hold your hand or a tool. You start to think instead about what your pot needs to look like and how to achieve that goal. There is no need for you to change the way you do things to match how I do them. I encourage you to experiment: you may find you like doing something in a new way! Yet if you already have good studio habits and effective methods, incorporate only what makes sense. It's all about what works for your body, materials, and desired objects.

Let's get started!

THE STUDIO

It's often said that working in a clay studio is like "playing with mud." There is some truth to that! But studio setup and safety are very important. Please take your clay environment seriously and ask experienced potters whenever you're in a situation and you're not sure how to proceed. Safety comes first.

A slab roller is considered essential studio equipment for many hand builders.

CONSIDERING YOUR ENVIRONMENT

If you're like most potters—myself included—you're probably working in a shared studio space. Establishing habits that keep the studio tidy is doubly important for these settings, but even if you have your own studio, you should keep it clean.

One clear advantage of a clean, well-organized studio is that you can come in and get right to work. Another advantage is that you'll create a safer environment for everyone in it. Moist clay is considered inert and safe. But when clay dries and is crushed up, you will eventually breathe in the clay dust. A studio covered in layers of clay dust is not safe.

Breathing in clay dust over extended periods is unhealthy and can lead to disease and lung issues. If you think, "Ahh, I don't make that much dust," try working with red clay in a primarily white clay space and see if you stand by that opinion. Ⓐ

This happened to me the first time I had my own space in a shared studio. I started working in red clay and very quickly realized how much it traveled: There were red footprints all around the studio! It even turned up in spaces I hadn't visited. It was wild, and I am grateful for that lesson. I started making a point of cleaning up my space every night and mopping at least once a week to keep my clay dust contained.

***Note:** In shared studios, be extra courteous. Even if you feel cavalier about clay dust, think of those around you. As an instructor, I believe that if even one student per class disregards what I say and sweeps instead of mops, that's extra clay dust I am breathing in. While this may seem like common sense, it is not always obvious to everyone. Please be considerate!*

That brings me to the idea of the mental space of a studio. I have been blessed to travel to some amazing facilities around the country, from state-of-the-art studios to small buildings in the woods with no running water. While a studio might have a certain feel, what I've noticed is that the magic isn't in the space; rather, it's what you bring to it that matters. The best studios I've visited all stood out because of the people. Think about this whenever you join a new studio. Ask yourself: How do I contribute to this space?

That said, you also need to set boundaries in communal studios. My studio space is about being free, comfortable, and safe to create anything. My studio time is mine: It is valuable and deserves my respect and the respect of my studio mates. My studio time is primarily about making, not socializing. Even though I do require some social interaction and enjoy that part of a shared studio, it is important that it is a secondary function. In any studio there needs to be a balance.

***Note:** When people share a studio, there are bound to be conflicts. Try to handle these conflicts with sensitivity and kindness. Remember, everyone coming to the studio deserves to have a safe, happy, and comfortable space to work. If conflicts have gotten beyond easy resolutions, seek out assistance. If you have a studio manager, that person can often help.*

In short, I encourage you to bring your best self to the studio. Come to work and engage in a productive way. Respect the time you are devoting to your practice and the time others are devoting to theirs.

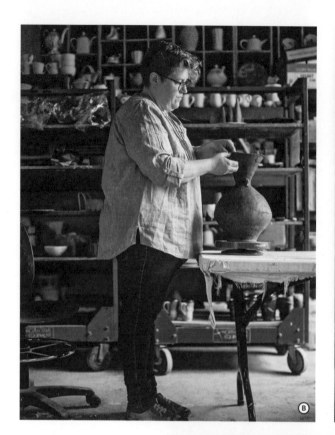

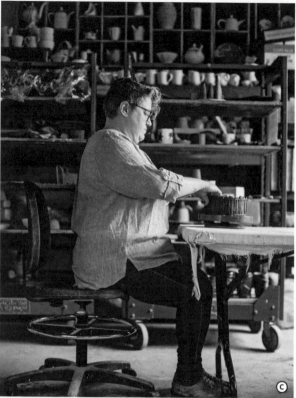

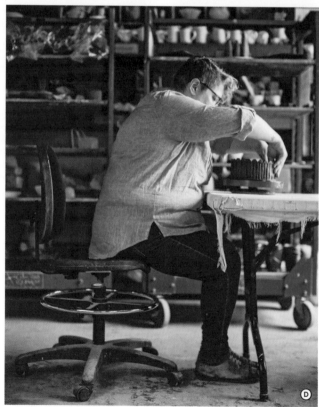

YOUR WORKSPACE AND STUDIO EQUIPMENT

In addition to the social interaction, shared resources are a major benefit of working in a communal studio. Before I get into specialty equipment you might want to buy, let's take a quick tour of the setup you'll find at most communal studios—including some larger pieces of equipment. Most studios have electric wheels, scales, extruders, kilns, wedging tables, slab rollers, and sinks with running water (often with clay traps). Some studios may allow supervised use of clay mixers, pug mills, spray booths, air compressors, sandblasters, and grinders. Others even have shared ware boards, bats, shelving, rolling pins, and piles of plaster molds. The list can go on and on, depending on the studio and whom it serves! Here are my notes for making the most of your studio setup.

Note: If you don't know how to use a tool or machine, ask someone! You don't want to risk breaking something (ceramic equipment can be costly to repair or replace). If it's not on your shelf, or clearly meant for communal use, don't use it without permission.

The first step is figuring out where you'll work. Do you want to stand or sit? Any studio will offer a variety of options, because potters tend to labor for long periods of time. Be mindful of how you hold your body. If a table is too high or your piece is large, stand up to work. Ⓑ

As far as a sitting workstation goes, make sure to adjust your chair so that you're comfortable and your spine is straight. Even small differences in seat height can affect your posture. It may seem insignificant, but sitting hour after hour in an awkward position will make a difference in how you feel at the end of the day. Ⓒ You can exhaust your body by being uncomfortable; be kind to it in the space available. Adjust the height of your work on a table for better posture. Ⓓ

Too often when I travel, I encounter stools that are quite uncomfortable to use for an extended period. The first thing I did when I set up my studio was buy myself a chair with a back and adjustable height! If you don't want to commit to a chair, try cushions to improve the available seating in your studio. Whatever you do, think about your posture and remember to stand up and move occasionally. Sitting too long in one position can cause stiffness and sore muscles.

If you like to work while standing, remember to monitor your projects as they grow and adjust the height of your table accordingly to keep yourself comfortable. Also, you are most likely standing on concrete, so wear good shoes and take breaks.

Next comes your work surface. If the tabletop isn't sticky, you may be able to work directly on that. Some tables are covered in canvas, which can be fine. (Still, canvas does have a tendency to leave marks on clay and can be very dusty. When cleaned with a sponge, it becomes wet and requires drying time.) Rather than working directly on a table, however, I recommend working on drywall, a ware board, or even a bat. Having a work surface that's portable will allow you to easily move your piece and keep your main work area clean.

The wedging area of most studios includes one or more wedging tables as well as a scale or two. Ⓔ If you don't have a wedging table, clay can be prepared on a sturdy, dry canvas-covered tabletop. Wedging can even be done on a piece of drywall. Just be careful to work on dry wallboard that has been properly prepared: There should be duct tape around the cut edges and the paper covering should be intact. You don't want any parts of the drywall to get into your clay.

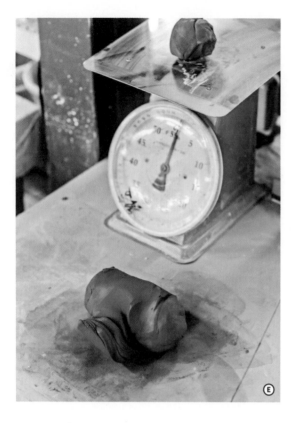

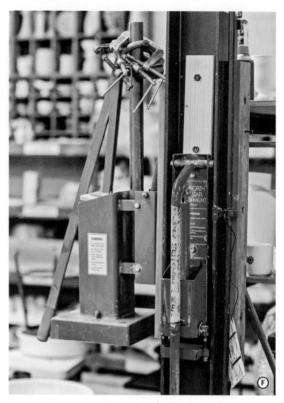

Slab rollers are a very handy tool for hand builders. Nearly all models work on the same principle: You're going to press clay through it to create a slab of a specific thickness. The models can look wildly different, though, and it may take a lesson or two from someone in the studio before you're comfortable using one on your own. If you don't have access to a slab roller, no problem. Slabs can be easily made using wood slats and a rolling pin (see page 80 for more on making slabs).

The extruder is similar to the slab roller: It's a convenient tool, but not essential. ⓕ I actually prefer to make my coils by hand as I go (see page 56). But an extruder can save you time when you're making a lot of coils (or other extruded shapes) for a large project. Take a look at Nathan Craven's pieces on page 37 or Robert Brady's images on page 194 for some ideas on what can be achieved with extrusions. Again, different models have different mechanisms, so always get a tutorial before using an extruder by yourself.

Your studio may have damp/dry rooms or boxes. These can be helpful for managing the state of your work and are described in further detail on page 34.

Last but not least: Clean up! It's important to clean as you go, especially in a shared space. I like to tidy up between tasks because this prepares my workstation for the next step and sets me up for success. It's a way for me to transition more fluidly with tools and equipment at the ready.

STAGING WORK

Staging your work means setting up an area so that you will be able to return to continue working on your project or so that you can easily move your project from place to place. When it comes to staging my own work, I try to problem-solve in advance any situations that may arise during the entire making process. From preparing slabs to the final glazing, I know I'll need a clean workspace, boards large enough to hold my clay slabs, and enough plastic to transfer them. I'll also need ware boards, a space on a shelf to let my greenware dry, a place to store bisqueware until I am ready to glaze, and often a ware cart to move my work around.

Also, consider the size of your piece. Will the piece eventually be so large it will be difficult (or impossible) to move by yourself? I'm of the school that if you can't move it alone, you shouldn't build it, but that comes from moving a lot of other people's work! Check with potential helpers before you start going large with your project. Also, consider the space you are using because building large-scale work takes up valuable studio real estate while it dries.

Even if your work is not what you would consider big, you need to make sure it will fit in your studio's kiln. More than once, I have attempted to load a kiln and found that someone's piece wouldn't fit. Know the dimensions of your kiln before you create a beautiful piece you can't fire.

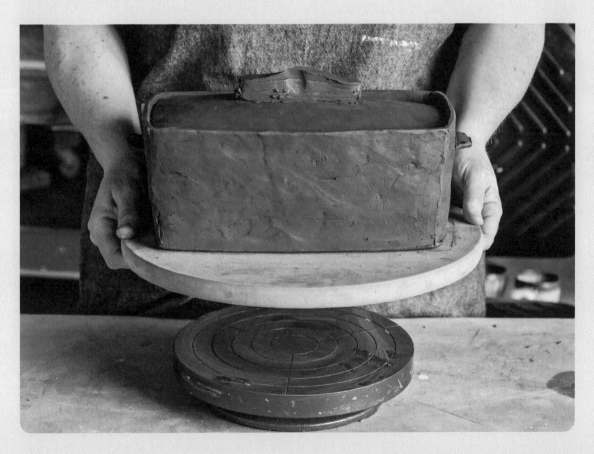

SELF-CARE

Self-care is something that has become very important to me. A lot of the language in this book is deliberately geared to make you think and relate back to your body or mind. Our mental and emotional states can affect our studio practice.

I have been working in clay for decades, and a long time ago I made the development of professional practice my priority. Physically, I always feared I would injure my hands or my arms in a way that would prevent me from working. But I was unprepared for what actually happened a few years ago: My studio practice and livelihood were threatened in a different way when I hit an emotional and physical wall. I was traveling extensively, workshopping, teaching, and trying to make pots in the studio. I found myself exhausted, unhealthy, and unhappy! At the end of an incredibly busy year, I wasn't sure I wanted to do it anymore. I had put my health, emotional and physical, at the bottom of my to-do list for too many years, and something had to change.

I started the next year by instead putting myself at the top of my list. I made a commitment to improving my health, losing weight, and making exercise a priority. I made changes that allowed me to take better care of myself when I traveled, and I made some new rules for my studio life. No more twelve-hour days or pulling all-nighters, eating chips while I glazed! Some habits were easy to break, and others took some time. After years of putting my studio life first, I had to remind myself that devoting a couple of hours a day to me and my well-being was in my best interest.

I'm happy to say this strategy worked. I love my studio practice again, and I am a more energetic teacher. I am able to bring my best self to my work and my home life. This commitment to self-care has changed my life.

If you are thinking about making a career in ceramics, strive for balance, take care of yourself, exercise, and make time outside the studio to refresh and energize your body and mind. I promise it will serve your studio practice well and help sustain a long career. On the other hand, if you are coming to clay later in life, clay may become your self-care. Awesome! There is something magical about clay and how it can make the hours melt away. It can be a gift to yourself and a wonderful outlet. Just make sure to nurture and protect your newfound creativity but spend some time away from clay too.

BEST PRACTICES

There are some general best practices for potters. Posture and ergonomics are important for all studio artists. Be aware of how you're sitting or standing and for how long. Pay attention to how you are holding your body and your hands. Most people tend to hunch over their work, increasingly tightening up over time. Breaking this habit, or at least moving around and straightening your body, is very important.

I also recommend setting tasks that are limited in time. For example, I weigh out a limited number of balls of clay to make mugs, then I make those mugs. When it's time to make more mugs, I have to get up and weigh out more clay. In this way I make sure I'm not sitting in one place for hours on end. If you need a reminder to move but don't want to break up your work in this fashion, try setting a timer.

Working with clay is an activity that requires physicality and strength in different, sometimes previously unused, parts of your body. You may

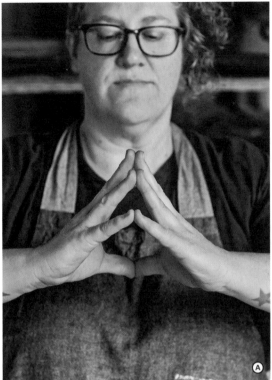

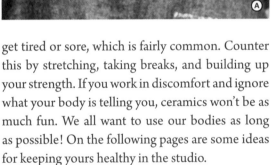

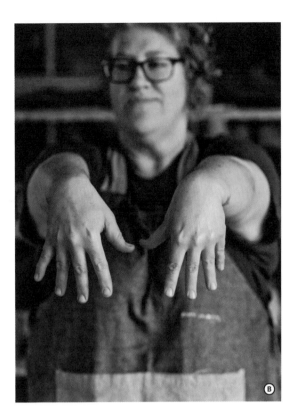

get tired or sore, which is fairly common. Counter this by stretching, taking breaks, and building up your strength. If you work in discomfort and ignore what your body is telling you, ceramics won't be as much fun. We all want to use our bodies as long as possible! On the following pages are some ideas for keeping yours healthy in the studio.

HAND STRETCHES

Do your stretches! As my mother, who is a physical therapist and my go-to source for this kind of help, is always reminding me, "Flexibility is the key to longevity." So, with her help, I have developed a few basic moves that address some of the common issues we hand builders face.

Before trying any of these stretches, remember to listen to your body. I am by no means an expert in this subject and certainly don't know your limitations! If you can, consult a doctor or your own physical therapist, chiropractor, or yogi for moves

suited to your body and physical ability. The following stretches can be performed every hour or two, or anytime you are starting to feel fatigued (when you experience hand cramps, for example). Do each stretch for twenty to thirty seconds.

Finger Push-ups: Start with your hands pressed together in a prayer position, fingertips all touching. Next spread your fingers apart as far as you can, then "steeple" the fingers by separating your palms but keeping your fingers together. Ⓐ

Hand Shake: Shake your hands out as if you just washed them and they are air drying. You're shaking the water off!

Thriller Hands: Start with your arms stretched out in front of you, your hands and fingers pointing down. Spread and move your fingers. You should feel a good stretch. With care, you can use one hand to increase the other hand's stretch a bit. Ⓑ

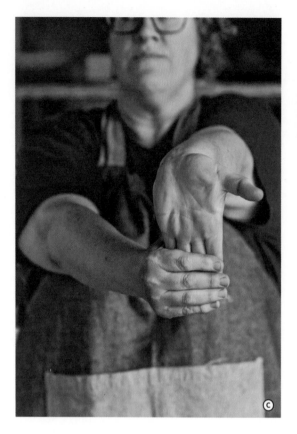

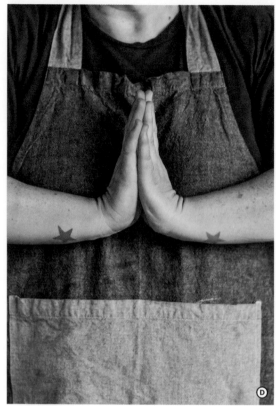

Flip the Script: Stretch one arm out with your hand and fingers pointing down, then use your other hand to increase the stretch if necessary. ©

Prayer Pose: Press your hands together in front of you, close to your body. Move them with the goal of getting your arms horizontal while keeping your palms together. ⓓ

OTHER STRETCHES

When potters are working for long periods, either sitting or standing, we may forget that we're hunched over our work. We get so focused on what we are doing that we put stress on our arms, shoulders, and backs. It is a very good idea to stop and reverse this action. Relax your shoulders and back, and sit up straight. Think of it as realigning yourself!

Expand on the Hand Stretches: Stand up and start with Thriller Hands and Flip the Script. These will get you warmed up. Then progress to the following more intense stretches that address the rest of your body.

Head Stretch: Move your head, ear to shoulder, on each side. Be gentle.

Doorway Stretch: Position yourself in an open doorway, hands on the doorjambs at about the height of your shoulders, with elbows pointed down. Now lean forward. This should stretch your shoulders.

Table Dog: This is one of my favorites and easy to do in the studio. Stand about 2 or 3 feet from the table, feet planted under your hips. Place your palms on the table and slowly bend forward. The goal is

to have your head come between your arms, butt back, and gently stretch your body (don't hit your head). You should feel this stretch in your thighs, lower back, between your shoulders, and maybe even your arms.

Move!: Okay, this one is not really a stretch. But you have a whole body, so use it! Often during that midday lull in the studio, I take a bicycle ride. It gets my body moving and my blood flowing. It also gets me out of the studio and into the sun for a bit. I return energized and ready for another few focused studio hours. Choose your own adventure. Just make sure you break up your day up with some physical activity.

Note: I am a huge advocate for massage. I trained to be a massage therapist many years ago. During that training, undergoing massage was a huge part of day-to-day life. The physical nature of massaging others necessitated receiving massage myself as therapy. Beyond being relaxing (for some), it can be helpful as a type of recovery treatment. If you undergo massage, have your masseuse or masseur focus on your hands, arms, shoulders, and back, or anyplace that is tired or sore.

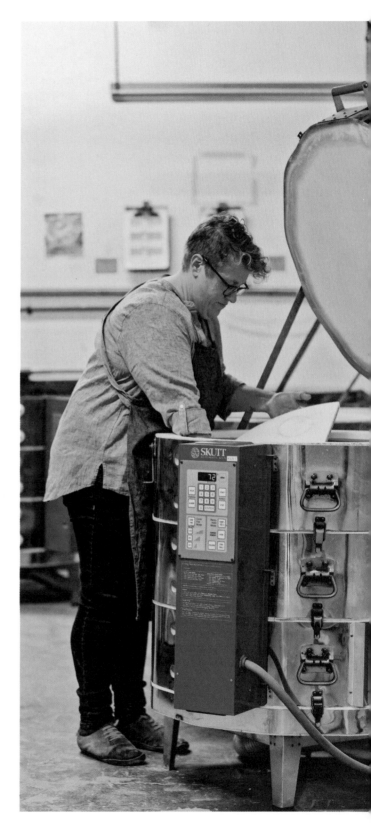

Many studio tasks, such as loading a kiln, require attention to posture and ergonomics.

Bryan Hopkins
Clay and the Motivation to Make

How did you get your start in clay?

I first touched clay my junior year at West Chester University of Pennsylvania. At that time I was a mathematics major and needed an art elective to graduate. I followed a friend into a ceramics class.

I did not like the feel of clay and was not good at hand building at first. However, the potter's wheel was another story. The first time I made a pot on the wheel, something clicked inside me. And I don't mean that in some hippie potter, pop-Zen way. Making that pot made sense and felt natural in a way nothing in my life ever had. I started selling work at craft shows on a very local, farmers' market level and gradually worked up to selling at the premiere craft shows in the United States.

What is your motivation to make?

Change. Although a pot will never change the world, I believe strongly that a pot—say, a mug—has the potential to affect a single person's life. Drinking your morning coffee from a handmade mug becomes a ritual, and the mug attains an importance in your life as an instrument of that ritual. Slowing down enough to consider what object you will consume that coffee from becomes almost a political choice. You decided to buy a mug from a potter, whom you perhaps met at a craft show, a potter whose hand you shook upon purchasing the mug. That mug and the memory of that interaction become part of your life.

I, as the maker, receive not only the price of the mug but also the reinforcement that that design, that mug, resonates with another human being. This creates a connection between two people and completes the thought of why the mug was made in the first place. So while my pots might never affect society as a whole and all at once, I believe affecting one person will ultimately affect each of our worlds.

What led you to discover the method of building you use?

I am a perfectionist, so porcelain and I are made for each other. It's white, translucent, smooth, with no grit. I hate gritty clay. Porcelain is not passive in the outcome of a piece. Porcelain is a partner I am working with, trying to negotiate simple issues like verticality. It has a mind of its own, and I feel I do not simply "use" porcelain. I feel we are in a long-term relationship. I developed my current methods to fully exploit the translucence of porcelain, and it is important to say that firing to cone 11 in a gas reduction kiln adds as much to the result as does my construction method.

What type of clay do you use and why?

I use a porcelain of my own formulation. I make it in my studio. It's small-batch, artisanal, and gluten-free. It is the whitest and most translucent porcelain I have ever encountered, and it took about four years to perfect. Translucence and whiteness are beyond important to me. I use only a monochrome palette, so I need that purity of clay to have a clear and concise conversation with it. My clay has set me apart and shown people how much I care about participating in the continuum of porcelain tableware.

What important lessons have you learned in your process?

1) Control is a negotiation, not a given.
2) There are no absolute truths. (Scoring? No need.)
3) Being a perfectionist sucks.
4) Developing a clay body specific to my needs was essential and has become almost as important as the forms.

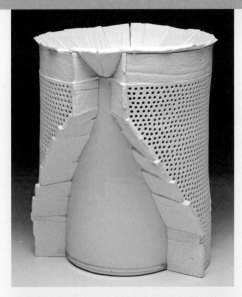

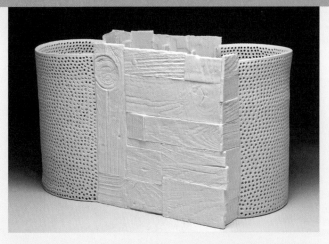

ABOVE: *Basket*. Bryan Hopkins. Slab construction, pierced, reductive process. LEFT: *Vase*. Bryan Hopkins. Slab construction, pierced, reductive process.

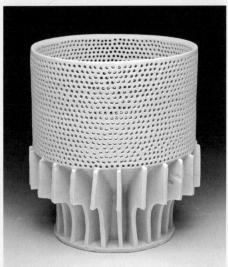

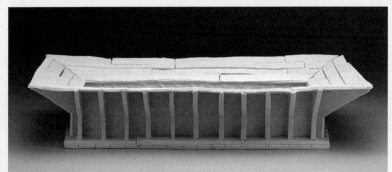

ABOVE: *Tray*. Bryan Hopkins. Slab construction. LEFT: *Raised Bowl*. Bryan Hopkins. Slab construction, pierced, reductive process.

LEFT: *Small Cup*. Bryan Hopkins. Slipcast slab.

RIGHT: *Small Cup*, backlit. Bryan Hopkins. Slipcast slab.

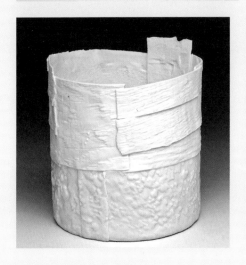

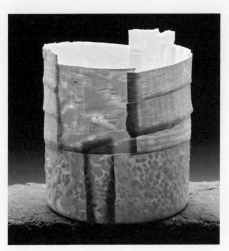

All photos courtesy of the artist.

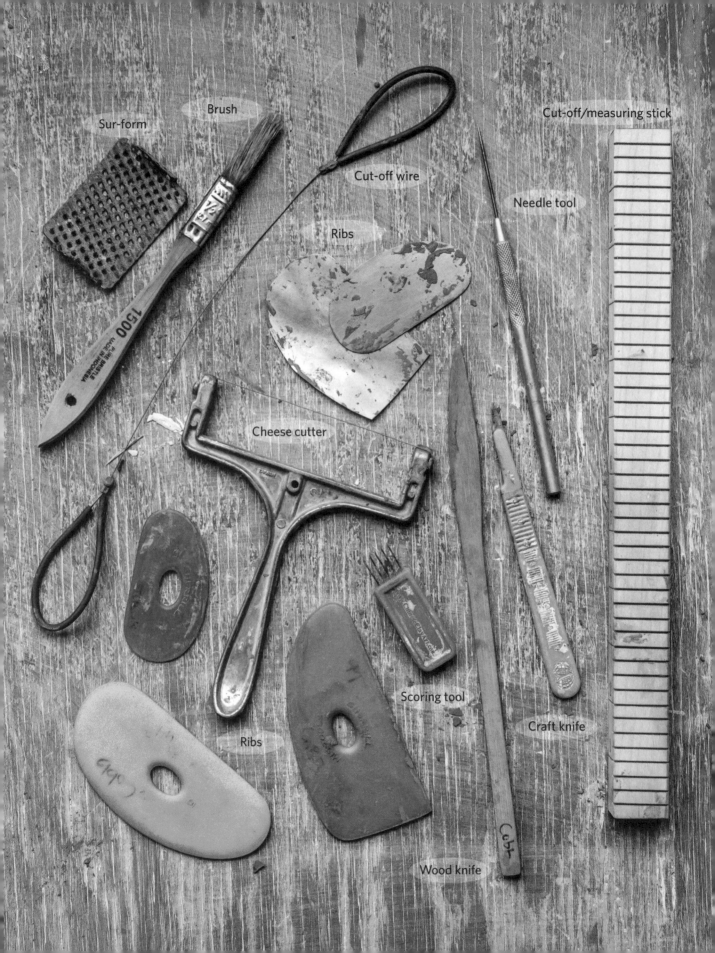

Sur-form

Brush

Cut-off wire

Cut-off/measuring stick

Needle tool

Ribs

Cheese cutter

Scoring tool

Craft knife

Ribs

Wood knife

TOOLS AND MATERIALS

As I said at the beginning of this chapter, the most important tool in your studio when it comes to making work is you! No matter what other tools you have or don't have, nothing in the studio will get done if you don't show up. So show up! Don't let issues such as not having enough space or not having the perfect tool or clay prevent you from making work. You will make progress and build your skills when you show up and make.

Okay, with that pep talk out of the way, let's talk clay tools! I am a right-tool-for-the-right-job sort of a person and try to keep the number of my tools to a minimum. It's natural for your tools to become more stylized and specific as your practice grows. But many of us tend to collect tools. At some point you need to get rid of the excess. Call it a spring cleaning of tools: Once a year go through your tools and eliminate the things you never use. Donate them to your studio if it offers community tools.

COMMON HAND-BUILDING TOOLS

I have worked in clay for two decades in many different studio situations. What follows is a distillation of all the tools I've encountered. Again, keep it simple! Start with the basics and add more as you like. While some of these tools will be referred to throughout the book, they are suggestions only. Check to see what tools you have that will work; there's no need to go out and buy every tool on the list. I am all about being resourceful, either grabbing what I have handy or quickly improvising a tool. Tools are about being more efficient in the studio and making the most of the time you have. Don't waste time waiting on tools.

The Basic Toolkit

Sur-form: This surface-forming tool is what I often use for leveling or evening out leather-hard clay. I reach for it frequently when shaping lids or boxes with capped lids. I also use it as a plane for larger surfaces. A sur-form and a level can take care of clay that's ill-suited for a cheese cutter. I keep two types of sur-form in my studio. I use a 4-inch-long handheld rasp/plane that is easy to find at a hardware store. I also like a more specialized sur-form you can get at clay store or sometimes at a hardware store: it's a short, 2.5-inch sur-form with a slightly rounded or bent blade.

Note: For sur-forms, I actually prefer the blades dull. When they're new and sharp, they catch on everything. I'm also not a huge fan of the handle for the small blade. The 4-inch-long blade is more like a plane, so that handle is nice for fluid motion. The smaller one I generally use without a handle so I can manipulate its direction more quickly. It is better for working on the round, like a lid or something else that I will also be holding in my other hand.

Brushes: To avoid smudging things with your fingers, you can use a wet brush to apply water or a dry brush to brush away clay burrs. There are lots of styles of brushes available. The most common in my studio are cheap hardware-store brushes, which I find are great for burr removal and simple water or glaze application.

Cut-off wire: Some type of wire is essential for removing your work when it's stuck on a work surface. My preference is for shorter cut-off wires to avoid tangling. I also like the kind with soft rubber handles.

Needle tool: This is always needed and a must for a basic kit. I often use my needle tool to trace and cut around templates (see page 63). It typically won't cut into a tabletop surface the way a blade tool will.

Ribs: I have three favorite ribs: a standard metal rib, a green right-angle Sherrill Mudtools rib, and a small metal Sherrill Mudtools rib. I usually cut cheap metal ribs into different shapes using tin snips or decent scissors. If you want to do the same, be careful when cutting. Make sure you don't leave razor-sharp edges. I usually reshape my ribs so that they have a 90-degree angle instead of only round edges. I like the Sherrill Mudtools polymer ribs for their varying sizes and degrees of flexibility (different colors indicate different levels of firmness). I do have a couple of serrated ribs for good measure, but I rarely use them.

Cheese cutter: At workshops I am often asked what my favorite tool is, and I think this is it! Yes, a cheese cutter is indispensable. It's a reductive tool I use primarily to cut my forms evenly, sometimes in combination with my wood measuring stick. Unlike knives, it stays perfectly sharp. It doesn't drag. It cuts cleanly and elegantly every time. When you're buying one, look for one with a flat handle. The larger, bubble-like handle can actually make it feel clumsy in the hand. Most cheese cutters come with a small roll guard for slicing cheese. Just remove that because it is not useful for our application.

Scoring tool: A needle tool *is not* a scoring tool. A scoring tool should have multiple needles on one end, as the purpose of the tool is to make scoring—roughing up the surface of the clay—easy and effective. You can make one out of plumber's epoxy and T-pins if you can't find a commercially made tool. With hand building, you're constantly attaching coil to coil, coil to slab, and handle to pot: Your attachments are a vital part of your practice, often making or breaking your work. This tool is essential to good scoring and strong attachments.

Craft knife: X-ACTO knives are readily available, but I don't love the thickness of the blades. Instead I use a craft knife or surgical blade, a knife with a fixed cutting edge. They can stay sharp a long time, depending on your clay. The only time I have broken one is when I'm working with clay that is too hard. So remember that disposable knives are not meant for clay use, let alone long-term use, and can have a shorter lifespan than an X-ACTO knife, whose blades are intended to be replaced often.

Wood knife: This classic knife is another favorite I use constantly, especially when I'm coil building. I use it as a rib substitute when a regular rib will gouge or be cumbersome—or when my hand no longer fits—inside a form. It's a great compression tool for corners as well.

Cut-off/measuring stick: This stick has notches on it for measuring, and I use them as a guide for the cheese cutter when I even out the top edges of forms. (For some projects, it's useful to have a pair.) These sticks are also great for making slabs from a block of clay. As an alternative for the projects in this book, you can get by with a ruler instead.

Banding wheel: While I love my cheese cutter, the banding wheel is the one tool that I'd need to replace the same day if it broke. I am not alone in feeling this way! The banding wheel is a fundamental tool for hand builders. Mine is heavy-duty, and its weight and design let it spin and spin and spin.

A good one is an investment, but it should last forever. Don't suffer bad banding wheels! They can turn you off and keep you from discovering what an effective studio tool they can be.

Note: While you want a good-quality banding wheel, bigger isn't always better. Of the three I have, I use my smallest, a short tabletop wheel (8.5 inches in diameter), the most.

Sponges: I keep a few standard kit sponges handy, and I like them even better after some wear. I don't like sponges with a lot of pushback! I prefer them soft and want them to wring out easily. For some reason, though, sponges tend to walk away. Keep more than one around.

Optional Tools

The tools on this next list are the extras. But they're also tools that I now consider indispensable in my hand-building practice. While they're not used for everything, they are used often enough for me to recommend that you consider them once you get serious about hand building.

Brayer: A brayer is a useful tool for flattening out clay. I use my brayer mostly to make very thin, wide strips of clay used for decorative effect. But brayers come in handy also to thin sections of clay that will be scored and joined; this helps reduce the amount of clay overlap. They can be used to a similar effect as beveling (cutting the clay to increase surface area).

Trimming tools: When it comes to trimming tools, the basic shapes work best in most circumstances. I recommend three shapes: the classic loop (pear shape), a rectangle, and one that is about a quarter of the size of the standard loop tool.

The key to effective trimming tools is keeping them sharp. If I'm planning a trimming session, I sharpen my tools beforehand with a grinder. Some people also use grinding stones (used for sharpening knives) on their trimming tools.

Wood knives: While I consider one wood knife essential, I like to keep a variety of them handy to use different blade shapes for different situations. They are an optional addition to your toolkit, but they are inexpensive and worth adding early.

Paddles: Paddles are wonderful for shaping larger objects or to firm up attachments such as knobs to lids. All of my favorite paddles are handmade, and they serve different purposes. If you have access to a sander and wood, you too can make custom paddles. However, start off easy with something like a wooden spoon. Or your studio might have some communal paddles available. Paddles are an optional tool, but once you come across (or make) a good one, keep it nearby!

Level/ruler: A small level comes in handy when you need to level off larger forms (vases) or forms that have feet or are raised from the tabletop (plates, boxes, cake plates). The type of ruler you choose is up to you, but I recommend a clear gridded ruler as shown in the photo on the next page.

Texture tools (roulettes): There are lots of commercially made texture tools available, and you are welcome to play with those. But there is more character if you make your own texture tools—and they are cheaper! One of my favorite downtime activities is to make some coils, let them get leather hard, and carve into them. I make ten to twenty at a time, bisque fire them, and then keep the best three or four. You will eventually break them, but it's okay. Keep pictures of patterns and texture ideas in an image file on your computer, then when you're ready to make roulettes, you can sit down and browse through the pictures for inspiration. (For more on making roulettes, see page 167.)

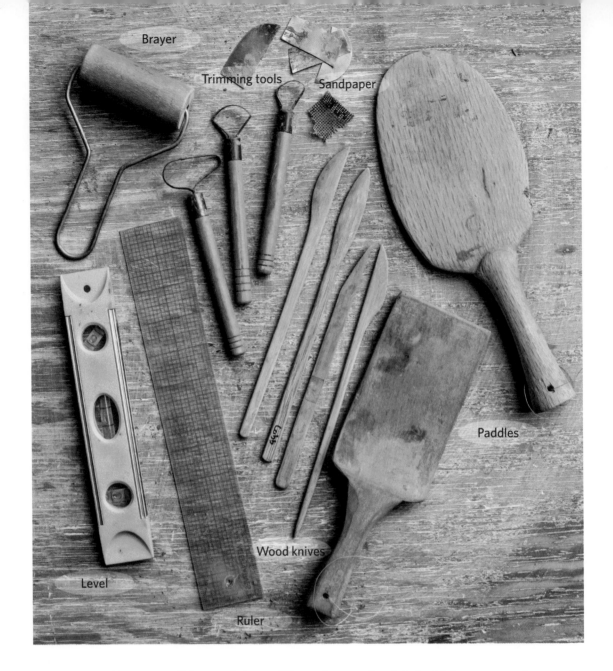

Brayer

Trimming tools

Sandpaper

Level

Ruler

Wood knives

Paddles

Torch/heat gun: It may sound like an indulgent addition to the studio, but a simple torch or heat gun is not expensive. It can often be purchased for twenty dollars or so. I prefer the trigger-style propane torch. It uses a regular propane can for camping, and even as a full-time studio artist I replace the propane can only about once a year.

Although you must use extreme caution with either device, I think heat guns are more dangerous than torches. Maybe it's because people are naturally more careful around fire, but in any case most everyone respects a live flame. (I've been burned only by a heat gun, never by a torch.) Again, safety comes first no matter which you use, and be just as careful with these tools before and after you turn them off as when they are turned on. They remain hot and can still injure you.

CLAY

One of the most common workshop questions I get is "What clay are you using?" My answer is hardly ever the same. That's because I use whatever is handy in the studio where I'm teaching. I don't travel with the clay I use in my studio—and even there I do not mix my own special clay. In fact, I've traveled and moved a lot, and my clay of choice changes based on where I live.

That said, clay is my canvas. It is important since it is the foundation of what I am building. My main concern when choosing a new clay is that the clay is the right color for the content I'm interested in developing. It is also important for my practice that the clay I use is workable and not overly fussy. While making your own clay can be cheaper, and for some it can be integral to their work (see Bryan Hopkins on page 20), I am happy to buy my clay. It frees up time for me to do what I love: make things with the clay! So my advice to most beginning potters is to find a clay that is workable and the color you want. Then spend time making things. Developing a clay body or exploring a custom clay body can come later if you are still interested in that avenue of exploration.

SELECTING A CLAY

When you're starting from scratch, a good place to begin is finding out what your studio's clay guidelines are, such as firing temperatures and any rules on the type of clay you can bring into the studio. You may not have as many options as you thought. Speak to studio mates and mentors to find out what they use and go from there. It is true that not all clays are created equal. Some will be easier to work with, especially for beginners. So don't be too quick to blame the clay for not working. Failure is often caused by user error rather than clay error. It takes time and practice with a clay to learn its rules.

Note: When I first started in ceramics, I tried every clay I could get my hands on. It helped me develop a

sense of how different clays worked and didn't work. I know this will seem absurd to some people, but I found I love a clay that pushes back and is a little hard to work with—even to the point of dictating the type of work I can make with it. Clay can be smooth as silk or as rough as concrete. Each is beautiful and complex, depending on how you approach working with it.

Here is a list of the things I think about when I select a clay:

Color: Is the clay the right color for the palette I am interested in exploring? How will it work with the glazes I have access to? Will the glazes completely overwhelm the color, or will the color be a wonderful backdrop for the glaze?

Grog content/plasticity: Clay is a plastic material. If you have a coil and you bend that coil, the amount the clay breaks or cracks at the fold will help you determine how plastic the clay is. If there are very few breaks, it is probably considered a "plastic" clay. If it breaks a lot, you have a "short" clay. Most commercial clays are plastic in nature, as this makes the clay good for throwing and generally suitable for hand building too.

Part of developing a nice, workable clay body is having a variety of particle sizes in your clay. Grog is used to help with diversity of particle size and is present in many types of stoneware—and even some earthenware-style clays. What is grog? Simply put, grog is clay that has been bisque fired (chemically changed to ceramic, so it can't be slaked

down to workable wet clay again) and then ground into a variety of small particles able to pass through different sizes of mesh. Some grog added to a clay body can be great, especially when building large pieces. But the particle size will make a difference in how the clay feels. I am not a fan of large-mesh grog and prefer fine-mesh grog, which allows the surface of forms to remain smooth. Too much grog can also cause clay to be crumbly at scored joints. If all of this is too much information, just remember you want a plastic clay with a bit of tooth (sand or fine-mesh grog), at least to start.

Shrinkage: Another thing to be mindful of when selecting your clay is how much it will shrink. Clay shrinks throughout the process: from building, to drying, to bisque firing, and then glaze firing. Some clays have high shrinkage rates (10 to 13 percent);

others, low (5 to 9 percent). This can be a factor when you begin building. With shrinkage of 10 percent or more, the size of a piece may surprise you after the first firing. Clay with a higher shrinkage rate will also be a bit more prone to cracking, especially if you are attaching pieces that have different moisture contents (soft leather hard to leather hard). If you're curious about a clay's shrinkage, check with the manufacturer.

Hardness/softness: This last consideration is not about selecting a clay body, but about selecting a clay to work with at a particular time. In a communal studio, it is often worth considering what the bag of clay you can buy on any given day is like. I want my clay to be soft when I work with it. I don't want to work with hard clay! Hard clay can be an indication that the clay has sat too long on a shelf or that the moisture content wasn't great to begin with. More important, working with hard clay is exhausting, and my hands start to hurt and tire quickly. I also don't want to be racing the clock, trying to catch up to the clay—meaning, that it is drying faster than I can keep up. The perfect moment to work with the clay may have already passed. On the flip side, I don't want my bag of clay to be so wet that it feels as though I am waiting forever for it to be ready to work with. Still, if it's a choice between too hard or too soft, I will lean toward too soft.

SPECIALTY CLAYS

Although I have not run across any paper clay or flameware clays available commercially, you may encounter these two types of specialty clays along with *raku* clay in your studio. Specialty clay bodies typically are developed according to a maker's need. They can be unique to a specific function or firing process. When you get to this point, you are entering the realm of making your own clay. This section is a brief description of three common kinds of specialty clay bodies.

Note the difference in size between the fired cup on the left and the greenware cup on the right. This is a good example of shrinkage.

Paper clay: Paper clay is a favorite clay among some large-scale hand builders. It can also be used as a repair compound. Paper clay is made by combining paper pulp with slurry-like clay and then letting it firm up enough so that you can hand build with it (this happens once it has dried to the consistency of a regular bag of clay). Since paper pulp is fibrous, it creates a structure in the clay that makes it incredibly strong during building and drying. It's flexible to work with and easily repaired at all stages.

Don't jump ahead and think paper clay is the answer to all your problems, though. As with any clay, it requires a learning curve, it has its own issues, and it usually stinks to high heaven (thanks to all that rotting paper). There is no need to consider paper clay for the projects in this book. However, it is something you should explore if you're thinking about moving into large-scale work. There are whole books about using and making paper clay.

Flameware: Flameware is a clay for making finished pieces that come into direct contact with a flame. You'll want to use it if you want to make something like a clay frying pan or a tagine. While most clays will withstand a small degree of thermal shock, some are prone to cracking when the heat becomes too great. Flameware is more specific in its chemistry: it's designed to absorb the shock of cooking over a flame or the shock of, say, transferring a pot from the oven to the refrigerator.

There are various materials that can decrease the thermal shock in fired clay, but most flameware recipes are closely guarded. So if this piques your interest, research and test!

Raku: *Raku* firings require a clay that has strength and good thermal-shock properties. There are many recipes out there for *raku* clay bodies, and commercial *raku* clays are likely available for purchase at your clay store.

STATES OF CLAY

One of the keys to learning the language of ceramics is describing the states of clay. It can seem mysterious and confounding until you get a good feel for what's what. In this section I will outline some of the basics.

The states of clay relate to the projects and lessons in this book, as many hand-building techniques are easiest to perform during a particular state of clay. Only with regular studio practice will you master knowing when to do what with your own pots.

Clay straight out of the bag through to the bisque firing is considered **greenware.** At any point up until bisque firing, you can still recycle or reclaim the clay and begin again. Within the greenware state there are many stages of workability. The different names we use to identify those stages indicate how much the clay has dried and how much more workability remains.

Let's get cheesy! Yes, believe it or not, cheese can be helpful when it comes to discussing the stages of greenware. To begin with, think about **wet clay**, the clay right out of bag. This clay should be very moist and soft, sort of like cream cheese. It can be torn into a handful of pieces and easily smashed back together. It should stick together easily without needing any slipping or scoring. Using clay at this stage, you can easily coil, press mold, build with slabs, and add handles, knobs, and feet. This is also the best stage for repairing any issues with the form.

As clay sits in the open air, it begins to dry. The first commonly referred to stage you'll reach is **soft leather hard.** Ⓐ Clay in this state is firm but still very flexible and plastic, although no longer wet (think of that famous yellow processed cheese or Muenster). If you bend a piece of clay, it will fold over and onto itself. Clay at this state will retain a shape as long as you handle it with care, yet it's soft enough to take on impressions from your hands or

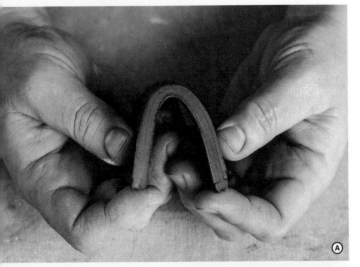

(A)

(B)

(C)

other objects. It will support itself somewhat but still easily stick to additional wet clay or other clay at the soft-leather-hard stage. Attachments generally will require a small amount of scoring and a bit of slip or water.

With clay at this stage you can do some soft-slab building, building with molds, template building, and texture application. If you've left clay to dry in this state, you can still add to it by coil building, and you can combine clay in additive processes (such as incorporating handles, knobs, bottoms, or lids). You can also try reductive trimming or carving.

Before moving on to the leather-hard stage I want to mention that I love the time when clay is between the states of being. In other words, I find the place between soft leather hard and leather hard to be the sweet spot of working with clay. Your own sweet spot will also likely be somewhere in this range, depending on the task at hand.

Once clay is **leather hard**, (B) (C) it will support weight without losing its shape. It will retain limited flexibility, but there will also be a shortness to it. Think of a thick slice of cheddar cheese: If you bend the cheese and try to fold it in half, it will break into two pieces. The same is true for clay at the leather-hard stage. It still bends slightly, but there is very little flexibility. That said, this can still be a great state to work in. You'll have to score and slip attachments well, but the clay will also hold its shape—there will be very little chance of distorting your form when doing something like adding a handle.

Once all the physical water leaves the clay, it is considered **bone dry**. (D) While you want the clay to reach this state before you move on to bisque firing, it is not a state in which you want to work on your piece. There is no way to add new clay to your piece once it's bone dry. In fact, even if you find a crack, it's best to just let it be. Bone-dry clay is no longer repairable. However, bone-dry clay can be a good state for some decorative processes such as water etching or laying in colored slips.

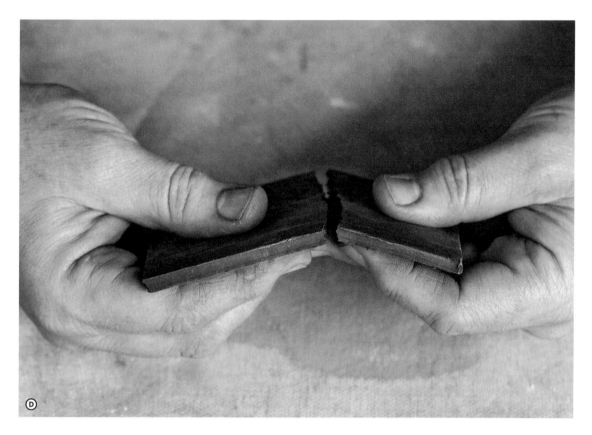

After the first firing of the clay it is no longer greenware. Now your piece is **bisqueware**. Once it's bisque fired, the chemical water is removed and it's considered ceramic. Your clay can no longer be recycled, and you can't add anything to the piece or carve into it. It's time to move on to underglaze or glaze decoration.

Note: Does your studio have a shelf labeled "To be fired"? This isn't really a state a clay. Studios often mark their shelves for pieces ready to be bisque or glaze fired. The "To be fired" shelf is for bone-dry work. The "To be glaze fired" shelf is for work that has already been bisqued and glazed, and is awaiting its final firing.

Once you glaze your piece and it's fired a second time, you have **glazeware**. Depending on your clay, this final firing could be anywhere from cone 04 to cone 10; each clay has a different vitrification point. *Vitrification* is the term we use to describe the fusion of the clay and the low porosity of clay after the firing. Think about the difference between a terracotta flower pot and a diner mug. Those objects have very different densities! Commercial clays in the low-, mid-, and high-fire ranges are formulated to achieve vitrification at the prescribed temperatures. For functional work, most glazeware will be dishwasher- and microwave-safe if fired to its vitrification temperature. Some glazes and iron-rich stoneware will spark in the microwave, though, so be cautious. Always talk to the studio supervisor if you are unsure about using a particular clay or glaze for functional ware.

Janice Jakielski | Ceramic Exploration

How did you get your start in clay?

I was incredibly lucky to have a high school art teacher introduce me to clay early on. He nurtured my love of the potter's wheel and introduced me to some of the greats in our field, such as Lucy Rie and George Ohr. I was given a copy of Daniel Rhodes's *Clay and Glazes for the Potter* at fourteen and made a science fair project on lead substitutions in low-fire glazes. I still have a huge fondness for ceramic chemistry, though it's taken on a different form these days. This teacher had a pipeline from our little high school to Alfred University. It's amazing how many of us he has sent there over the years.

Can you explain your clay and how your exploration has developed?

My husband is a ceramics engineer and over the years would bring home various samples of ceramic components used in industry. I would drool over the catalytic converters with their complex extrusion patterns, the silicon carbide armor plates, and nickel fumed aluminum tubes. Invariably there would be a reason why these extraordinary ceramics were out of reach of the ceramic studio artist—usually for reasons of cost, the dangers of the chemicals used, and most often extremely high firing temperatures. One day he brought a piece of tape-cast alumina into my studio, though, and this was a material that I had to have.

Tape casting is a casting process used to make thin ceramic sheets traditionally used in the microelectronics industry for things like solid oxide fuel cells and piezoelectric devices. I began reading about this process and used my time at various residencies to begin to develop a formula. My goal was to create a safe tape-casting process for any clay or glaze in the typical ceramic studio range. Once I had the basics down, I looped my husband in to help me refine and perfect the process.

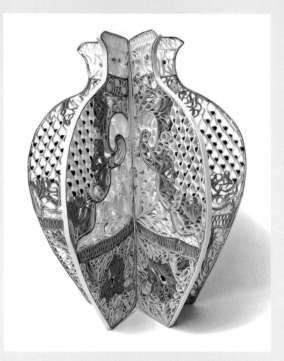

Jardiner. Janice Jakielski. Quilled tapecast porcelain. When using this new material, I am trying to push the boundaries of what can be made in clay. Quilled porcelain seems almost magical, and I am not one to eschew a little magic in my work.

Are there any tools in your practice that have inspired you?

Because sheets of tape cast are flexible in the green state and never dry out, working with this material is more akin to using paper than clay. I have been very inspired by the amazing work being made by contemporary paper artists. This is a field that I might not have explored had it not been for my foray into tape casting. I use a vinyl cutter in a lot of my work. I love its immediacy. But I have also done quite a bit of traditional hand paper cutting as well as die punching. I find this new material both exhilarating and exhausting. There are so many new avenues to explore and so much research to be done.

What is your favorite thing about the method you use?

Everything: the newness, the excitement, and the subsequent exhaustion from a brain that won't stop racing. The fact that I know that every piece I complete will lead to the next, hopefully better (and if not better, then at least educational), exploration.

What type of clay body do you use and why?

I am currently using a cone 6 porcelain that I have devised for its incredible translucency and ability to carry color. I have no loyalty to a particular clay or firing range, though, and change as needed to fit the work being made.

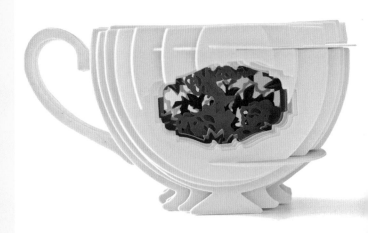

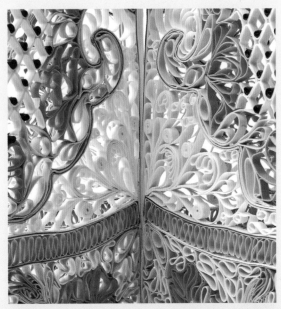

Slotted Teacup. Janice Jakielski. Slotted pieces of tapecast porcelain assembled into a three-dimensional teacup form. This is the first in a new series of deconstructed teacups. I am intrigued by the combination of historical vessel reference and industrial ceramic process.

Jardiner, detail. Janice Jakielski. Quilled tapecast porcelain.

Honeybee Porcelain Garden Collaboration. Janice Jakielski. Quilled porcelain strips. I am collaborating with my honeybees by creating various porcelain, garden-themed designs for their hives. My hope is to have the bees complete my designs.

All photos courtesy of the artist.

MANAGING THE DRYING PROCESS

Now you know a bit about the states of clay, so how do you keep a piece from drying out while you work on it? In most studios, a simple, soft plastic sheet will be your primary tool (I recommend dry-cleaner plastic). The longer you leave a piece out in the open air rather than under plastic, the quicker it will dry. When you leave a piece in the studio overnight but want to work on it the next day or later in the week, you should cover it with plastic.

Besides the covering (or uncovering) of your work, the biggest factor in how fast your work dries is your studio environment. I have been lucky to live in places with a dry climate, so work tends to dry quickly and evenly if it's not exposed to directional air (for example, an air conditioner or fan). What I love about a dry climate is you can work on multiple pieces simultaneously, easily moving from one to the next when each is ready. Still, it is always possible for work to dry too fast.

If you live in a humid environment, work can take a while to dry. I have found that covering projects with plastic in high humidity can cause them to become completely saturated, absorbing the condensation and making pots seem more damp than when you first wrapped them. Chances are you will still have to cover your work when you leave it overnight, and you may need to return to the studio early to uncover it if you want to keep your work moving.

Besides using plastic and gauging your studio environment, you may have other options to slow or speed up the drying process. Damp boxes are great if you need to rehydrate your work or keep it moist in a dry studio. There is little risk in using a damp box other than the clay drying out faster than you expected (which can happen, depending on the effectiveness of the damp box). Use great care when using a dry box, though. It can be a very useful tool in a humid studio, but it can also ruin your work. Set a timer and continually check your work until you can begin working on it again. Rapid drying can lead to cracking and other problems, so it is best to let your work dry at a normal to slow rate. The goal is to allow your work to dry at an average rate despite the humidity—see page 35 to learn about using a torch or heat gun on the rare occasions when you want to speed-dry a piece.

The next thing to consider in the drying process is wall thickness. I like to make work relatively thin. Besides conserving clay, thin walls help to reduce drying time. The thicker your work, the more patient you'll need to be.

Once you're finished working on a piece, the final drying process is again dependent on the environment and your clay. Is it picky clay or a fragile object? Will it be exposed to directional air? In general letting your piece dry slowly will help decrease the chance of cracking or breaking before firing.

If your piece might be exposed to directional air, drape some plastic or a bedsheet over it to help it dry at an even rate. Also, throughout the drying process, monitor forms that may be prone to cracking or getting too tight in spots (for example, lidded jars).

PICK THE RIGHT PLASTIC

Not all plastic bags are created equal. In fact, I often refrain from using the term "plastic bag" because what students often think of is the small bag you get from the grocery store or the bag that the clay comes in. Neither of these bag types is great for wrapping your projects. The grocery bags are not airtight. They breathe so well that your work will dry out under them. Clay bags can obviously retain moisture, but they are so rigid that it can be hard to wrap them around projects without trapping a ton of air or damaging your work.

That's why I suggest using dry-cleaner plastic. It is soft and airtight, and when cut lengthwise it becomes a large sheet perfect for flipping slabs or wrapping up a full board of pots. It's also transparent—a huge plus in communal studios where you want to quickly find your work among others' on the shelf.

Finding dry-cleaner plastic is usually easy. Someone in your family may already have extra bags from a recent trip to the cleaners, or you can stop by the cleaners and purchase a few bags. You can even buy a whole roll, though that much plastic will last a lifetime!

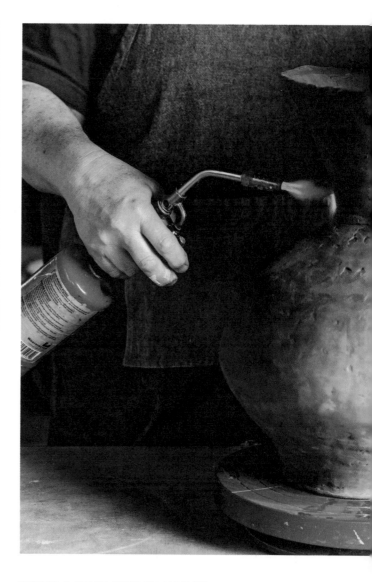

USING A HEAT GUN OR TORCH

Ah, the lure of fire! Chances are if you've been hand building for a while, you have seen people use a propane torch or a heat gun to speed-dry their work. Using a torch or heat gun can be very tempting, and each can be a great tool if used cautiously.

I often use a torch in the early stages of a form, getting the foundation of the form firmed up so I can continue building. A few best practices:

- Keep the object moving (preferably on a banding wheel) when applying heat.

- Be mindful about how close you allow the flame or heat gun to get to the form.

- Let the form rest a bit after you have heated it to let the moisture in the clay equalize (the water will migrate, and the clay will steam for a bit).

When using a torch or heat gun, there are also things to avoid:

- Don't heat clay that is prone to cracking or a form that is particularly thin.

- Don't heat the surface where a future attachment is going to be made.

- Don't heat a seam. It will start to pull apart.

- Don't heat one spot too much, because the goal is to dry your piece as evenly as possible.

- Don't burn yourself! I prefer a propane torch with a trigger that, when released, shuts off the heat. Heat guns may seem safer; however, once they get hot, they stay hot in places. I have seen many people accidentally burn things they set too close to a hot heat gun or forget that the tool is still hot despite the absence of an open flame.

In short, exercise caution when playing with fire!

FAST DRYING DONE RIGHT

I have found one method of fast drying that seems to work better than just leaving a piece to survive a dry room on its own. However, this will require having your own kiln or the permission of your studio technician or manager.

Place a sheet of dry-cleaner plastic over the piece, covering the form loosely but making sure to cover the whole piece from top to bottom (tuck the plastic under the piece securely). Vent the plastic bag at the top (dry-cleaner bags are perfect for this since most already have a hole for a hanger). Now either place the piece in a dry box or in a kiln set at 180 to 200 degrees Fahrenheit and hold for as many hours as necessary to dry the piece. (Do not heat the piece to the point of boiling water, though, or your piece will explode. Keep the temperature between 180 and 200 degrees!) Approximately one hour per ½ inch of wall thickness is the standard drying time, or hold pattern, I recommend. And note that this should be done only for work that is a struggle to dry evenly or work that needs an extended drying period.

GALLERY

Triple Oval. Nathan Craven. Extruded ceramic.
Photo courtesy of the artist.

Untitled Figures. Robert Brady. Solid construction, reductive process. *Photo courtesy of the artist.*

Kosmeo Bricks, detail. Nathan Craven. Extruded ceramic.
Photo courtesy of the artist.

Nocturne. Rain Harris. Hand sculpted with nichrome wires.
Photo courtesy of the artist.

Anamorphosis_Diptych (Shale). Anne Currier. Slab construction. *Photo courtesy of the artist.*

Olive Trough. Lindsay Oesterritter. Solid construction, reductive process. *Photo courtesy of the artist.*

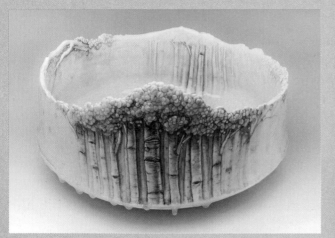

Right before Sunrise. Heesoo Lee. Coil and pinch construction, additive elements. *Photo courtesy of the artist.*

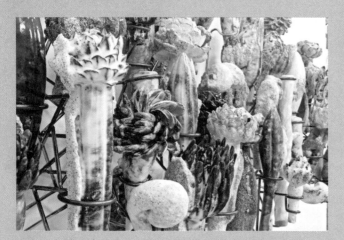

Bloomfield, detail. David Hicks. Coil and pinched, solid construction. *Photo courtesy of the artist.*

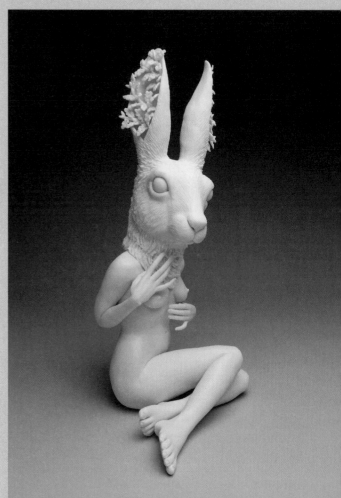

Entangled Wonders: Interconnected Fate. Crystal Morey. Coil construction. *Photo courtesy of the artist.*

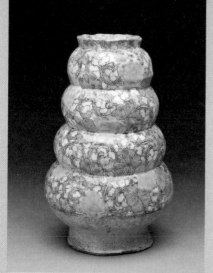

Vase. Shoko Teruyama. Coil and pinch construction with sgraffito decoration. *Photo courtesy of the artist.*

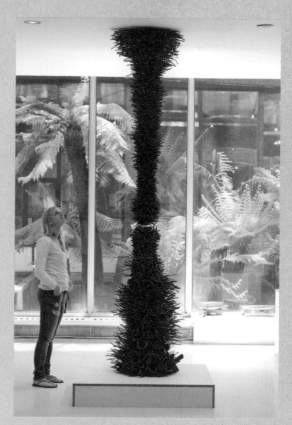

I am walking in a forest of shards. Zemer Peled. Installation. *Photo courtesy of the artist.*

A Simple Complicated Truth. Joanna Powell. Mixed media. *Photo courtesy of the artist.*

Urn. Deborah Schwartzkopf. Slab construction with templates and molds. *Photo courtesy of the artist.*

Head. Kensuke Yamada. Coil and pinch construction. *Photo courtesy of the artist.*

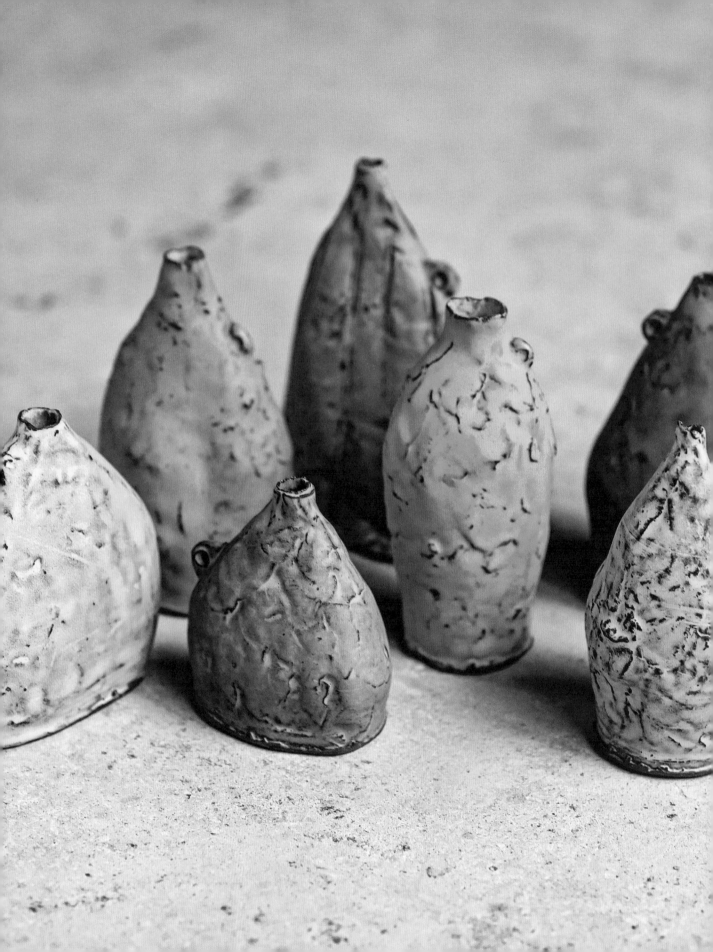

2 PINCH POTS AND COIL BUILDING

YOUR SUCCESS OR FAILURE in learning new skills is often tied to the attitude with which you approach learning. Beginners tend to find one method that comes easily and stick with it to the bitter end. The downside to this is that you end up forcing too many ideas to fall under a single method of construction.

I challenge all of my students to keep an open mind as they learn. And I challenge you to keep an open mind as you review the methods in this chapter and Chapters 3 and 4. The lessons are designed to help you develop new skills and refine them. If you try a method once and then abandon it because another comes more easily, that's okay. But don't forget about the more difficult technique. Give it another try later. You might be surprised to find that your experience in clay has improved your skills. What was once difficult will now seem simpler, and it will unlock new paths for your work.

At the heart of this chapter are the two techniques most hand builders learn first: making pinch pots and coil building. As you practice them, pay attention to any fleeting thoughts that come as you work and jot them down. This chapter should not only develop your skills but also be the beginning of a notebook for future pieces. Skills and ideas are intertwined—the more you realize that, the richer the experience you'll have.

This chapter also covers a few topics that cross over into slab building, such as removing clay from and adding clay to projects and fixing cracks. If you are already familiar with pinch pots and coil building and thinking about skipping this chapter, you may still want to glance over pages 44 through 47.

PINCH POTS

As you think back, making pinch pots in grade school might be your first memory of clay. At some point, you were handed a lump and told to pinch a shape—a bowl or a pony or a flower. While it might seem simple in retrospect, pinching a single piece of clay to achieve a complex shape is extremely difficult! But by mastering pinch pots you build a skill that will prove helpful again and again. After all, pinch pots can also become part of a larger form. You will undoubtedly create many shapes by hand even when primarily building with slabs or coils.

TOOLS AND MATERIALS

1 pound of clay
Basic toolkit (page 23)

INSTRUCTIONS

When you begin a pinch project, it is important to start small and then scale up. In this section, let's start with half of the clay. You'll want a ball of clay that is roughly ½ pound, or the size of a lime. Starting with the ball in one hand, press your thumb into the center to start shaping it. Use the fingers of

your other hand as a backstop to help shape the ball into a small cup. Ⓐ This backstopping of your hand and fingers also serves to compress the clay.

Note: *With this project, you will find that as you pinch, applying pressure from the inside and outside of the form will give you vastly different results. If more pressure is applied from the inside, the form will widen, and it will be easy to lose control of the form. More pressure from the outside will keep the form heading toward the middle (think: up and in). As you make these simple forms, notice the pressure you are applying and its effect on your form.*

From the bottom of the form, continue to pinch and shape the piece. Work gently in a circular manner around the form, eventually moving all the way to the top. You can try applying different amounts of pressure, but work slowly and keep your piece uniform in thickness. Slowly develop the wall; you may lose control of the form if you attempt to create the desired thickness in just one pass.

Once you've reached the desired thickness and overall shape of the form, it's time to make a second piece with the remaining ½ pound of clay. The goal will be to make a second piece identical to the first, then combine the forms. Ⓑ Before we do that, though, take a look at your first vessel. If it is not quite up to snuff, try making it again. This exercise can be something you lose yourself in while strengthening your hands' response to the clay.

COMBINING FORMS

Small pinched vessels can easily be combined to create a form that is hollow. This technique is often employed to build small figures or whistles. To start, we'll need the two identical cup forms you made in the previous section. Note their thicknesses; it is easier to work with thicker walls in the beginning so that you can manipulate forms more easily with the extra clay.

Before combining the two pieces to create a sphere, use a scoring tool to score both rims well where they will meet, then use a brush to moisten one rim with water. ⓒ Now it's time to attach the two pieces. After you have attached the forms, I recommend setting them aside and letting them firm up before cleaning the seam. The clay should still be malleable. Trapped air inside the form will also give you a bit of resistance as you work on the exterior of the form. This will help maintain the "inflated" body of the piece. Once the form is not so easily distorted by handling, clean the seam.

Now set aside the form again to dry slowly before firing. I encourage you to make a few of these hollow forms, because you will gain a better command of pinch pots the more you practice.

Note: *It's a good idea to use a needle tool to poke a hole in a hollow form when you're done. If trapped air doesn't have a way to escape from the piece as heat increases during firing, your piece can crack or explode from the pressure of the expanding water vapor. Find a place that is not obvious to the naked eye. Make sure the clay isn't too wet, because you can inadvertently fill the hole with wet clay that sticks to the needle tool. Also think how the form will sit on a kiln shelf when it's fired. Do you need to build a small base for it to sit on? Or will it lie on its side? There should be no glaze anyplace the form touches the kiln shelf. (Melted glaze will cool and lead to your piece sticking to the shelf, ruining your piece and the shelf.)*

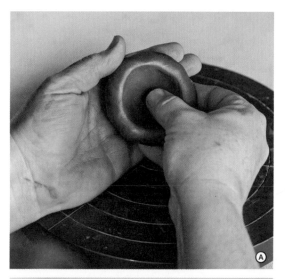

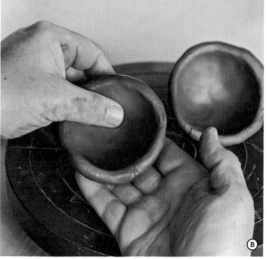

REMOVING AND ADDING CLAY

Okay, you've constructed an object! You've reached the point where you may want to trim or carve to finish the piece—and you may need to add some new clay as well, in the case of something like a handle.

Trimming or carving to remove clay is considered a *reductive process*. In other words, it is taking an amount of clay away from the piece. Attaching more clay to a piece is an *additive process*. We'll discuss both processes separately on the pages that follow. Chances are you will be using both for many of your pieces.

REDUCTIVE PROCESSES

Reductive processes require patience, because you'll need to learn to wait for the clay to reach the right state before you start trimming or carving. If you are unsure what I mean by this, try taking a small piece of clay straight out of the bag and compare it to a piece that has been exposed to the air long enough to become leather hard. Every tool you use will have a different effect on the moist clay versus the leather-hard clay.

While trimming and carving sound similar, for most potters they mean different things. *Trimming* is most often used to describe the removal of clay to create the feet on cups, bowls, and other functional pieces. When trimming a foot on a pot, you must consider the visual weight of your piece and of the foot you want to create. How much visual lift do you want to give your piece? And how much of the bottom of the pot should touch the surface of the table? Ⓐ

Trimming is an evolving skill. You can't be afraid to destroy pots as you learn and improve your skills. Researching feet is a good idea too! Look at the bottoms of bowls or other trimmed objects made by other potters. You'll soon notice many potters do this when examining the work of a colleague or

(A)

friend. We love picking up pieces and turning them over to see the foot better—sometimes accidentally dumping out what's inside!

For most trimmed feet, you'll use traditional trimming tools common in throwing. But in the hand builder's world, we are moving a bit more slowly and not relying on the electric wheel. This means trimming has unique challenges: It requires a steady hand and thoughtful intention. That said, one of the perks of hand building is we can move back and forth in the additive/reductive process more fluidly. I have seen many a foot attached as a coil, for instance (additive instead of reductive)—this is not as common on the wheel.

When you're trimming, your clay needs to be at the right state to work with and the form needs to be thick enough to have clay trimmed away. On your first pots, don't worry if you trim through the form (many a planter has been made this way!). When you're ready to try trimming, turn to the mug project on page 48, and see the gallery on page 75 for inspiration.

Carving is the word potters use to describe the process of removing pieces of clay for decorative or functional purposes. (B) Sometimes potters carve

MAKE A BIRD

Another way to get comfortable with clay is to make pinch pots in the shape of figurines. Birds are one of my go-to forms because there are so many types to choose from and they can be very playful in the interpretation. Find your favorite bird and see what it looks like in clay! Pay attention to how the clay responds as you push and pull it to make your bird.

Remember, you can always cut into the hollow form and pinch wings or score and attach feet to the form. Explore and play! The only rules are to pierce a hole in your finished bird and to make sure none of your attachments is too thick—you don't want an exploding bird. Once you finish the first bird, make a few more. See how your forms change from one to the next. Fire the birds, and use them to practice different glaze and underglaze techniques.

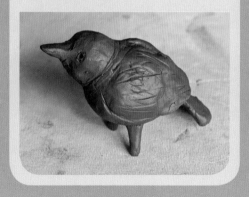

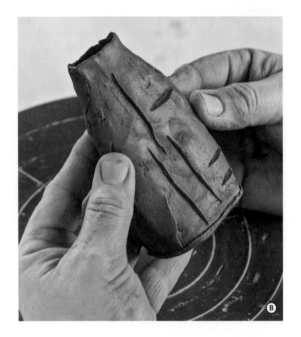

on the surface of a piece, and sometimes they carve straight through a piece. Many potters use carving to enhance their pot's surface in tandem with their glazes, creating ridges or valleys where glaze breaks and pools. You can carve the exterior or interior of a pot and carve deeply or more shallowly. Your carving can even be filled later with colored slip, as in the decorative *mishima* technique. The tools for carving are as unique as the maker and often refined over time. Clay stores have a variety of sculpting tools that can double as carving tools. Try a few out! For more on carving, see page 168.

ADDITIVE PROCESSES

Adding clay to a piece as you would for handles, knobs, and some decorative elements is what first comes to mind when you consider the additive process. Yet there are more options. Before bisque firing, you can add some non-clay elements, such as nichrome wire. You can also add fired clay or non-clay materials to your pot after bisque firing.

What I love about additive processes is the opportunity they provide for whimsy. You can make lots of odd, decorative, fun, playful things and see what works with your form! On the other hand, successful additions to your piece usually require a bit of planning. You will need to attach clay at the right point in the process and/or plan for your post-firing additions. My advice is that you craft a plan while also giving yourself some wiggle room to improvise.

Moist clay attachments: Handles and knobs top the list of hand-built additions. ⓒ They can be made with clay in almost any configuration, limited only by what your piece will accommodate. There are so many ways that people interpret this that my advice is to see what inspires you and start making! More information on making handles can be found in the mug project on page 48.

Note: One of my only caveats about knobs is to make them functional. Even though knobs have tremendous potential for decorative enhancement, the point of a knob is to be able to lift the lid off of a pot. So be mindful of functionality while your creativity is exploring the wild side of knobs.

Other additions run the gamut from functional to sculptural. Some functional potters build separate feet for their pots. Sculptors often add clay as they work, such as an ear to a head. No matter what you're attaching to your piece, here are a few tips:

Make sure that the clay you're adding to your pot is in a very similar state to your pot. If you add very soft clay to clay that's on the dry side of leather hard, you increase the chance of cracking as the pieces dry at different rates. Scoring well will help ensure a secure connection between attachments.

Score aggressively and use slip or water when attaching pieces. ⓓ These days I primarily use water rather than slip and usually don't have many issues. (I always keep a brush and a little measuring cup full of water handy.) However, if you're just starting out, using finicky clay, or concerned about an attachment, using slip is a good idea. Just make sure that the slip is made of the same clay you are using for your project.

Note: The best way to make a slip is to take some of your clay, let it dry out completely (to bone dry), crush it with a rolling pin, put it in a sealable plastic container and add water. The clay should slake down easily, and you can adjust the moisture content by adding more water or letting it dry uncovered.

Make multiple pieces, such as knobs or feet, in case you ruin one while trying to attach it. You can also make a few variations in different sizes if you're unsure which will look best on your piece.

For large attachments, you may need to consider a support system to hold the attachment in place as it dries: This is called an armature. Traditionally armatures are used to build sculptures, holding wet, heavy clay in place. When working on small pieces, you can improvise an armature. Stacked sponges or wadded-up newspaper (with some masking tape to hold it in place) make for good makeshift support. Just be sure to remove your supports before firing.

Non-clay/post-firing attachments: This is the mixed-media approach to adding elements to your piece. Attaching a metal knob or a fired clay knob to your fired pot with epoxy is a great example of this technique.

This book will not go deep into this topic because the options are truly endless. However, I will say that if you're making functional work, you have a responsibility to make sure you are using nontoxic materials. Adhesives can break down over time when subjected to harsh conditions—say, a cup in the microwave or a casserole dish in the dishwasher. Be mindful of potential downfalls when attaching non-ceramic elements after firing.

Look around your studio and scour the Internet for ideas. Don't be afraid to contact other artists to find out how they add nontraditional materials to their projects. Just be respectful of their work and time—and know that you may occasionally get a "no" or no response at all. Some methods and practices are hard-won and developed through years of hard work and testing. Still, potters are a friendly group overall, and many are willing to share their personal tricks and processes.

PINCH-POT MUG

Now that we've discussed removing and adding clay, let's look at a pinch-pot project that will let you practice both: a mug! A mug may seem like a basic form, but it is also a rewarding challenge. Many potters return over and over to the form, tweaking and fine-tuning as their skills grow. Mugs are also wonderful objects to make and decorate as test vessels. They're not too large or time-intensive, but you can still get a lot of information from decorating and glazing these 3-D forms. If you're having trouble deciding what size to make your mug, just ask yourself: what do you want to drink from your mug?

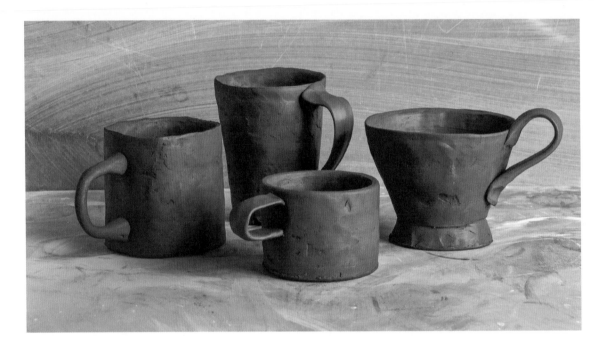

TOOLS AND MATERIALS

About 1 pound of clay
Basic toolkit (page 23)

INSTRUCTIONS

For this project I recommend that you work directly on a banding wheel, which will help keep the form close to round. But you can also work on a bat.

Start by forming the clay into a ball, then place the ball in the center of the banding wheel. Tap the clay down firmly, but don't squash it flat. The base should be about the diameter you want the foot of the mug to be. Ⓐ

Press your thumb into the center of the clay, using your fingers as a backstop on the outside of the mug to ensure it doesn't expand beyond the desired diameter. The goal from here is to slowly pinch the form upward. Use your outside fingers to keep the form rising rather than spreading outward. Ⓑ Work round and round the form, being careful to avoid pinching fast or deep. Slow, overlapping pinches over many passes will keep your

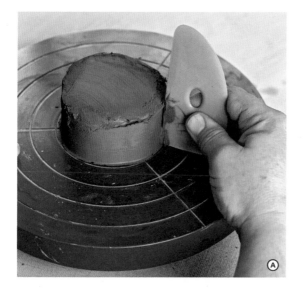

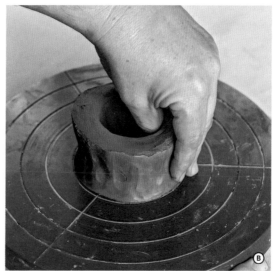

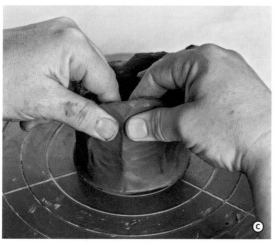

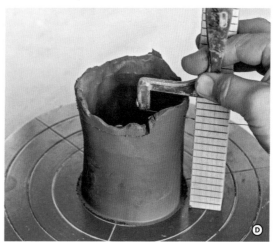

mug in line. Remember that you want even walls with a consistent thickness from the bottom all the way to the top. Ⓒ Use a rib to smooth the surface and shape the mug.

Once you have reached the limit of your clay and the mug is as tall as you can make it, it's time to cut the top off and make the lip even. Find the lowest point of the lip and use the cheese cutter and the measuring stick or ruler to cut off the top. Ⓓ Now finish the lip in a way that matches your form. In the example shown here, you can see that I gently pinched the lip with a slight lean toward the middle and used a chamois or soft sponge to

smooth the rough edge. The hard edges created by cutting off the excess clay remain but are softened. I intentionally leave the line on the interior lip. This is an aesthetic choice that anticipates my glazing decisions.

Now you'll need to cut the mug off the banding wheel to finish the foot. Using a cut-off wire placed behind the bottom of the mug, pull the wire taut. Use your fingers to hold the wire against the surface of banding wheel, then drag the wire toward you and all the way under the mug. To finish the bottom of the mug, you can trim, tap, or roll out a variety of feet. Read on for two of the most popular options.

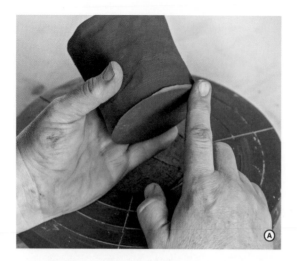

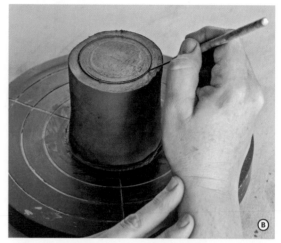

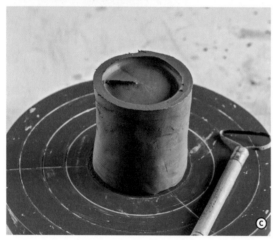

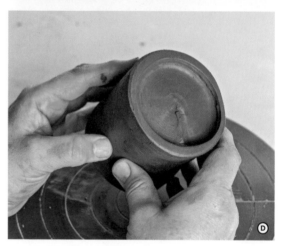

FEET

Flat-bottomed foot: If your mug's bottom has a thickness similar to your mug's wall, you're ready to make a flat-bottomed foot. If it's thicker, you'll need to trim away clay to make a flat-bottomed foot, or make a trimmed foot instead. To finish a flat-bottomed foot, use the heel of your palm to gently tap up at the center of the mug's bottom. Using a damp finger, gently begin rolling the outside edge up. You can roll it in a subtle way or make it more noticeable, stopping when the foot looks good to you. Ⓐ

Trimmed foot: There are many variations of a trimmed foot, but perhaps the most popular is the cut foot ring. If you'd like to make this style of foot, place the mug upside down on a banding wheel. Use a needle tool to ensure that the mug is centered on the banding wheel, then mark a circle on the bottom of the mug indicating where you'll leave clay for the foot. Ⓑ Generally you'll want to leave about a ¼-inch ring. Using a trimming tool, gently dig out and remove clay until you reach the desired depth. I tend to trim away about half the clay that I leave at the bottom. Try to trim the mug in a single pass if you can. Afterward you can smooth any sharp edges, smudging them with your finger. ⒸⒹ Alternatively, you can use a trimming tool to take off the corner on the outside bottom edge of the mug. This will give the mug a bit of visual lift off the tabletop.

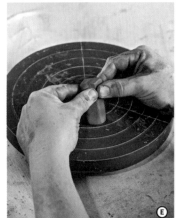

HANDLES

What's the difference between a cup and a mug? If you said, "a handle," you are exactly right! Handles may seem simple, but I'll confess that it took me ten years of making them to find my handle style. In those years, I tried so many techniques, but nothing stuck until I watched a fellow potter demonstrate how to pinch a handle, fat at both ends, thicker down the center and thinner on the edges. In cross section, the handle looks like a diamond. When I saw this, it was as if all the stars aligned.

I hope that anecdote illustrates my point that handles are trickier than they seem, and it will take making lots of them to find a method that works for you. Whenever students tell me they hate making handles, my response is to tell them to make more! How can you ever make an object you appreciate and enjoy if you hate the process? Try to see the challenge in handle-making as an adventure! I promise the more handle variations you make, the closer you will get to finding *your* handle.

Let's look at some possible handle options. There are a few main categories, with endless variations, to choose from. No matter which style you select, remember the mark of a good handle is its

relationship to the mug and how comfortable it is to hold. After you make your handle, see page 47 for more on attaching it. You will want to let your handle dry slightly so that you are attaching a leather-hard handle to a leather-hard mug.

Pinched: Pinched handles are formed from a wet piece of clay just like a pinch pot. You can make these handles in any shape you desire. They are best when you want a handle with finger marks, ridges, and other evidence of a piece made by hand. Ⓔ

Rolled/coiled: Once you are adept at making coils, use them to make your handles! Go beyond a simple coil by tapping them on the table to change the shape, rolling one end thinner, or adding texture. Coiled handles can have lots of personality.

Pulled: I make pulled handles by attaching a piece of clay to a mug and then pulling it gently, moistening with water as needed, until the shape and thickness match my mug. But you can pull a handle in other ways as well. You can prepinch a coil into what I call a "blank handle," essentially a handle close to its finished shape. You attach it to your mug and finish the pull in place. Handles can also be pulled completely and set aside to firm up. This allows you to make a few options and pick the one that looks best before attaching it to your cup at the leather-hard stage. Ⓕ

Giselle Hicks | Coil Building

How did you get your start in clay?

I've been practicing for about eighteen years. I received my BFA in ceramics from Syracuse University and my MFA in ceramics from New York State College of Ceramics at Alfred University. There were a few reasons I chose ceramics as my medium. I was fascinated with the rich history. (There are ceramics traditions pretty much anywhere you go in the world, so ceramics was a way for me to learn about different cultural histories and traditions.) The medium is pliable and incredibly versatile. I figured I would never get bored using this medium given there is so much to learn—technically and conceptually. I liked that potters tend to be communal. They like to eat together, talk about food, sit around the table, and share studio space, equipment, and recipes. And lastly, I remember my undergrad professor and his wife always had their doors open to students for meals and to share their collection. This was the first time I saw what it was like to live in a house full of handmade objects. Everything in their house had a story. Their home was very alive, very rich. I wanted to be a part of a life like that. The choice to work in clay was a holistic one—I liked the material, the people around it, the history, and the lifestyle it promised.

Can you briefly describe why you were drawn to pinch pots and coil building?

There is a quality and sensibility that I've been looking for in my work and studio practice for a long time that reflects a sense of ease and simplicity. For a long time my work and processes were rather complicated, involving a lot of steps, technical skill, knowledge, and material. By the time I finished a piece, it would feel suffocated, overworked, and overwrought.

I started making the pinch pots in response to the frustration with this other work. I wanted to make something with a process that was as simple

Nesting Vases. Giselle Hicks. Coil and pinch construction.

and direct as possible. The coil and pinch technique is fundamental—no bells or whistles—and I use as few tools as possible. That way it's just my hands and the clay. My goal is to create forms that explore volume, proportion, posture, shape, and color. The qualities I was (and still am) looking for are: generosity, stability, slowness, softness, simplicity, and beauty.

What draws you to still-life exploration? What are you trying to achieve aesthetically, emotionally, and/or design-wise?

In my work I am inspired to capture that sense of beauty and transience in three-dimensional form, to make solid, still, and permanent something that

Bottle Still Life. Giselle Hicks. Coil and pinch construction.

is fleeting and invisible, such as the characteristic or sense of a person, an exchange between loved ones, or an exuberant meal shared with family and friends. I find beauty in these daily illuminations that often take place within the domestic realm, and I want to hold them still and give them form. Though these moments are intangible, they mark us and become a part of who we are.

What type of clay body do you use and why?

I use whatever is cheap and available. Right now I use a reclaimed stoneware. I've used cone 6 white stoneware; I've used porcelain. Stoneware is my favorite to build with. . . . It stands right up. I use one glaze base and fire cone 6 electric.

What important lessons have you learned in your process?

Make what you love. Make what you want to live with. Make what makes you happy to make. I started making this work for myself and never really thought it was "enough" to show or to pursue as a body of work. . . . Visitors would come into my studio and want to talk more about the pinch pots in the background than what I was working on . . . which was a lot of flowery stuff. The more conversations I was having, the more I realized the pinch pots were enough. . . . Sometimes outside validation from smart, caring people is really helpful. Sometimes we are just too close to the work to know what we are doing. But it became clear that the work I loved making was resonating with other people, and the work I was agonizing over was not so much.

Zig Zag Vases. Giselle Hicks. Coil and pinch construction.

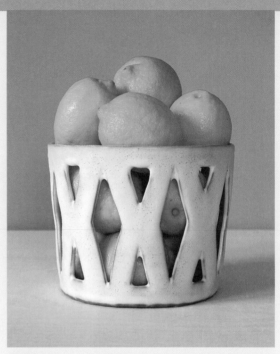

Basket with Lemons. Giselle Hicks. Coil and pinch construction.

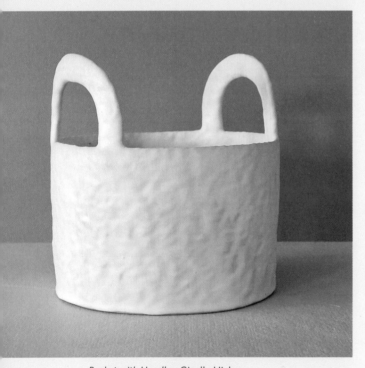

Basket with Handles. Giselle Hicks. Coil and pinch construction.

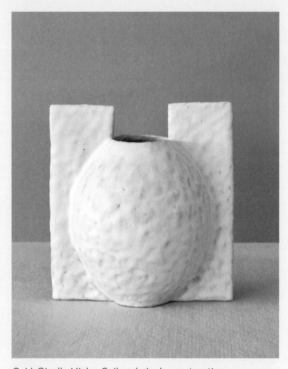

Ovid. Giselle Hicks. Coil and pinch construction.

All photos courtesy of the artist.

COIL-BUILT VASE

Coil building is an ancient technique people used when working with clay that was difficult to throw. To this day, coil building is one of the most versatile, most popular hand-building methods, and it's one of my favorite ways to work with clay!

You'll find coil building is a fast and simple way to create forms, from the classic to the complicated. A quick warning, though: Becoming a skilled coil builder does not happen overnight. It requires patience and practice. In this section, I will cover the basics for making a coil pot, starting with building in the round and then moving on to beginning a form with a template.

Starting with a clear idea of what you want to make is essential to your success when using coils. After you make a form like the vase demonstrated here, try something new! Find an image of a vessel you love, or draw a form that excites you. Keep that picture handy so you can refer to it as you construct your pot. After you have printed or drawn your reference image, the next step will to be to decide how big you want your vessel to be and sketch your image on grid paper so that you know, step by step, where you should be with your form. I recommend beginning with a medium-size form (10 to 15 inches tall and not more than 5 to 8 inches wide), as objects that are smaller or larger present additional challenges.

TOOLS AND MATERIALS

4–6 pounds of clay

Basic toolkit (page 23)

INSTRUCTIONS

Start by building the floor of the vase. Grab a piece of clay large enough to cover the area for the vase's footprint (about ¾ pound), form it into a ball, and place it on the center of your banding wheel. Ⓐ With your fist, gently pound the clay down, spinning the banding wheel to spread the clay evenly in the desired circumference. Once the clay is close to the desired thickness, about ¼ inch, use a plastic rib to smooth your fist marks. The goal is a base

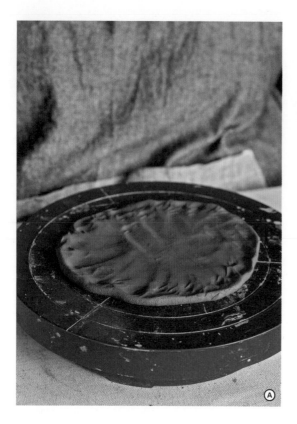

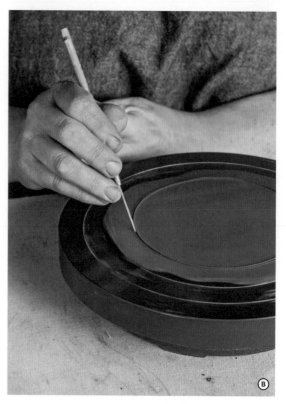

that's level and consistent, with no lumps or thin spots. Don't worry if the outside edge is a little thin. I will address that in the next step.

Note: *If you noticed the slab of clay is now stuck to the top of your banding wheel, do not be concerned. This is good! Having the clay centered and stuck will help with building in the round.*

As you spin the banding wheel, brace your hand and use a needle tool to gently cut into the slab to make the circular footprint of the pot. The trick to this step is to come down into the clay with your tool slowly. When the banding wheel slows down, just take the tool away, spin again, and come down on the previous cut mark. With some practice this will become second nature! You want to end up with a flat footprint in the center of the banding wheel. Ⓑ Use the circles on the banding wheel as a guide if you need help dialing in on the center.

Let's coil! For making coils, you can choose among three main methods:

My preferred method is to cut some clay from the bag with a cut-off wire (don't grab it with your hands!) and then squeeze the clay into a coil with both hands. I've found this method comes naturally to me, and the coils don't dry out as I make them; they stay close to the same state as the pot I am building. ⒸⒹ

If you have access to an extruder, you can use that specialty tool to make perfectly uniform coils for your project. Be sure to store coils on plastic and keep them wrapped to preserve their moisture content (maybe even misting them occasionally).

Another method is to roll coils on a tabletop. It will take some practice to get a consistent coil thickness. Note that moisture will seep from the clay onto any surface, making the clay less plastic and possibly more difficult to use, so try to use coils made this way immediately. Store coils wrapped in

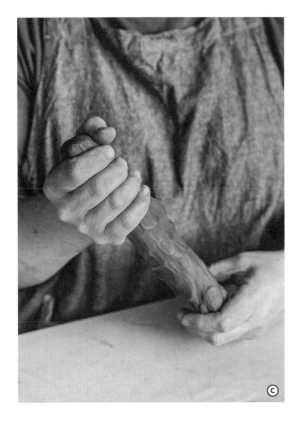

plastic or in a damp box if you're making multiples before assembling a project. ⒺⒻ

To attach the first coil to the vase, use your scoring tool to score the outside top edge of your footprint. Score the "bottom" of your coil directionally, meaning in the same direction as your footprint, and wet the footprint. Attach the coil by pinching the coil in a downward motion onto the footprint, creating a shape that is slightly wider at the base and narrower at the top. When you bring your fingers close to your thumb, your hands and fingers will naturally create the shape, a kind of tapered triangle with the base wider to ensure a secure attachment to the vase's footprint. Ⓖ

After your coil is attached to the footprint, the shaping begins. Using a rib that has a corner, reinforce the interior attachment (creating a clean corner). Ⓗ As you rib this connection and all future connections, make sure you are supporting the form with your other hand. So if you are ribbing the interior

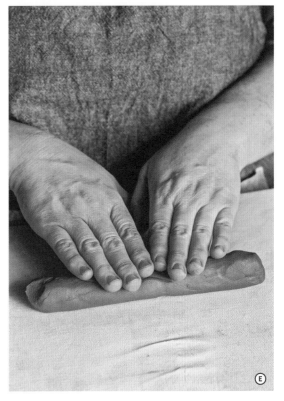

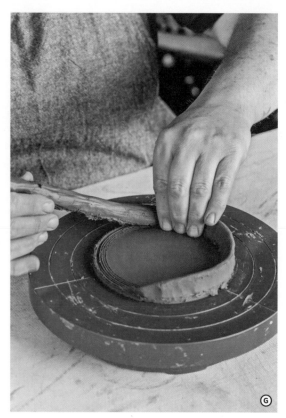

with your right hand, your left hand should be on the exterior as a backstop, and vice versa. This will help you gauge the amount of pressure you are applying and determine the thickness of the wall, which will, in turn, help you shape the form.

Next rib the exterior of the coil. Focus on the attachment and make sure the seam disappears. I tend to rib the interior and the exterior in three passes, working on the general shape and wall thickness, addressing the final shape only the last time around. (At this point you should be aiming for consistency in wall thickness and matching the shape of the form you are trying to make.) Do not move on to the next coil until you have the form exactly set to the correct shape, in line with the image of the form you're making.

As you continue to add coils, hold each one in your left hand. Pinch the coil onto the interior wall (the wall on the far side of the banding wheel) using your left thumb, making sure your fingers are supporting the exterior wall. ⓘ The coil will grow and twist slightly as you attach. (Do not lay the coil around the whole lip and pinch downward. You will wind up with too much clay and lose control of the form quickly.) Once the coil is pinched on, rib the interior and exterior as before. The goal is to ensure secure attachment, consistent wall thickness, and a vase resembling the image you selected. When you rib and shape the interior, the vase will get wider. ⓙ When you rib and shape the exterior, you want to keep the vase moving upward and inward. ⓚ If you find your vase getting off track after a few coils, consider darting (see page 61).

Note: *As the vase gets taller, you may need to use a wood knife to rib the interior. (Your hand may be clumsy with a rib or too large to fit inside.) Use whatever tool works best, remembering that which tool you need will depend on whether the vase calls for narrowing or widening.*

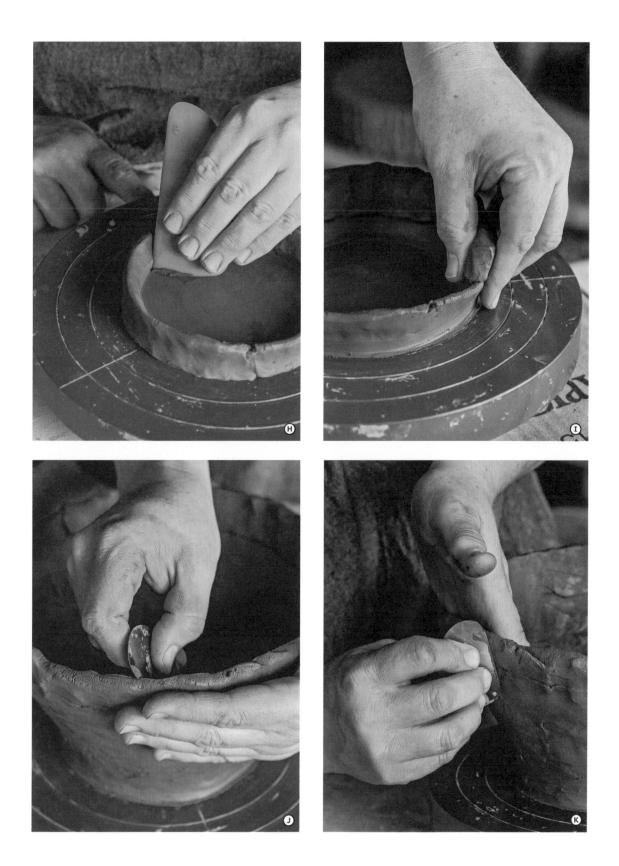

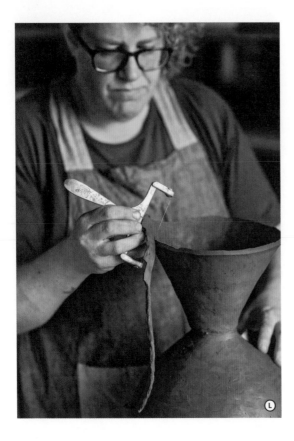

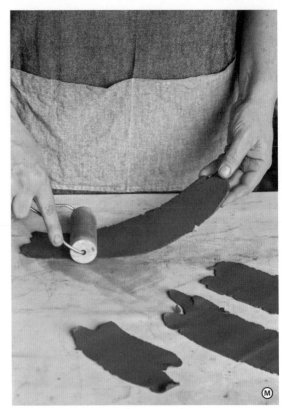

When you are ready to finish the vase, there are some additional considerations: the lip, the foot, and any additional elements (such as handles). Each of these elements can change your form dramatically! We'll complete this vase in the text that follows, but you can see more options in other projects and the galleries in this book.

First, we'll cut the lip to make it even. It is easiest to even the lip on a round object while it is still attached to the banding wheel. Spin the banding wheel slowly, and use a needle tool or sharp knife to cut into the top edge at the lowest point of the lip. Ⓛ

Note: *If you have difficulty holding your needle tool or knife steady, anchor your arm on the table or against your body to brace the hand/arm that is holding the cutting tool. This should improve your stability and help you cut more evenly.*

Now that the top edge is even, how are you going to finish the edge? There are many possibilities. Since this is one of my classic forms, I will be adding a thin strip of clay that I call a skirt. If you'd like to do the same, make a coil and flatten it out until it is about ⅛ inch thick. It can be slightly uneven or torn if that suits your aesthetic. Ⓜ Score the top edge of the vase 1 to 1½ inches down. Score the skirt, and run a wet brush over it. Now attach the skirt to the scored section of the vase, going slightly over the top edge, applying pressure, and piecing it together as you work your way around the form. Ⓝ Once the piece is attached, gently rib it to make sure the skirt has a consistent look and feel. Do not rib it so much that the skirt blends into the vase, though.

Using a cheese cutter, cut at a 45-degree angle from the interior top edge, leaving a sharp top edge to about ¾ inch down and creating a clean line

DARTING

When you are shaping a form, darting is a technique that will help you keep the form in line with your vision. I have heard rumors that darting is cheating . . . Call me a cheater! No problem! Darting is a huge timesaver and helps keep frustration under control.

To dart, use a sharp tool to cut a **V** shape out of the clay, then bring the two sides of the V together and attach. ① As long as the clay is soft, there's no need to score and moisten. Just use a rib to firm up the attachment. You'll usually want to dart a piece in multiple places, from two to four locations, around the circumference of the piece. This will keep the piece even. ② If you dart only one or two sides on a large piece, the form will turn out uneven.

A few notes on darting:
Soft clay darts best. If the clay has firmed to leather hard it will be difficult to reshape, and scoring will be necessary.

I rarely bother with beveling the points of attachment because the clay is usually wet and already sticks to itself easily.

Keep your darts small. The wider your **V**, the more drastic the change in the clay's direction will be during attachment. It is easier to take small bits of clay away than to try and fill in a large gap!

Darting can also be a way to shape a form in an asymmetrical way. Try darting only one side of a form and continue to build. You'll see what I mean.

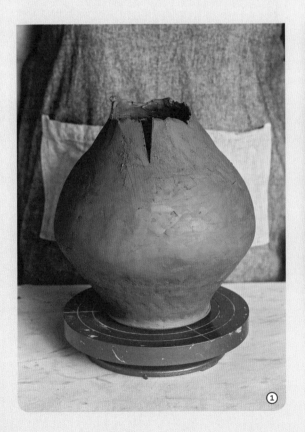

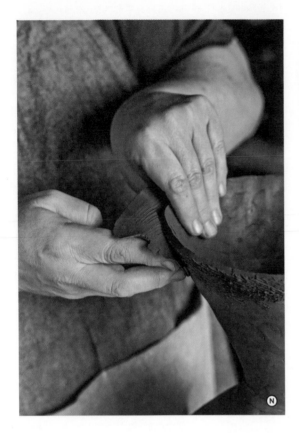

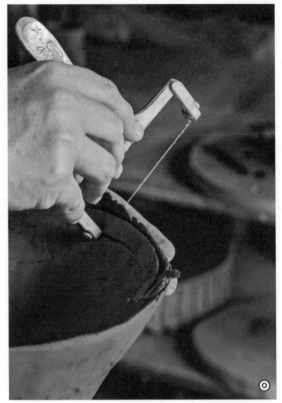

around the top. ⓝ Wet your finger and soften the edge. Roll the edge over slightly toward the outside of the vase wall, making a few passes and wetting your finger as necessary to glide over the clay.

Once you're finished with the lip, it's time to remove the vase from the banding wheel. Note that this can happen anytime you are comfortable taking it off. In a communal studio you may need to remove it long before you finish the vase so that others have access to the banding wheel. That is okay!

To remove the vase, I recommend using a pin tool or a craft knife to create a rut where the vase is attached to the banding wheel. This will guide your cut-off wire and help ensure an even cut. Place your cut-off wire around the back of the vase.

Keeping the wire very taut and snug against the banding wheel, pull the wire slowly toward you, cutting the vase from the banding wheel. If your vase's foot is thick, you can trim it a bit as on page 50. If it's just ¼ inch thick, make sure to pop up the foot and roll the outside edge up and over, like the rolled lip on this vase (see page 50).

Note: *Do not wait until the foot of the vase is dry to remove it from the banding wheel. Once it's dry, the clay can be very difficult to cut, and there will be a higher risk of cutting through the vase. Or the dry vase can unexpectedly come loose from the banding wheel, which can lead to a disaster!*

BUILDING WITH A SQUARE FOOTPRINT

We just learned to build with coils in the round, so now let's take a look at how to apply coils to other shapes. There are a few key differences when you want to build a piece with a square footprint—or any shape with right angles.

For the base, rather than pound a slab of clay, it's better to start with a soft slab that's already big enough to cover the area of the object's footprint. See page 80 for more on soft slabs and page 87 for templates and then head back here to continue!

Using the template "I" on page 199 or a ruler to measure a shape, create your footprint. It should be slightly larger than your ideal finished size. Cut the footprint from your slab with a needle tool or craft knife. Allow the slab to dry to soft leather hard or leather hard, then transfer it to a newspaper-lined bat or ware board. Before you transfer, you should be able to gently run a rib with a right angle along the edge of this slab without distorting the clay.

Now you'll follow the previous lesson for making and attaching coils. Make sure your first coil is long enough to fit around the footprint before you start to attach it.

Note: *Do not attach a coil by starting in a corner. Instead start each coil mid-wall—that is, midway between corners—and work your way all around. This helps prevent the possibility of cracks in the corners, one of the drawbacks to working on square pieces. Corners want to crack. This is one way to fix the problem before it starts!*

When you make a form that is square, the main consideration is keeping the corners intact as the piece grows. So whatever angular shape you attempt, mind your corners. Use your finger as a backstop so that you can shape walls and reinforce corners, compressing as you go. The corners should be a thickness that is consistent with the rest of the form—if they're too thin or thick, they can cause cracking. Check your form's overall shape as well. Is it tapering upward and inward (like a lidded box) or flaring out (like a tray or casserole dish)? These choices will affect the form, starting with the first coil.

When it comes to cutting the lip of a square form, I use the cut-off/measuring stick and a cheese cutter to help me cut off clay evenly on all sides. You can try using a ruler to measure the same height all around the object, then use a sharp knife to cut along the guideline. After you attempt to cut lips a few times, you may, like me, be a cheese-cutter convert as well! No matter which method you choose, build the form a bit taller than you want it to be when it's finished. I build about an inch higher than needed with square forms.

FIXING CRACKS

Cracks, cracks, and more cracks! Why do cracks happen? It could be that you are working with a clay body that is prone to cracking. It could be the way you handled your clay during the building process. Was water sitting in your pot for an extended period? Did you make an attachment late in the drying game? Whenever two pieces of clay of different states of workability are joined, there is the potential for cracking.

As you can see, there are many reasons for cracking. The good news is that you will learn to identify the cause of a crack as you gain experience. (And don't despair if you get many cracks at first! The better your skills become, the less often you will see them.) Before I discuss repair, I want to share a warning as well: do not spend too much time fixing your pieces. Once a structural crack begins to appear, you will likely have to deal with that crack repeatedly during the rest of the process—and you may still have a crack once the piece is fired and completed. So make sure your attachments stick: score, moisten, and compress. When a crack appears, don't panic. You will have several repair options. Just be mindful of the time you are spending to save a piece. Sometimes it is best to start over.

REPAIRING SOFT TO LEATHER-HARD GREENWARE

Greenware is the best stage to catch a crack and stop it in its tracks. I recommend repairing cracks or structural problems as you go because cracking will often start to appear at points of structural weakness. For example, cracks are common where one coil is attached to another or where two walls meet. Cracks can appear right away in the building process, or they may show up once there's added stress such as the weight of another coil or new elements, like a flange. As a piece dries out, cracks begin to appear in these vulnerable areas.

Leather hard and soft leather hard are perfect times to fix a crack or a weak spot in the clay before it becomes a more serious problem. While it may seem counterintuitive, the best way to remedy a developing crack is to open it up more. Ⓐ As I have mentioned elsewhere, clay has a memory. So, in an effort to erase the memory of a crack, score the area in question deeper and larger than the crack itself, Ⓑ then place a bit of scored soft clay into the space you've made and compress it with a rib. ⒸⒹ This will heal a crack in most cases, depending on how dry the cracked clay is.

After you have repaired a crack, if the clay still seems weak, you can wrap the form in plastic and allow the moisture levels of the form to equalize. Be very wary of adding water to a crack at any time, though. Water can swell the crack and lead to growth of the crack, not eliminate it as you might hope. If possible, do not add any water to a crack and use moist clay instead.

Here are a few specific situations where you're likely to encounter cracks, with advice on how to proceed:

Coil pots tend to develop thin spots when you are first learning to use the rib to create even wall thickness. Those spots should be shored up with extra clay as soon as they're discovered to help prevent collapses and cracks.

When you make coiled pots, be mindful of your initial connections (coil to floor and coil to coil). These connections can be tricky when clay is too dry to connect, or you are connecting a new, wet

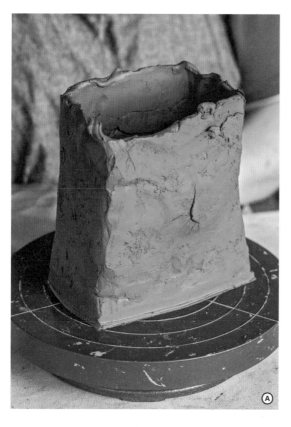

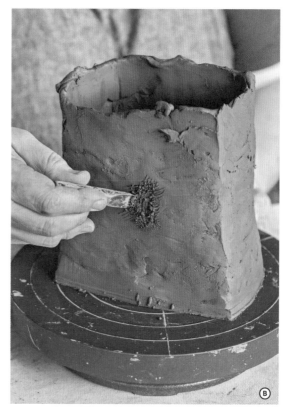

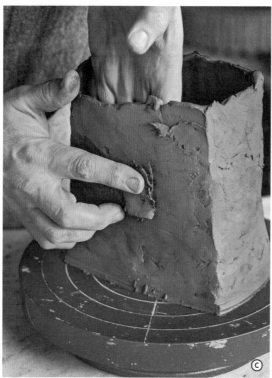

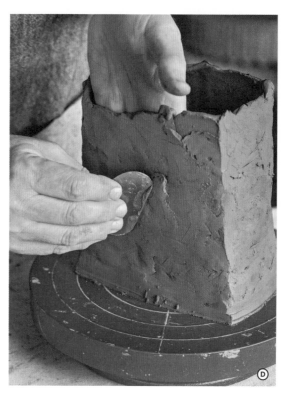

coil to a leather-hard, partly built form. Scoring well and making sure the connections are true and thoroughly compressed will help minimize potential cracks.

Hard-slab forms (see page 118) tend to crack most frequently at the seams. Again, scoring the initial connections well and using small amounts of water or slip will help lay the foundation for a solid, well-attached seam.

The lip or rim of a form can also be a problem area. I've seen many pots start to crumble or crack from the top down. Make sure you maintain a decent thickness at the top of your piece, shoring it up if necessary with a small coil or using a chamois (a wrung-out sponge or a thin strip of plastic will also work) to compress the lip. Quickly troubleshoot any cracks that begin to form.

REPAIRING BONE-DRY WARE

Your choices at the bone-dry stage are limited, so don't waste a lot of time trying to repair a piece. If you have a structural crack, such as a corner where one wall meets another, it is only going to become a larger crack once you fire the piece. If something small has popped up during the final drying process, you may have a better shot at fixing it in the bisque stage.

At this point, if you do attempt to repair a crack, adding water, wet slip, or wet clay is a mistake. This will lead to a bigger crack or the new clay falling off and leaving more of a mess. Generally, wet clay does not want to stick to dry clay. Instead I recommend trying to repair small cracks with paper clay. To do this, make a small amount of very thick slip with the same clay your piece is made of. In another container cover a wad of toilet paper with water and let it sit until the paper has broken down into pulp. You can speed this process by using an immersion blender. Wring out a small amount of the paper pulp (you don't need the extra water) and add it to the slip, then mix well. (Don't add too much water, and let the slip dry out so it is the consistency of a sticky putty.) Then open the crack slightly by scoring it extremely well, to the scored area add a bit of water if necessary to create a bit of roughness and stickiness, then pack the crack with the slip. Check the repair before firing the piece. Repeat the process if needed.

REPAIRING BISQUEWARE

If a crack has appeared after bisque firing—or if you had a small crack you rolled the dice on and it did not grow much during the bisque firing—you now need to repair bisqueware. If your crack is very, very small, you may be able to hide it by filling it in with glaze. But the glaze firing is hotter than the bisque firing, so there's also a good chance your crack will continue to expand.

For cracks that require filling in, I've found that using commercial repair solutions, such as Amaco Bisque Fix and Bray Patch, are the best bets. The formulas vary, but most are a mixture of paper clay and sodium silicate. Follow the directions included with the product you choose.

Remember: Don't waste precious time on a lost cause. If you find yourself repeatedly developing cracks in your work, step back and ask yourself some questions about your building methods. See if you can identify any common issues. If you have no clue, find a teacher, mentor, or technician who has more experience and might be able to give you some advice.

Lilly Zuckerman | Pinching Clay

How did you get your start in clay?

I was very lucky that my public high school had a large and thriving art department. My high school ceramics teacher allowed me unlimited after-school access to the studio. I experimented with wheel-thrown, altered vessels and some hand building.

What led you to discover the method of building you use?

While getting my BFA at Pennsylvania State University with Chris Staley and Liz Quackenbush, I was challenged to create using both throwing and hand-building techniques. I chose hand building because I love its slow and methodical nature. Liz Quackenbush assigned hand-building projects where we copied the same object using coils, slabs, and carved solid blocks of clay. After they were fired, it was incredible to see the subtle ways in which each method lent a different feeling and quality to the object. It was from this assignment that I decided pinching from a solid slab was going to become my method.

Could you share a little about the process you go through designing and refining the form?

I don't incorporate a lot of two-dimensional drawing exercises into my making process. The most planning I will do with pencil is sketching a bird's-eye-view line drawing of the edges of the form. I am interested in how lines and curves can be combined to balance each other or create false but balanced symmetries. Most of my preliminary sketching is done using 1-pound balls of clay. I prepare twenty to thirty balls and let myself pinch them for only one or two minutes each. I don't let them become precious or overworked. At the end of this three-dimensional sketching exercise, I have models that I can refine: I can manipulate

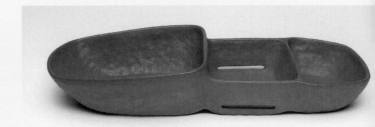

Untitled 2. Lilly Zuckerman. Pinched construction.

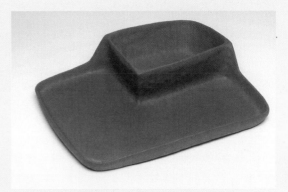

Untitled 4. Lilly Zuckerman. Pinched construction.

them only on one side to compare, cut them up, or combine the best sections. My hands and mind really work best in 3-D, and this exercise allows me to brainstorm forms.

When I am ready to make a form, I use really soft, plastic clay that I throw out into a slab, approximately 2 to 3 inches thick, whose rough footprint is similar to my sketch. I lay this slab on a large piece of firm 1-inch-thick foam on a ware board, which rests on top of a banding wheel. The foam allows me to get under the clay slab to pinch, and the banding wheel allows me to constantly reevaluate the shape from different angles. I start by defining and pushing the floor down, then I lift and pinch the walls up. In the beginning it was very important for me to use only the clay I started with. If I trimmed the height of a wall, I had to add

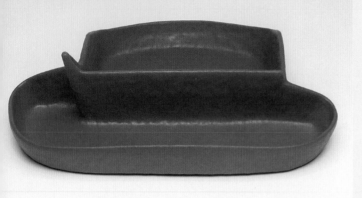

Untitled 1. Lilly Zuckerman. Pinched construction.

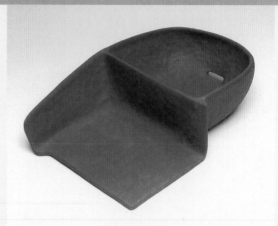

Untitled 3. Lilly Zuckerman. Pinched construction.

the excess clay back to the form somewhere else. Sometimes I cut windows and doors or created horizontal ledges. This work was influenced by a research trip to Morocco where I was very inspired by the adobe architecture and traditional unglazed earthenware cooking pots. I always think of this work as mimicking shelters and structures, so I use the language of architecture.

After the walls have been pinched to a uniform thickness, I trim and refine those edges. When the piece has dried to a stiff leather-hard firmness, I support the inner spaces with foam and flip the piece upside down. Using a sur-form tool, I scrape and refine the bottom so it is flat. Flipping the piece over again, I let it dry to a very hard leather-hard firmness by layering cotton fabric under the plastic I wrap the piece in for storage. The cotton helps absorb moisture slowly and keeps that water from "raining down" on the piece. Finally I spray the piece with a watered-down commercial clear Amaco glaze and fire the piece once to cone 04 in an electric kiln.

What is your favorite thing about the method you use?

I really love pinching. I adore how clay records everything about how we touch it. To me pinch-

ing is the most direct way to interact with clay. It leaves your fingerprint, which makes that mark undoubtedly yours. I enjoy how slow and methodical pinching is and the way I can change direction or axis that leaves a record of how I moved around the form.

What are some of the technical challenges you face with that process?

Cracks and warping are my main technical challenges. Clay has a memory and can spring back or warp in a firing, so keeping straight lines is very hard. Through much trial and error, I figured out how to pinch walls so they would maintain a curve or spring back to a straight line in the way that I wanted them to.

What important lessons have you learned in your process?

My process teaches me patience daily—whether that's in the trial-and-error nature of getting to know a clay or glaze recipe over the years or in the technical pitfalls of making, drying, or firing. Clay has also taught me to handle and care for objects and to accept their fragility. Everything will break one day.

All photos courtesy of the artist.

COIL-BUILT BOX WITH AN INSET FLANGE

While it might be easier to make a bowl than a box, I just can't resist making boxes. Boxes are the best! They are one of the forms that initially drew me to hand building. There was something satisfying about puzzling out how to make a functional box and exploring its various uses. From tiny trinket boxes to large storage boxes, there's really no going wrong.

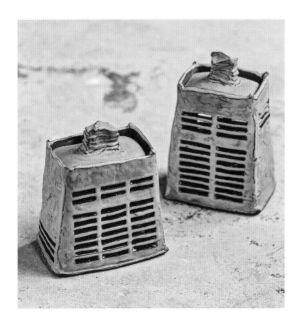

Aside from your inspiration and decoration, there are two things that will be important in the construction of your box: the method of construction and your choice in lid seat solution. This first box I will discuss uses a coiled construction method and an inset flanged lid, while the box on page 120 is built with slabs and features a capped lid. Try both and see which you prefer, then feel free to mix and match the construction techniques and lid types.

One thing I want to mention again is to be mindful of cracking. Boxes will make you very aware of when you are pushing the limits of the clay or when you are working at the wrong state of clay. If possible, try to make your box in a single day. If you can't manage to finish in a single go, wrap your parts well or keep them in a damp box.

TOOLS AND MATERIALS

3–4 pounds of clay prepared as follows:

Slab 1: 5 x 8 x ¼ inches, for the footprint
Slab 2: 5 x 8 x ¼ inches, for the lid

Extra clay for coils

Template (page 197)

Basic toolkit (page 23)

Drywall sandpaper (optional)

INSTRUCTIONS

Cut out the footprint of the box from the prepared slab, using the template as your guide. Start building your walls, using the coil-building method of your choice (see page 56). ⓐ Continue to build until the piece is about 5 inches tall, but build a bit higher than you think you should because you will be cutting away clay to make the height even (the box shown is about an extra ½ inch tall). ⓑ Once your box is tall enough, cut the top with a cheese cutter and cut-off stick or ruler. ⓒ

Note: *Remember to watch your corners; use a finger as a backstop when giving the corners definition. And don't start your coils in a corner—always start them mid-wall.*

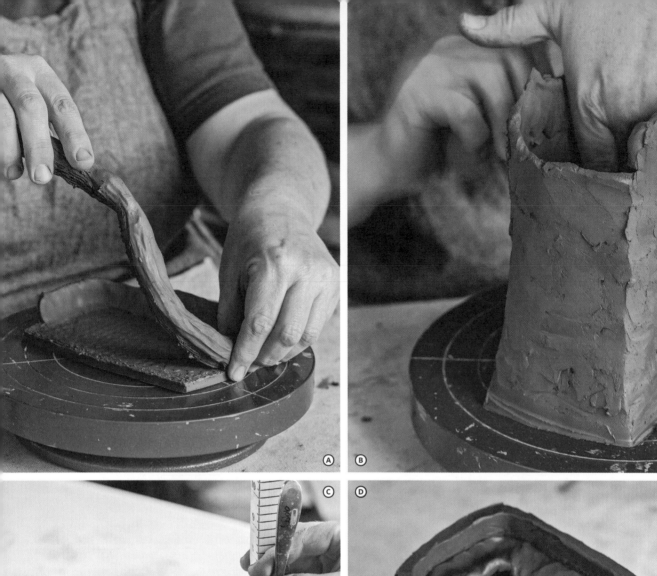

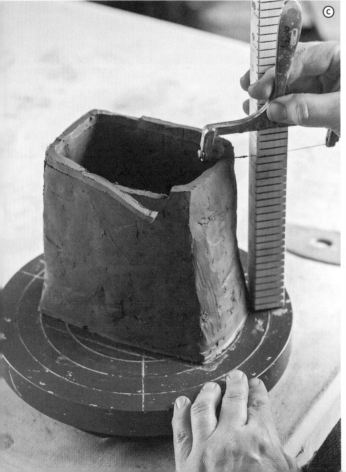

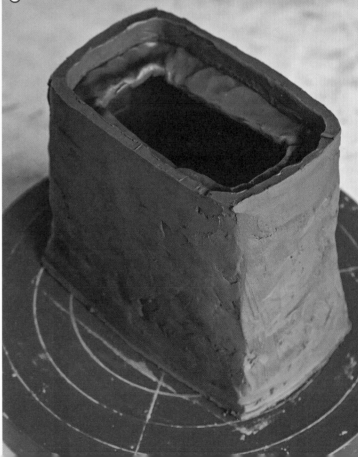

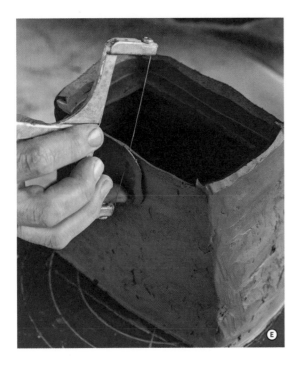

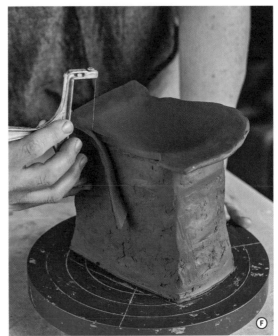

Roll a coil long enough to fit around the footprint of the entire box. Shape the coil into a soft prism, and set it aside on the tabletop. About an inch down on the inside of the box, score about ½ inch of the walls all around, as level as you can manage. Score one flat side of the coil (the side that was on the tabletop), then wet it with water, and attach the coil to the wall, starting mid-wall, not in a corner. Ⓓ Take care to maintain the integrity of the wall, and aim to keep the coil attachment as even as possible. Once the coil is attached all around, your box now has a flange, which will be used as a shelf for the lid.

Before moving on, take the time to firm up and clean the attachment. Use a wood knife or a rib to compress the underside of the attachment. Rib the exterior wall with a firm metal or plastic rib to reshape. Now is the time to get rid of any distortions you caused while adding the flange to the form.

Once the flange is firmly in place, use a rib with a right angle to work your way around the top of the flange. Place one hand on the outside of your box as a backstop to ensure that you don't distort the form. Compress the corner of the flange to the

wall and flatten out the lid seat of the flange. Go slowly, making several passes until you are satisfied with the attachment and the lid seat. You will find you have pushed the coil slightly down the wall and it intrudes farther into the center of the form. Don't worry. This is supposed to happen! Using your cheese cutter, slim down the flange depth into the form. I leave ¼ to ½ inch for most boxes. (You can see the finished flange in photo Ⓕ and a clearer example can be found in the photos for the Casserole Dish on page 110.) This will open the space on the interior of the box and give you a nice flange thickness (hopefully matching your wall thickness). After you have your flange set, finish the lip of your box. For this form, I use my cheese cutter to cut the interior edge of the wall, leaving a bit of the corners. Then I do the same for the outside. This creates a sharp, clear end to the wall and makes the form appear more architectural, which is what interests me. Ⓕ Feel free to explore!

Now let your box set up. The box should be a firm leather hard before you drape your second slab over it to create the lid. (You're using your form as a drape mold.) Take a soft rib and gently press the

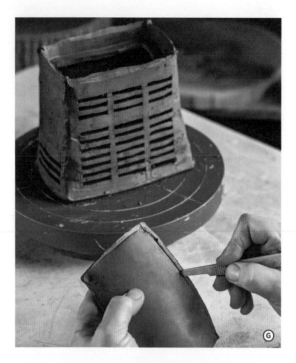

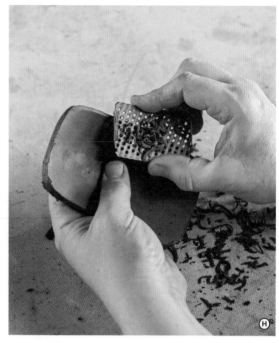

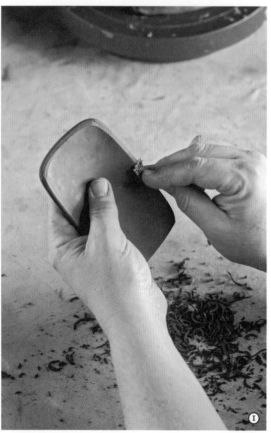

slab down on the edge and give the slab a soft curve into the form. Cut the clay that is hanging over the side off, right up to the box wall. Ⓕ Now let the lid set up to leather hard. If you can't work on the box in the next couple of hours, wrap it and set it aside until the next day.

Once the lid has set up enough to handle (almost leather hard), pull the slab off the box. It should be rigid enough to keep its curve when you are working with it—if it's too soft and flexible, wait before proceeding. Using a craft knife, cut along the lines created when the piece was draped over the box. These lines should be a rough guide of where the lid will sit inside the box. Ⓖ After you have cut the lid, gently flip it over and place it on top of the box. Note where clay needs to be sheared away, most likely the corners and a bit on the sides. Going slowly, use a sur-form and remove the excess clay to make the lid fit. Ⓗ Use caution! Continually check to see how the lid is fitting. It is easy to take away too much clay, making the lid too small. The only way to fix that situation is to start over with a new

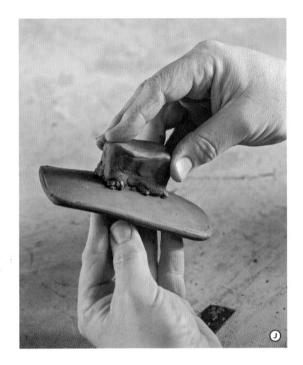

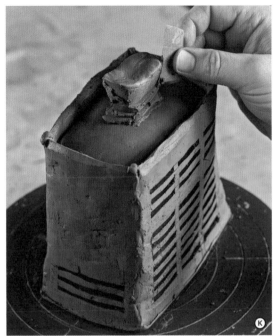

slab. You can refine the finish on the edge by using drywall sandpaper and a damp (not wet) sponge. Ⓛ

Once your lid fits your box perfectly, it's time to make a knob. While a knob has a specific function, the design is largely up to you. The curve of the lid will make your lid strong and able to support a decent amount of weight from a knob. Don't get crazy, but try a few different options, keeping in mind that a knob gets a lot of abuse and a lot of attention. Whatever you decide, score, moisten, and attach the knob onto the lid. For this box, I've attached the knob as a blank block of clay and used small metal ribs to remove clay until the knob matched my box. ⒿⓀ

Keep your box and the lid together from here on out. Dry both pieces gently, making sure to drape them with dry-cleaner plastic or a bag, depending on your studio environment. Generally, this project should take at least two to four days to dry. Drying the lid on the box will help ensure that the pieces will fit together as a final object. I like to check at each step to make sure that the lid comes off easily

because the form is shrinking as it dries, which can cause a small amount of warping. Greenware is the easiest time to adjust any issues with a lid that is too tight. But if you have a "sticky" bisqueware lid, you can always sand it down. I also recommend firing the lid and box together in both the bisque and glaze firings. This will decrease the risk of warping as well.

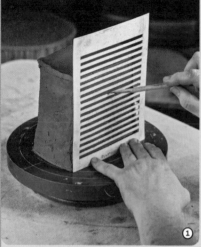
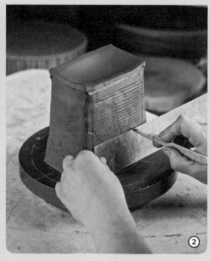
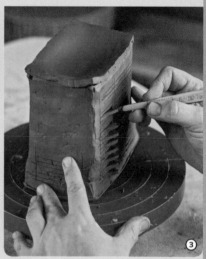

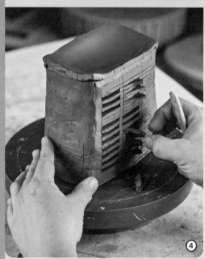

Do you like the look of the finished box here? I do, and I love piercing pots. I was first inspired by windows that looked dramatically different from the inside versus the outside. I wondered what the effect would be of making windows on a ceramic object.

Boxes were the first project I experimented on, as they have an architectural quality to them. I liked the results but continued to develop this process over years, eventually using it on other objects such as vases and colanders.

Piercing is only as exact as your measuring and marking. I mark all my pieces as shown before I make a single cut. ①② Once I begin to cut, I make sure the clay is firm enough and will not distort under the pressure of a knife. ③④ I usually pierce and then rib over the piercing. This will help compress the corners and walls and alert me to any potential issues. ⑤

At workshops, people often ask if I have any tips. Here are a few that I've learned the hard way:

Use the right cutting tool for the job. A dull knife will only give you trouble.

Don't ask too much of your clay! Cutting holes in your pot can weaken the walls. If you are firing your piece at a high temperature, that could cause the walls to slump (melt).

If your walls are too thick, they will be difficult to cut and pierce and, in turn, it will be difficult to extract the cutouts.

Mind your corners and do not "precut" them. Think about a ketchup packet, where a tear on the edge helps you open the packet. The same idea works against you in clay: If you create a cut corner, you may have created a potential crack.

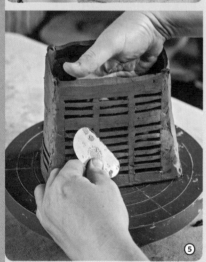

GALLERY

Serving Tray with Four Bowls. Ingrid Bathe. Coil and pinch construction. *Photo courtesy of Stacey Cramp.*

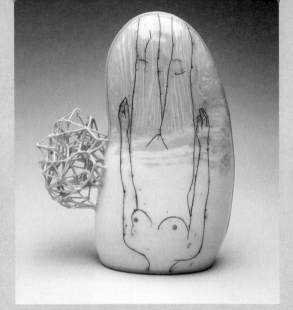

Upside. Lauren Gallaspy. Coil and pinch construction. *Photo courtesy of the artist.*

Prow. Sam Harvey. Coil and pinch construction. *Photo courtesy of the artist.*

Untitled (Salmon Dust Furry with Hole). Linda Lopez. Coil construction. *Photo courtesy of Mindy Solomon Gallery.*

In a Dream. Heesoo Lee. Coil and pinch construction, additive elements. *Photo courtesy of the artist.*

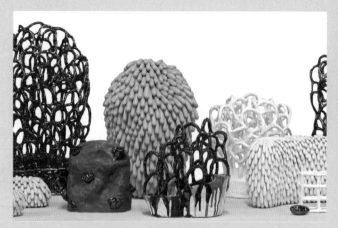

Installation Image. Linda Lopez. Coil and pinch construction.
Photo courtesy of Mindy Solomon Gallery.

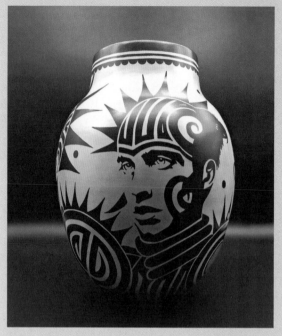

Tahu 2180; Revolt Series. Virgil Ortiz. Coil construction.
Photo courtesy of the artist.

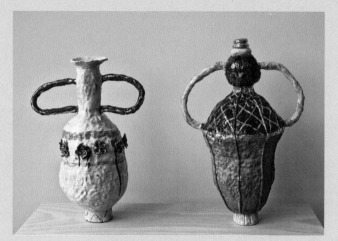

Vessels. Joanna Powell. Coil and pinch construction.
Photo courtesy of the artist.

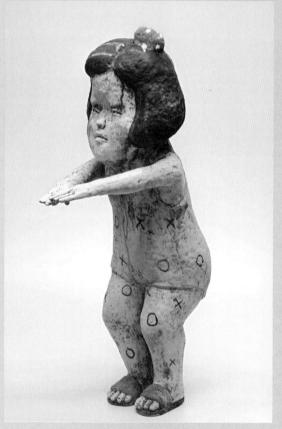

Diver. Kensuke Yamada. Coil and pinch construction.
Photo courtesy of the artist.

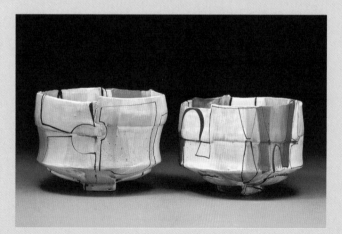

Bowls. Kari Smith. Pinch and slab construction.
Photo courtesy of the artist.

White Looped Vase. Emily Schroeder Willis.
Pinch construction. *Photo courtesy of the artist.*

Cream and Sugar Set. Emily Schroeder Willis.
Pinch construction. *Photo courtesy of the artist.*

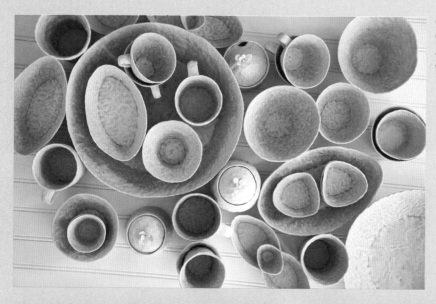

Collection. Ingrid Bathe.
Coil and pinch construction.
*Photo courtesy of Stacey
Cramp Photography.*

Mortar and Pestle. gwendolyn yoppolo.
Solid sculpture, press mold, and reductive processes.
Photo courtesy of the artist.

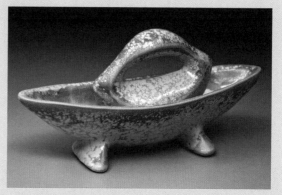

Mortar and Pestle. gwendolyn yoppolo.
Solid sculpture, press mold, and reductive processes.
Photo courtesy of the artist.

3 GETTING STARTED WITH SLABS

SLAB BUILDING can be used for a wide variety of projects. But because the basis of my own work is functional and because functional work will help build the foundational skills you'll need for developing sculpture, Chapters 3 and 4 will focus primarily on slab techniques and functional pottery.

There are a variety of benefits to making functional work, but perhaps the biggest upside is the ability to integrate your own cups, bowls, plates, and boxes into your life and the lives of your family and friends. You're sure to find that drinking out of a handmade mug in the morning makes your coffee or tea taste better!

One of the most important aspects of using your own work is learning about functionality firsthand.

In the beginning, you'll definitely discover w. doesn't work! However, soon you'll also find t subtler aspects of good design. Pay attention the pieces you use every day, and think about wh you gravitate to that favorite mug or bowl. Defin those characteristics and look for ways to incorpo rate them into your own work.

In this chapter and Chapter 4, I will teach the projects the way I do in workshops, with an eye toward sizes and shapes that are friendly for those who are less experienced at hand building. After you master the basics, feel free to move on to more complex shapes, or smaller and larger variations. Let your imagination run wild as you improve.

HOW TO MAKE SLABS

In the next few projects we will be working exclusively with slabs, so it is easy to think that slabs are only for "slab projects." But that's not the case! I frequently use slabs in conjunction with coil building and pinch pots. The ability to make a slab that is a consistent thickness and to monitor its workability are foundational skills that will open many creative doors.

I believe controlling the thickness is the easy part of slab building; it is monitoring when to use a slab that can be tricky. For some projects, fresh slabs are best. In others you'll want the clay completely rigid. No matter what state your slabs are in, keep them wrapped in plastic when you're not working with them. It is easier to keep them soft and wet than to rehydrate dry slabs (which only causes frustration). When you get ready to work with your slabs, uncover them and watch them closely so that they are at the perfect state to suit your project.

TOOLS AND MATERIALS

A full bag of clay, or at least 10 pounds

Basic toolkit (page 23)

Slab roller, or a rolling pin with wood slats
(depending on the technique you choose below)

Dry-cleaner plastic

Spray bottle

Texture tools/roulettes (optional)

USING A SLAB ROLLER

There are two popular ways to make a slab, but let's start with the more common: using a slab roller. As long as your studio has a slab roller, using it is the easiest and most reliable method for making your slabs.

Start by cutting a chunk of clay, about 3 inches thick, from your bag. Ⓐ I find this is roughly ⅓ of a bag. Why so much clay? To save time later you'll want a slab big enough to cut multiple templates!

Use either a dry wood table or the floor (I have a concrete floor in my studio) to prestretch the slab. This will take some practice, so don't worry if it feels awkward at first. Toss the slab down gently, at an angle, pulling the toss toward your body and catching the top edge of the block of clay on the floor or tabletop. Gently peel the clay up, rotate the clay a quarter turn, and toss it again, pulling toward yourself. This will help stretch the clay evenly and hopefully keep it relatively square. If the clay is thrown straight down, it will stick and kill the efficiency of this process. Use the weight of the clay, not the strength of your toss, to draw it across the table or floor.

When the clay is about ½ inch thick (and, ideally, fairly even), you're ready to move to the slab roller. Most slab rollers have canvas mats or something similar. You should never put your clay through the roller without first sandwiching it between some type of cloth. (If you don't, you will have a serious mess on your hands and most likely garner some "oh jeez" stares from your studio mates.) So lay your slab gently on the mat, squaring it up toward one end. The slab is going to increase in length, so placing it at one end ensures that it will have room to spread out on your mat. You don't want the clay to extend past the mat during the rolling process.

For the first pass, set your slab roller to about ½ inch. When adjusting the height of your slab roller, you will want to decrease the thickness of your slab slowly, no more than ¼ inch at a time. If you try to decrease by more than that, you will run into issues with the slab roller not being able to compress the clay in one pass. Also, stretching the clay too far in

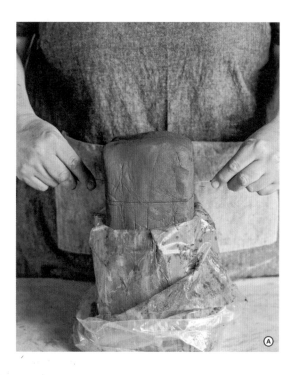

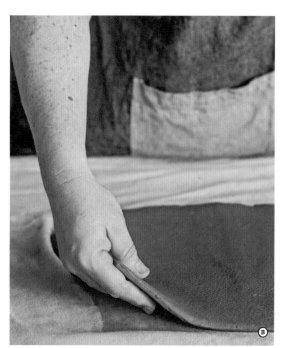

one direction can lead to shrinking, cracking, and warping problems later.

I typically make two passes. The first pass provides an initial evenness to my stretched slab. Ⓑ On the second pass I lift the slab and rotate it a quarter turn. This way I won't have uneven spots or cracking issues. Generally the second pass will be just under ¼ inch, the recommended thickness for most of the projects in this book. Ⓒ If you start with a thicker slab and work your way down in three or more passes, that's fine too. Just keep moving down ¼ inch at a time and rotating your clay a quarter turn.

Note: Slab thickness will vary from project to project or even within a project. Slabs for cup walls should be thinner than slabs for footprints, for example. My slab thickness recommendations and the thickness shown in the photos are an attempt to make it a bit simpler to work though the steps until you have built up experience with slabs. After that, feel free to adjust the thickness as your skills develop. If you want to make a really thin cup, go for it!

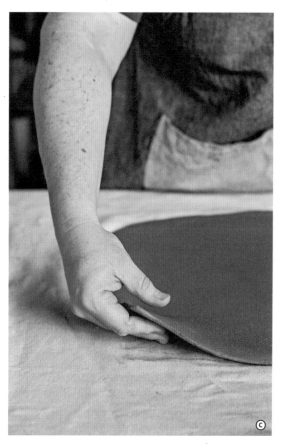

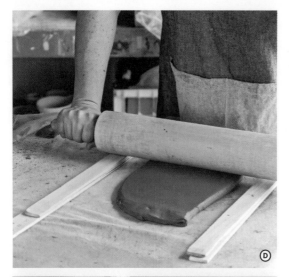

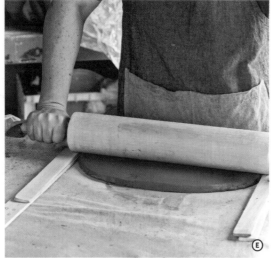

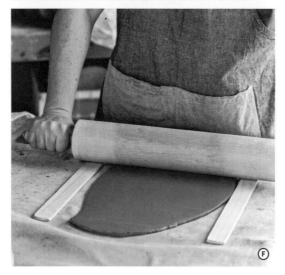

USING A ROLLING PIN AND WOOD SLATS

If you don't have a slab roller in your studio, don't despair! You will just need a clean worktable, a rolling pin, and wood slats. I recommend a rolling pin a bit longer than the width of your desired slab and four to six pairs of slats that are about ⅛ to ¼ inch thick. I've found that a pair of slats 1½ inches wide and about 2 feet long works nicely. Paint-stirring sticks will certainly work as well. In addition to wood, slats can be made of Masonite. And of course, keeping slats of different thicknesses handy will give you the greatest flexibility.

To make slabs with this method, prestretch your chunk of clay. Do this in the same way as the previous method, or use the rolling pin like a mallet. Don't go crazy and pound your clay to the tabletop, though. The idea is to move the clay gradually. Work your way across the slab, peel the clay up and give it a quarter turn, then repeat. It will take a few turns to beat the clay thin enough so that it's ready to roll.

When your slab is close to ½ inch thick (at its lowest point), position it between wood slats of equal thicknesses. As you can see, you should stack the slats higher for the first pass in the same way you make the first pass thicker with a slab roller. ⓓ Try to stack each side of slats to a ½-inch thickness. Make sure your rolling pin will span the distance between the slats. Then start flattening the clay gently, rolling away from you. The clay should even out where the rolling pin presses it down, though it will probably still have some low points. ⓔ

After the first pass, rotate the slab a quarter turn. This time it may be more of a struggle to work the rolling pin across the clay. If you are compressing and stretching the clay quite a bit, use a slow and steady rolling motion, both forward and backward. Keep your rolling pin positioned over the slats. Once the rolling pin is low enough and hits the slats, remove a slat from each side so that the thickness is reduced to about ¼ inch and repeat the process. ⓕ

WORKING WITH YOUR SLABS

When working with a slab, treat it gently. That means no twisting or torqueing and avoiding any activity that isn't keeping it flat and supported. Clay has a memory: it will remember abuse down the road and demonstrate its displeasure by cracking or warping. So, when moving a slab, make sure to keep it as flat as possible. If creases develop from the mats, or if the mat buckles, this is a sign that you may be trying to stretch the clay too fast. Back off the slab roller or wood slats and roll the clay again. Rework the slab when needed—don't just fill in or rib over a crease (doing this is basically precracking the slab).

Now that the slab is the thickness that you want (just under ¼ inch) and is square or rectangular in shape, it's time for the finishing touches. If the slab has ragged edges, use a straight edge and a needle tool to clean them up. Sometimes a ragged edge can pull or tear the clay as you pull the slab from the mat or tabletop. Ball up the excess clay, and put it back in your bag to reuse later.

When moving a slab, use the mat to transfer it from the slab roller to your workspace. Peel the mat off the top of the slab, leaving the slab on the mat underneath. Gently mist the slab with the spray bottle, moistening the top just enough so that a rib will slide over it smoothly and not catch on any dry areas.

Rib in every direction (horizontal, vertical, diagonal); this helps to compress the clay and removes any mat marks. 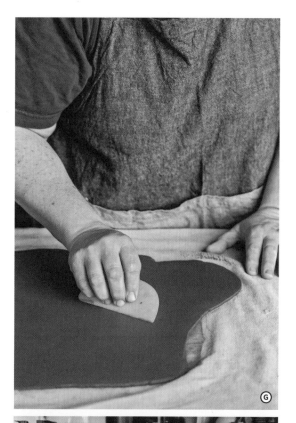 Now flip the slab, and repeat this on the other side.

If you are having trouble moving or flipping larger slabs, one of the best tricks is to use dry-cleaner plastic. Place a clean sheet of it over the slab, directly onto the clay surface. Run your hands over the plastic to gently press it flat against the slab. You don't want it billowing up and causing creases or escaping from under the slab when you flip. Using the plastic sheet on top and the canvas mat on the bottom, you can now flip the slab. If you have no mat under your slab, gently peel the clay off the work surface, using the plastic gently wrapped around the top edge. Peel

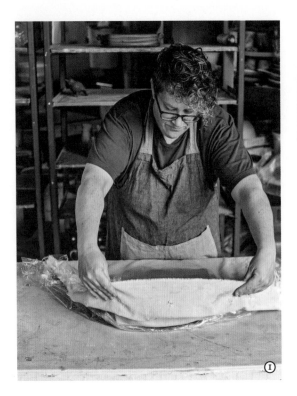

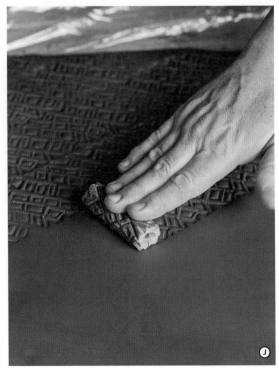

the clay up, gently lifting from the side farther from you. Once it's completely free of the work surface, extend your arms over the work surface and gently sling the bottom of the slab away from you and lay the clay down. This is to ensure the plastic and clay lay flat on the far side of the table. ① This sounds tricky, but you're using gravity to help your advantage. Make sure you have plenty of space to work, and practice on smaller slabs to get the hang of flipping them.

If you are going to be shifting your work area or sharing space, transfer your slab to a flat board (just make sure the board is large enough to accommodate your entire slab).

If you plan to add texture to your slab, now is the time to do so. For applying texture, use roulettes about the width of your hand (see page 167). I work diagonally because I like diagonal seam marks versus vertical or horizontal seam marks. ② (Diagonal seam marks can often become part of the design instead of a harsh line of a template meeting a vertical or horizontal pattern.)

If you are applying texture, you may want to start with a slightly thicker slab because compression will thin and weaken the slab. Also, certain patterns can be problematic on soft to leather-hard slabs since they can cause cracking when the textured slab is bent. If you run into this problem, try a thicker slab until you have the technique down.

Once you've added texture, let your slab set up for ten to thirty minutes, depending on your studio conditions. After the clay has dried slightly, you can flip the slab and apply texture to the other side if desired. If you do this, I recommend using another piece of plastic so that you can flip the piece by holding the plastic on the top and the bottom of the slab. Be careful about applying pressure, though. The goal is to preserve the marks that will be on the underside of the slab.

Okay, now your slab is ready! It's time to talk templates.

SOLID SOFT SLABS

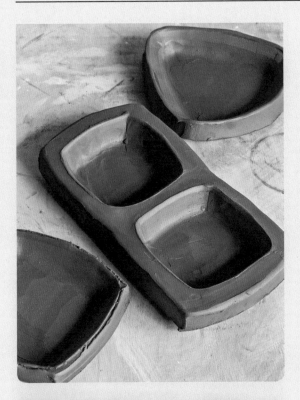

TOOLS AND MATERIALS

Basic toolkit (page 23)

Template

Loop trim tools

3- to 4-inch-thick slab that your template fits

This is a method of soft-slab building in which you'll create thick slabs and then cut away clay to create your piece. This method is often used to make a series of similar forms.

You can use many different templates for this process, but I'm using the one on page 197. Besides the template, you'll also need a block of clay that's larger than your template and quite thick. A fresh bag of clay is ideal for this.

Start by placing the template on the block of clay. The template will be a guide from the top to the bottom of the block. Using a cut-off wire and two measuring sticks as a guide, cut 1-inch slabs from your clay. ① If you're making only one piece, you need only one slab. But with this technique, it's easy to make multiples, so you may want to cut three or four.

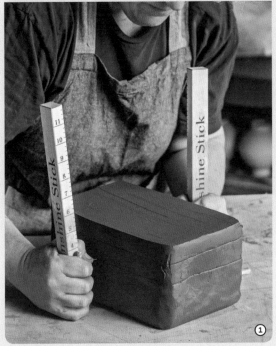

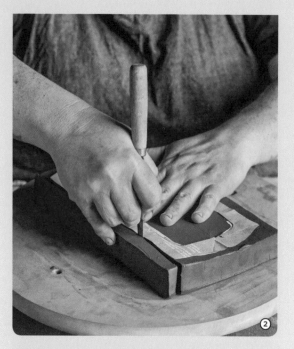

Working with one slab, cut out around the outside of your template and trace any interior lines. ② Use a loop trimming tool to carve out the interior of your piece, then use a rib to expand and shape the interior form. This will stretch the walls a bit. ③ Use a cheese cutter and rib to even out the lip if it rose in places when you ribbed the interior. Finish the lip, shaping it by hand.

For the foot on this piece, I mark a fettling knife with masking tape up to the point that I will cut into the foot. Then, holding the knife at an angle, I pull it through the bottom of the slab. The knife is inserted on all sides up to the point where it's marked with the tape. ④

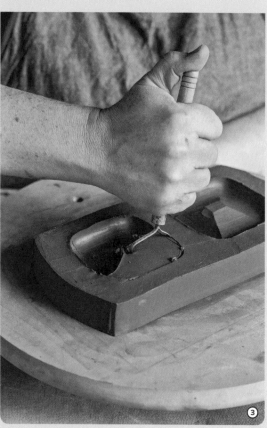

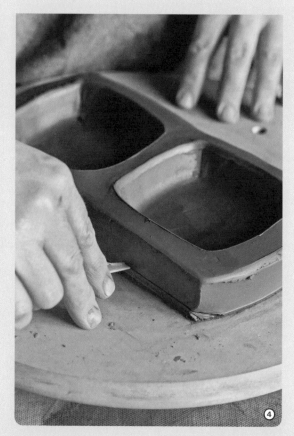

TEMPLATES

When working with clay, you'll use templates as a guide for making the shapes you want, much as you would use sewing patterns on fabric. From there, you'll either build on top of the clay with coils or piece the shape together with other shapes you cut from slabs (most likely also based on templates) to create a three-dimensional object. Templates can be used to create forms as simple as a tapered cup (see page 95) to an elaborate darted bowl (see page 94). Each of these examples was created from a soft slab and a template.

Developing templates requires an initial investment of time, yet they will save you more time in the long run. In my opinion, they are essential to your success when working with slabs. When you're developing new templates for original work, there will be lots of trial and error, so be prepared for some failure. Remember that failures are learning moments, and don't let them be stopping points! They are starting points. Learn your lessons, and move forward better prepared for the next attempt.

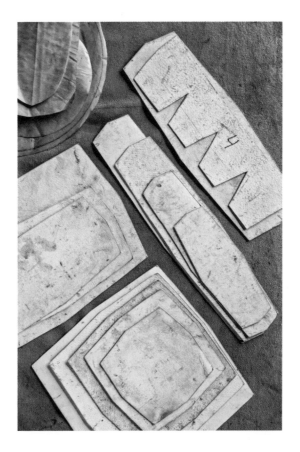

TEMPLATE MATERIALS

When selecting the material for your template, consider your goals. Are you in the early stages of puzzling out a new form? Or are you re-creating a template you've used before and want something durable? Paper will absorb moisture, shrink, and distort very quickly, but it is a great place to start. Once the problem-solving parts of template development are finished, move on to a longer-lasting (and often a bit more expensive) material. Here are the most common materials for templates:

Paper: Great for the early stages of developing templates, paper is easy to modify and cheap. However, it quickly absorbs moisture from the clay, which will cause it to shrink and distort.

Tar paper: With qualities similar to plain paper, tar paper is easy to cut and use to work out new ideas.

It's not as absorbent as paper, but it can be smelly (which I don't particularly like).

Watercolor paper: I highly recommend watercolor paper for templates. It is a very durable product, similar to tar paper in its resilience, but not smelly! The thickness of watercolor paper is ideal as well

because it provides a nice edge to cut along. Water-color paper is also good for footprint templates or stencil templates.

Masonite: I recommend Masonite for templates, especially for rounded-bottom designs. If you will have a clay piece with a rounded footprint resting on the template, Masonite can handle the weight of the clay and absorb moisture pretty well. It has good thickness for cutting cleanly too. If you have a form that you will be making multiples of, Masonite will also retain a sharp edge.

Wood: Use wood for templates for three-dimensional or other specialty designs. It's especially good for sturdy templates that you'll be building on. Wood holds up against long-term use, but it can be time-consuming to make templates with it.

DESIGNING A TEMPLATE

While a template can technically be any shape you want, you will find some shapes are more difficult to work with than others. At first, don't attempt to make any that are very small or very large, and try to avoid templates with supersharp corners (such as for a star). I recommend making your first few templates about the size of your hand.

The template shapes I share starting on page 197 come from years of working with certain shapes. The tapered design of the templates and footprints are a result of critiquing the objects I produce. I refined them, small step by small step, until the shapes provided the finished pieces I was after. There are many ways to work with templates and clay. Here are the basic steps for using flat templates to create 3-D objects.

First, take a look at one of my "square" or "rectangular" footprint shapes on page 197. I say "square" in quotes because you will soon see they are not perfectly square. I have found in the development of my forms that a taper lends a gracefulness and a more architectural look to a square form. Picture how the form will grow from the template, then use the template as the basis for a project. Ⓐ See page 199 for a template that is circular. Again, conceptualize how the form will come together. Ⓑ For some forms, you'll also need to consider how the angle of the connection (seam) will determine the top and bottom width of your form. It will also determine whether you will need a support system (such as molds or harder paper support).

Once you've seen how a template can inform the base of a form or the whole form, you can wrap your head around original templates. I recommend taking a paper cup or bowl and cutting it along the seam. Cut out the bottom and lay the pieces flat. Ⓒ Ⓓ Now you can see how two templates could be cut out of clay to make the same cup. Trace the paper cup pieces onto template paper, and use them to make your own clay cup!

Last, once you have a firm grasp of how flat shapes become 3-D forms, you can use a ruler, compass, and other tools to create uniform shapes as the basis for templates of your own. Freeform templates are challenging but rewarding.

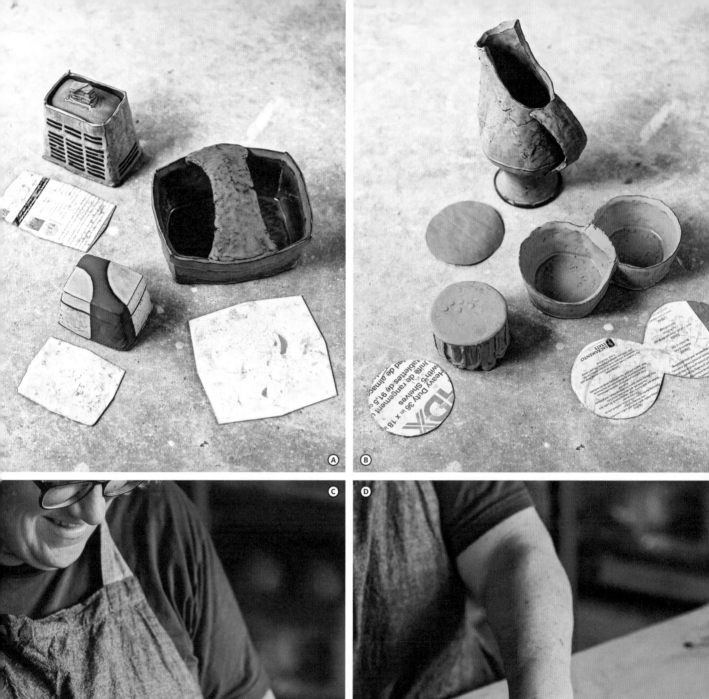

SLAB BOWL

Bowls are one of the most utilitarian objects you can make and, as with cups, their variety is endless. Be inspired by your surroundings! Imagine what you'd use most: Is it a bowl for large potluck salads or a small dessert dish? Or do you want a bowl to store something rather than to eat from? Templates and support molds are especially great for bowls and cups, since they are easily scaled up or down.

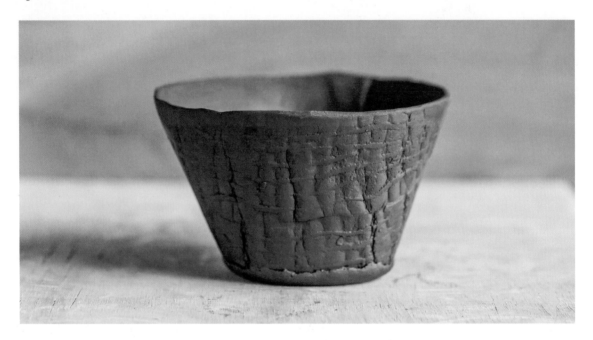

TOOLS AND MATERIALS

3–4 pounds of clay, prepared as follows:

 Slab 1: 20 x 10 x ¼ inches, for wall

 Slab 2: 4 x 4 x ¼ inches, for bottom

Template (page 200)

Basic toolkit (page 23)

Texture tools/roulettes (optional)

Brayer

Chamois

INSTRUCTIONS

Prepare your first slab with texture or surface decoration, if desired, being mindful of the thickness of your slab. For this project, I recommend using a firm but flexible paper (such as tar paper) for your template. It will work well as a relatively sturdy template and support the clay nicely. Trace and cut out the form.

Bevel the edges with a brayer, following along the edges. This increases surface area at the points of attachment and compresses the edge, which will help prevent cracking in the seams later. Ⓐ

Fold the slab in on itself until the edges almost meet. At this point, score and moisten at the point of attachment. Ⓑ Score both beveled edges of the

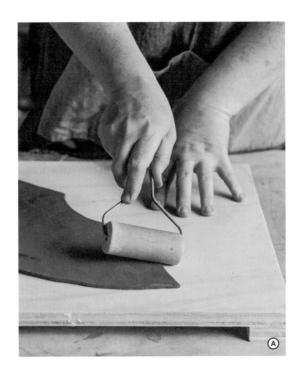

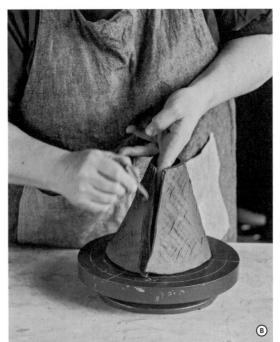

seam, wet one side, then attach. Firm up the attachment on the outside. Ⓒ

Now that you have the exterior seam attached, the next step will be working on the interior seam. Depending on the size of your bowl, the clay may need to set up before you handle it. Keep a close eye on your form as it dries. Remember, as the clay is drying, it is shrinking. Set a timer and check the clay every five minutes or so, depending on the conditions in your studio. If your bowl is smaller in size or the wall is thin, the attachment itself and the shape of the bowl should hold together without much drying time.

Make sure to support the seam from the exterior when you are cleaning the connection. You can either erase the seam completely or leave the seam visible to celebrate the creative process. To leave evidence of the seam, so long as your seam is well attached, you can compress the attachment gently with a soft rubber rib. If you want to erase the seam, backfill the gaps in the seam and rib more aggressively to compress and eliminate signs of the attachment.

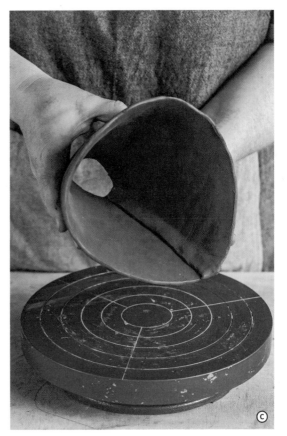

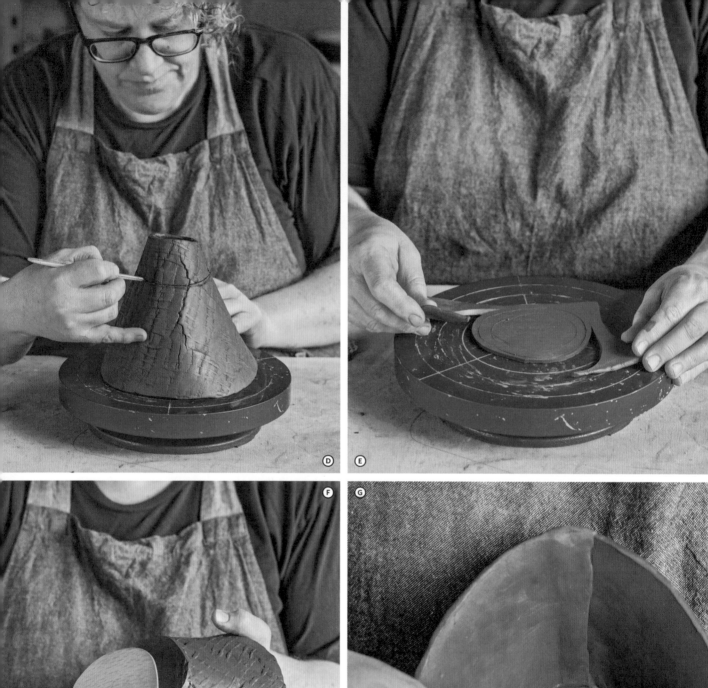
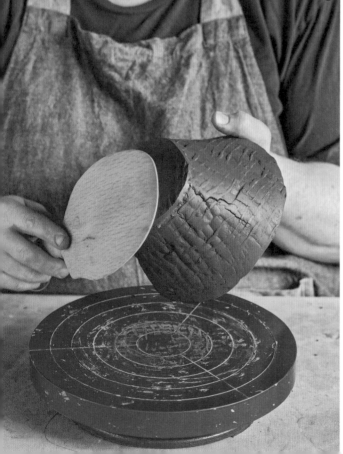
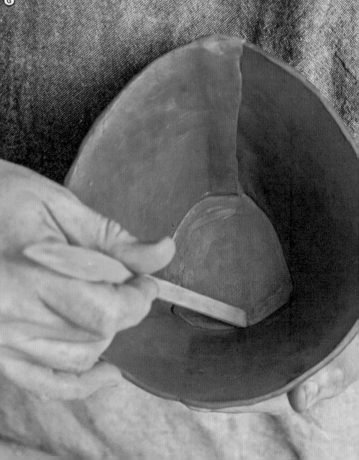

Now let's move on to the floor and/or foot of the bowl. For this form, I chose a flat bottom floor with a foot. To do this on your piece, use a piece of the slab that has the same texture as your bowl or use a second slab. Start by determining the height of your bowl and the width of the foot. With the bowl upside down (lip down), cut the working edge at the level you want for the foot. Ⓓ Use a surform to smooth the surface.

Flip the bowl over. Using the base of the bowl as your guide, cut the floor piece so that it is slightly larger in diameter than the floor you need for the bowl. To get a clear idea of where to score, trace gently around the interior and exterior wall. Remove the bowl and cut the slab along the outside line. Ⓔ Score the area indicated by the marks and the bottom of the bowl. Wet one side and attach. Gently paddle or rib the attachment to compress the connection. Ⓕ From the inside of the bowl, clean up the attachment and backfill any gaps. Use a rib with a right angle to compress the interior corner. Ⓖ

Now that the seam is attached well and compressed, it's time to make the final decisions on the decorative elements of the foot. Cut off the excess clay, leaving just enough to roll over the sharp edge. Tap the bottom slightly up into the bowl, as a slightly convex bottom is stronger and more durable than a flat one. Ⓗ

I am going to finish this bowl with a soft, rounded lip. If you'd like to do the same, use a sponge to smooth the edge, making a few passes around the entire lip. You can also use a chamois for this finishing touch.

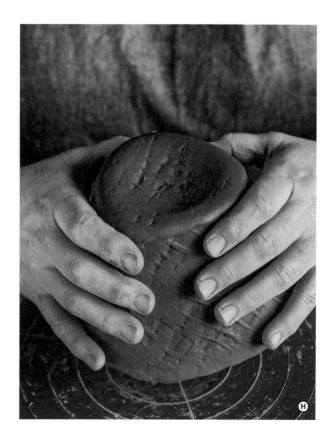

MAKE A SQUARED BOWL

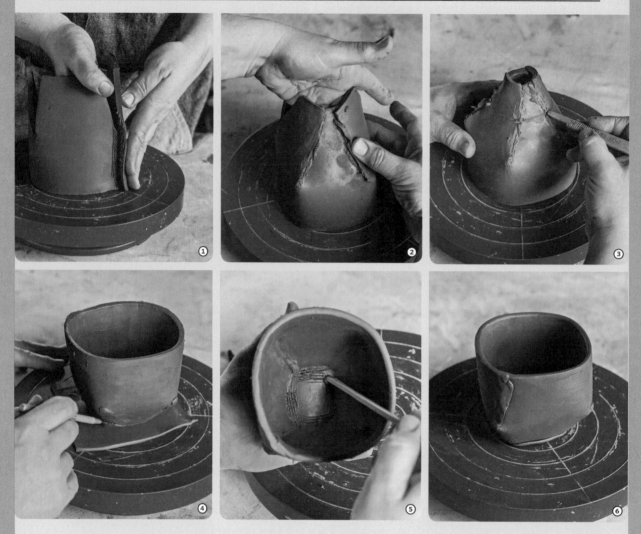

To make a squared bowl, you'll use an amount of clay and a process similar to those above, but you'll use the template on page 199 to cut out the initial form and you'll need a little extra slab rolled and ready for the foot.

Fold the bowl form in (lip down), as shown, scoring and moistening all points of attachment before making any connections. ① Start by connecting the exterior of the form, the "walls" of the bowl, then move on to the tabs, which will become the bottom. ② Connect the bottom tabs by working your way around, connecting one tab to another. Remember to bevel your edges because this will help secure seams and remove excess clay that might make your bowl feel heavy.

Note that there will be excess clay on top when you finish making the connections. You will need to cut this clay off the way you did with the round bowl, making a decision on how wide you want the foot of the bowl to be. ③ This will also determine how deep or shallow your bowl will be.

On the second slab, trace the foot for the bowl with a needle tool, using your bowl as a guide. Cut out the foot, and attach it to the bowl, scoring and moistening the point of attachment. ④ Clean up the interior of the connection. ⑤ Finish and compress the lip, using a sponge, chamois, or your fingers. ⑥

SLAB CUP (WITH BISQUE MOLD)

For this cup project, I am making the tall tumbler from the template on page 200. But I will be using a bisque wrap mold (see wrap molds on page 129) to make the tumbler. If you don't have a bisque mold, don't panic! You can use tar paper to create a similar shape (hold it together with masking tape). I hope that demonstrating the bisque mold for the cup and the paper mold for the bowl will illustrate the differences in various support materials. Paper molds are great for working on the fly and developing forms. But they break down quickly and cannot be used interchangeably with bisque molds. If your studio has a similar bisque mold, use it to follow along for this project.

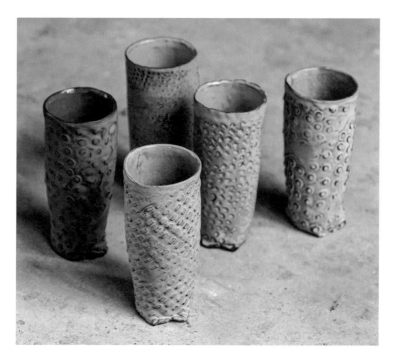

TOOLS AND MATERIALS

2–3 pounds clay, prepared as:
 Slab: 10 x 10 x ¼ inches, for wall
Paper for template
Bisque mold
Basic toolkit (page 23)
Texture tools/roulettes (optional)
Masking tape

INSTRUCTIONS

Prepare your paper template by wrapping your paper around the bisque mold, tracing, and cutting it out. Or, using the paper template provided, cut out the shape from a prepared slab (if you want to texture it, texture only one side). Ⓐ

Place the bisque mold on the banding wheel (lip down), then flip the slab onto its textured side. Lift the slab gently by edges, and wrap it around the mold from the far side of the mold on down, gently resting the slab on what will become the lip of the cup. Start wrapping the slab around the mold with your hands, slowly so that the slab hugs the mold gently. Ⓑ Now the slab should be supported and have a small amount of clay that overlaps in the front. Ⓒ Bevel both edges so they lay flat. Score and brush on a bit of water or slip, being careful not to wet the bisque mold (moisture could cause the clay to stick to the mold). Gently firm up the attachment. If the texture is getting lost, use the roulette to firm the attachment. Depending on the texture, a second impression may not match the first entirely, but it will blend in and preserve the semblance of the texture. Ⓓ

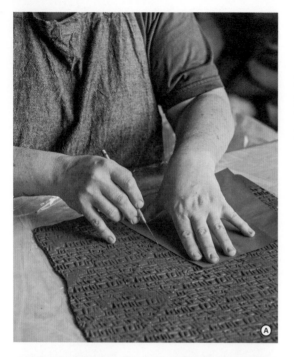

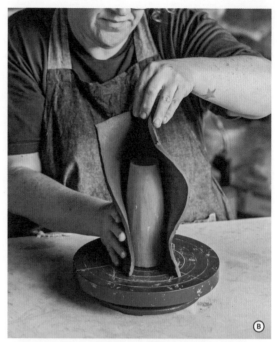

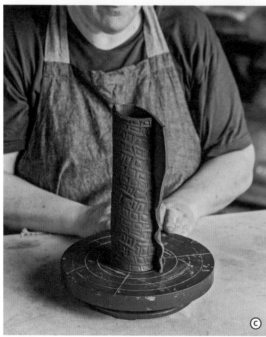

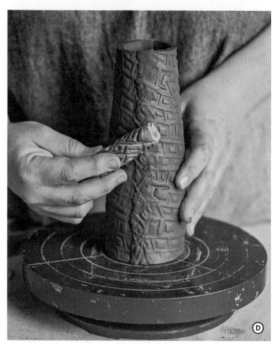

Note: Depending on the size of the object, you may need to cut a second template to build a structural support for the form while you attach the seams. Use a stiff but flexible paper: cardboard, tar paper, or watercolor paper. This is usually the case for very soft slabs.

For this type of cup, I usually finish with a folded foot. To make one, with the cup upside down, work on the top 1½ inches of clay. Use a cheese cutter to cut down on two sides, cutting out two sections opposite each other about an inch wide. Cut even farther down on the 1-inch section to create tabs to fold. ⒠ Fold the lower tabs in and blend them

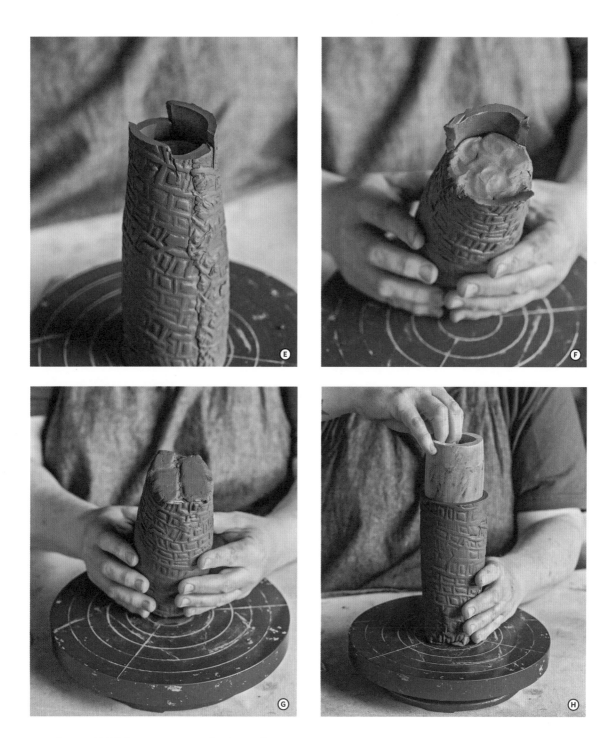

together. Ⓕ Fold the remaining tabs in, and press them together for a firm connection. Ⓖ

Flip the cup over, and roll the bottom until the edges are as soft as you like. Remove the bisque mold from the cup. Ⓗ Finish the top edge by pinching it, tapering toward the center.

Birdie Boone | Soft Slabs and Templates

How did you get your start in clay?

I started early, around age five! My best friend's mom made pots that I saw time and again; they resonated with me, and I knew that it was something I wanted in my future. I took classes as a kid, then again in college, where I majored in art with a concentration in ceramics.

What led you to discover the method of building you use?

It was definitely an evolutionary process, but I began hand building because the potter's wheel erased too much of the evidence of my touch that I sought to preserve. I had always worked with parts and assembly, so a transition to hand building wasn't a stretch. Slab construction and manipulation offer more opportunity for nuance and create a surface that is responsive to slip, which helps to build depth of surface.

What is your process for developing a new piece? Do you research or sketch? Does making templates or playing with clay come first?

When I first began making slab-built pots, it wasn't a very systematic process. I worked loosely, without templates, and the pots were much quirkier as a result. As I began to make more, I realized that it would be easier to duplicate forms and make multiples if I had templates.

Many of the artists I know who use templates create them either by playing with paper cutouts or with a computer-aided design program. Because I don't see in two dimensions nearly as well as I do in three dimensions, I had trouble with that sequence, so I thought I would try making an object in 3-D first, then cut it apart and lay the pieces flat to be traced onto paper. It's sort of fussy because I then need to standardize the template (make it symmetrical and clean it up) and make sure it's the right size so that all the parts fit

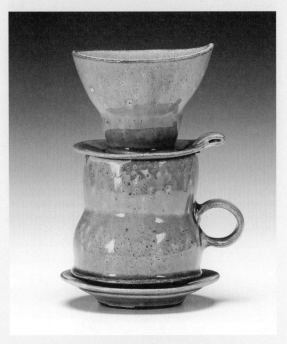

Mug and Pour Over. Birdie Boone. Slab construction.

without needing any adjustments during the assembly process. So, really, I sketch in 3-D. I do use roughly drawn sketches and lots of written notes to help me remember what I am trying to accomplish. Sometimes forms go through a lengthy design process, and that can make it difficult to remember where I left off. At this point for my current body of work, I can often modify an existing template for a new form, so I needn't start from scratch every time. Almost everything I make begins as a tapered cylinder, so it's mostly a matter of customizing size and considering details.

Can you explain some of your best practices or tips for working with soft slabs?

Being aware of simple but important things, like the best state at which to assemble or shape the clay slabs in order to get the results you seek, makes the process frustration free. One of the most difficult things about working with soft slabs

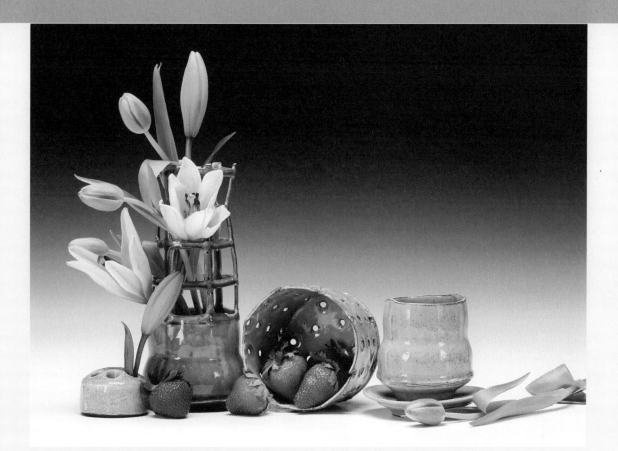

Still Life. Birdie Boone. Slab construction.

is touching the clay in a way that doesn't stretch or mar the pieces. It's important to know what your clay is capable of, and it's important to use a clay that will do what you need it to do.

Stretching thin, soft slabs is a great way to create volume. Working this way has its moments, of course, and it took me a few years to develop a true facility for the process, but it was worth it! Again timing is important: if the slabs are too wet during assembly, they will flop all over the place. If they are too stiff, shaping will be limited. The particular way in which I work does have size limits; I can manipulate only open soft cylinder walls that can be successfully flipped over onto their rims. At a certain point, it will take more than two hands to manipulate.

As for tips, it's important to have patience—to step back and wait if the clay isn't at the ideal stage for any given step—instead of fussing unnecessarily. Also, it's important to know how to make a strong joint between slabs, especially if further manipulation will occur after assembly.

The success of hand building is dependent upon being able to avoid cracking during drying or firing. Joints are areas of stress and need to be treated confidently and definitively. I use "magic water" and good scoring tools, and my clay always has plenty of tooth. Excess slip created from vigorous scoring is pushed to either side of the joint to create the equivalent of added coils. This small amount of slip gets compressed on both sides both sides of the leather-hard seam with a wood tool and any excess is easily removed.

What is your favorite thing about the method you use?

This way of working gives me all the nuance of form and evidence of process that I want. I love the fact that it's a low-tech process, so I don't need many tools. Assembly is straightforward because design has been worked out ahead of production. I also like the fact that once a piece is assembled, it's essentially finished and I needn't spend much time on cleanup.

LANA WILSON'S MAGIC WATER RECIPE

1 gallon water

3 tablespoons liquid sodium silicate

1½ teaspoon soda ash

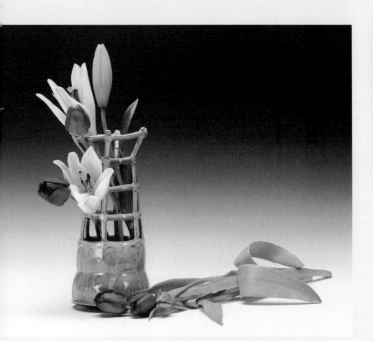

Vase. Birdie Boone. Slab construction.

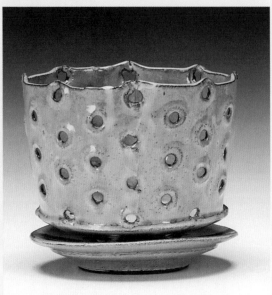

Berry Bowl. Birdie Boone. Slab construction.

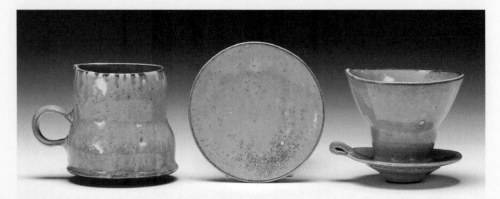

Mug and Pour Over. Birdie Boone. Slab construction.

All photos courtesy of the artist.

SLAB CAKE PLATE

Many years ago I was invited to participate in a dessert-themed show. Of course I accepted, even though I made no pieces specifically for dessert at the time! When I started to research ceramic objects used for dessert, cake plates came to mind early on—but I wasn't attracted to many of the ceramic cake stands I had seen in the past. They were too frilly for me. I started to wonder what kind of cake plate would fit my style.

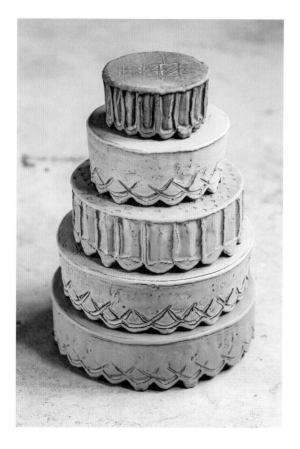

***Note:** Each cake plate shown is made in the same way. Start with the 7½-inch plate and make your next plate smaller or larger, depending on your preference.*

I went to the Internet and created a file filled with images of cake stands. My eventual cake stand was modeled after some interesting Victorian-era cake plates. They were not the typical pedestal style that you often see, but shorter stands that were more like cake plinths. They give the cake just a few inches of lift off the table.

After I spent some time developing this form, I hit on the idea of a stacking set. (I use the small ones for cupcakes!) This exercise will give you a delicious idea for how to use templates to scale up or down and to make a nesting set. The skill required here can be translated to casserole dishes or even boxes. This project will also cover the concept of shrink slabs (a shrink slab is a waste slab that you'll fire your work on to help keep it from warping).

TOOLS AND MATERIALS FOR A 7½-INCH CAKE PLATE*

4–5 pounds clay, prepared as follows:

 Slab 1: 9 x 9 x ¼ inches, for footprint (texture optional)

 Slab 2: 22 x 5 x ¼ inches, for wall

 Slab 3: 9 x 9 x ¼ inches, for shrink slab

Template (page 199)

Basic toolkit (page 23)

Texture tools/roulettes (optional)

INSTRUCTIONS

We'll start making this form upside down, so the footprint actually turns out to be the top in the end. On the first slab, use the template to cut out the footprint. Transfer the cutout footprint to a bat or ware board, with the textured surface facing down if you have added texture. Ⓐ I recommend lining your surface with newspaper to help prevent the footprint from sticking to the board and to preserve the texture.

Note: *If you want to work on multiple plates at once, you can easily cut multiple foot templates from the same slab.*

Measure the circumference of your working footprint. You will want to cut the second slab to a length equal to this circumference (plus a little extra to be safe). My wall is 3½ inches tall, though you can adjust the height of yours as you like.

Bevel the outside edge of the footprint and one edge of the wall slab so that they will fit together nicely. Ⓑ Score both beveled sides, wet the wall side, and prepare to attach it to the footprint.

Position the wall just above the footprint. You will want to attach the wall someplace in the middle of the strip, pulling and attaching the seam toward the front. Hold the ends of the wall, being mindful not to twist or torque the clay. Slowly tilt and attach the wall (at this point the wall should be vertical). When you get the seam closure close enough to overlap slightly, bevel the wall, cutting off the excess clay so the wall will meet evenly and maintain a vertical position. Score both sides, wet one side and attach, ensuring increased surface for the attachment and a solid seam. Ⓒ

Use a rib with a sharp corner to shore up the seam attachment on the interior and the exterior. Once all your seams are compressed, let the cake plate set up for about an hour.

To scallop the edge, use a ruler and needle tool to measure and mark 1½-inch increments all

around. After you have worked your way around the entire form, spin the form and make a mark ½ to ¾ inch down. This will be the mark that you cut down to for the curved edge. ⓓ

Cut the scallops in one direction first. Start in the middle of one of the marks created on top, and cut down to the line on the wall. Repeat in the opposite direction, then remove the unwanted pieces.

The cuts that you just made are potential crack zones. To reduce the occurrence of cracking, compression is the key! Rib the outside of the wall, erasing the line and cleaning up the surface. Use a wood knife to compress the "corners" (the low points of the scallops), moving the knife toward the interior. Rib the interior for good measure. ⓔ Use the cheese cutter to soften the interior edge, following the scallop. ⓕ

Now it's time to do a little surface alteration. My plate will be decorated with channels on either side of each scallop, but mark your channels wherever you like—or go your own way for decoration! ⓖ If you do want to make the channels, use a small piece of metal rib to carve into the clay. ⓗ Create a deeper mark in the clay closer to the lines created and more of a high point in the center. Once you have worked around the entire form, all that is left is to outline the curve of the channels. Use a metal or plastic rib to smooth the high points. This will push any sharp edges back into the clay. ⓘ

Depending on the size of the cake stand, the number of feet will vary. Generally I think three points of contact with the table is the best idea—the odd number will reduce any wobbling. This plate will have a series of feet placed evenly on three spots on top of the scallops. Make a small coil, cut it into three even pieces, then cut those three pieces in half. Pinch these pieces into small, chunky triangles, thick on the bottom and tapered toward the top. They should be the same size and shape. ⓙ Note that for larger plates, I still tend to use three points of contact but increase the number of feet to two or three in each spot.

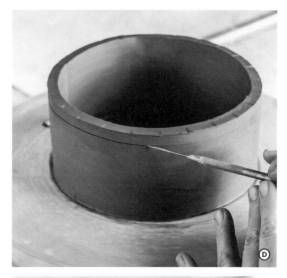

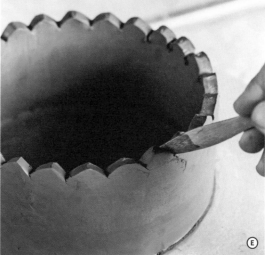

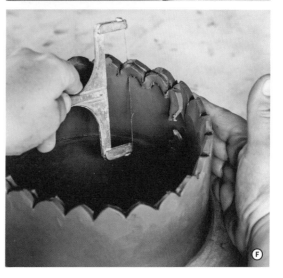

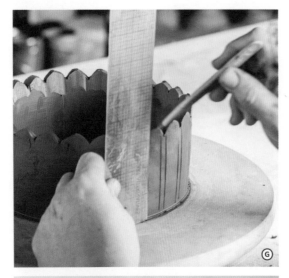

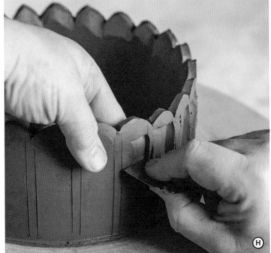

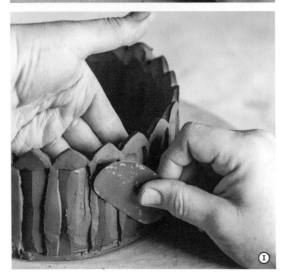

To attach the feet to the plate, score their bottoms and score the top of the scallops where the feet will be placed. Wet one side of the attachment. Compress the attachment and rib the surface. Ⓚ Using a cut-off/measuring stick or ruler and the cheese cutter to cut the feet evenly. Once they're even, finish shaping them with a craft knife to mirror the scallop shape. Ⓛ Use the cheese cutter to cut the backside of the feet.

Once the cake plate is leather hard, you can flip it over by placing a bat on top of the feet. (Using a bat will also give you a good surface to use a level!) Grab the bats as shown and carefully turn the cake plate over. Ⓜ Now that the cake plate is almost complete and you have access to the top of the plate, finish the surface as desired and don't forget to roll over the top edge. Softening that sharp edge is important! Ⓝ For safety's sake, after I have leveled the feet, I flip the plate back on its large flat surface of the top to dry and for bisque firing.

If your cake plate is the size of this project (7½ inches) or larger, I recommend firing it on a shrink slab. From the third slab, cut a circle the same size as the cake plate or slightly larger. Once the cake plate has set up (to leather hard) place the cake plate on the waste slab (make sure the entire footprint is on top of the slab). Ⓞ Let your plate and shrink slab dry together, and bisque fire them together as well, firing the plate upside down. For the glaze firing, you will want to flip the cake plate to fire it with the feet on the shrink slab. (Remember to keep the feet free of glaze!)

This method works well for any work that is heavy or spans a significant distance. It is a great technique!

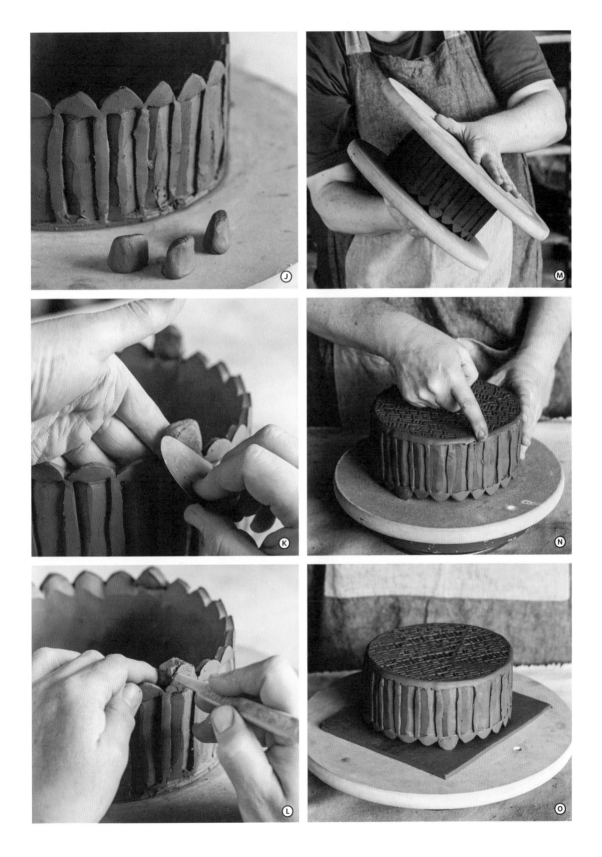

GALLERY

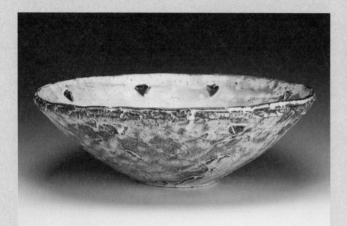

Large Salad Bowl. Bandana Pottery (Naomi Dalglish and Michael Hunt). Slab construction. *Photo courtesy of the artist.*

Triple Tray. Bandana Pottery (Naomi Dalglish and Michael Hunt). Carved from a solid block of clay. *Photo courtesy of the artist.*

Vase, No. 9. Kari Smith. Slab and pinch construction. *Photo courtesy of the artist.*

Clover Bowl. Matt Kelleher. Slab construction. *Photo courtesy of the artist.*

Pirate. Robert Brady. Slab construction. *Photo courtesy of the artist.*

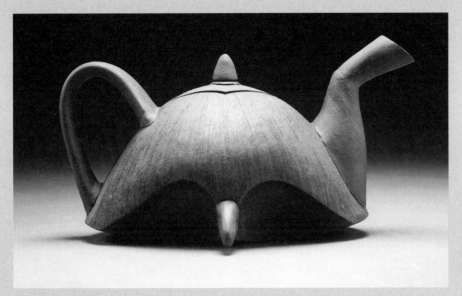

Hawk Teapot. Matt Kelleher. Slab construction. *Photo courtesy of the artist.*

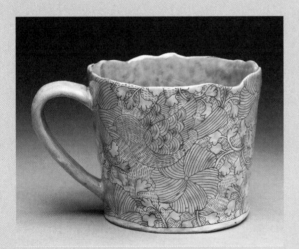

Mug. Shoko Teruyama. Coil and pinch construction. *Photo courtesy of the artist.*

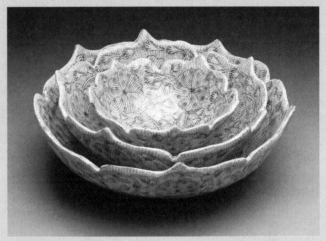

Nesting Bowls. Shoko Teruyama. Slab and coil construction. *Photo courtesy of the artist.*

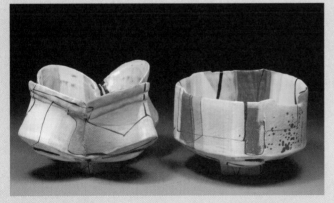

XO Bowls. Kari Smith. Slab and pinch construction. *Photo courtesy of the artist.*

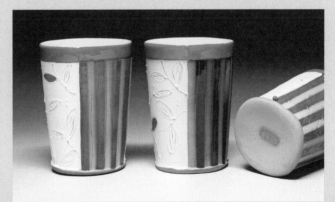

Cups. M. Liz Zlot Summerfield. Slab construction. *Photo courtesy of the artist.*

4 NEXT STEPS IN SLAB BUILDING

I HAVE JUST covered the major skills you need for slab building. In this chapter, we'll go further! We'll start with the longest soft-slab project in the book, in which you'll work with both soft slabs and coil building. This project is a good example of how I go about building much of my own work. Then we'll move on to working with hard slabs and explore this technique with a different type of box. Finally, I will address how to make and use molds.

As with Chapter 3, I have built the projects in this chapter similar to the way I build them in workshops, with an eye toward initial success. Once you master them, or if you already have the skills you need to make these projects, start creating your own variations! Speaking of workshops, I am often asked for tricks that are helpful to beginners.

While I admit that I have certain ways of doing things—many of which you'll see here—I want to stress that the most important "trick" is putting in the proper time and effort. There is simply no substitute for practice or experience. Even legitimate tricks, the processes that make a certain task easier, come from someone putting in hours and hours of time. They're the result of working away and then sharing that knowledge with other potters.

My advice is to push the pause button on these projects at some point and spend time thinking about the content of your work. Take a break from the studio to read Chapter 5! Only when your grasp of the content and the concepts of your work catch up to your skills will you be truly happy with your projects.

CASEROLE DISH

The first time I tried to make a casserole dish I was inspired by a form in a ceramics magazine. I just had to try it! Unfortunately it was a disaster. I started way too large, and I didn't yet understand how and when to handle and transfer my slabs.

Keep in mind that even with step-by-step instructions this project is one that will take practice, plus a knowledge of the state of your slabs. You may have cracks or a complete failure as you attempt your first casserole dish. This is okay! Challenging yourself and, at times, coming up short is a good thing. You can learn a lot from your mistakes, especially if you are paying attention to the process.

TOOLS AND MATERIALS

6–10 pounds clay, prepared as follows:
 Slab 1: 13 x 8 x ¼ inches, for footprint
 Slab 2: 15 x 10 x ¼ inches, for lid
Clay for coils
Template (page 198)
Basic toolkit (page 23)
Drywall sandpaper

INSTRUCTIONS

Place the template on the footprint slab, and use your needle tool to cut around the template. Transfer your slab footprint onto a clean wood or drywall board. Ⓐ You want a surface that the slab will pull away from easily once it dries. If you accidentally stretch or alter the shape of your footprint, lay your template over it and cut around it again. Make sure you are working with a very clear footprint. If your form starts off misshapen, you will spend a lot of time trying to correct it. Set yourself up for success from the first step!

Note: *I am using the template on page 198 enlarged to 12 x 7 inches. It is tapered from the center to the edges like the majority of my square or rectangular footprints. If you are worried about starting this large (it is ambitious), try a smaller form that is ½ or ¾ this size.*

Now you'll coil build a wall, similar to the coil-built box project on page 69. Score the top outside edge of the template slab all around, ½ inch from the edge. The connection to your first coil is vitally important. Attach your first coil, starting mid-wall. Pinch the coil on, pushing it down as you work your way around the footprint. Be mindful of the corners, and follow the footprint carefully from the outside. Use your thumb to push down on the interior side of the coil. When the end of your coil reaches the beginning of your coil, pinch them together. Ⓑ

Use a rib on the inside and a hand on the outside to refine the connection and the form. Go around a couple of times, reinforcing the corners. Then switch the rib to your outside hand, and rib until the seam disappears completely. Ⓒ

Move on to the next coil only once the form is exactly as you want it, the thickness of the wall is uniform, and the exterior and interior shapes match each other.

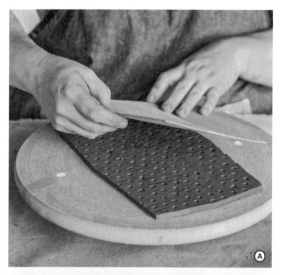

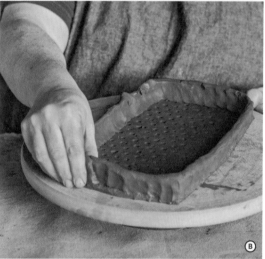

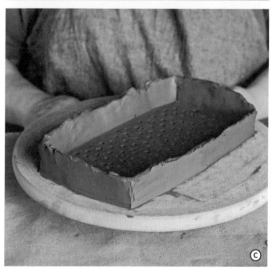

You'll continue adding coils, letting the form flare outward as it grows. This means you'll attach coils, pushing a bit harder from the inside. The wall should flare gently, and the clay should be strong enough to support the weight of the coil. If you move outward too fast or the clay is too soft, your form will have structural issues. You will learn how to manage your clay through practice.

Continue adding coils, ribbing and compressing after each one. I tend to set the form aside to set up after every two coils, but whether you do the same will depend on your studio environment. You may need to let this form set up after every coil if your studio is very humid. As far as the height goes, I build the wall of my casserole dish a little higher than I want it to be when fired and finished. In addition to the normal shrinkage of clay, you will need to consider making room for the flange inside. In general, if I want a 5-inch-tall casserole dish, I build to 6 inches. Keep in mind that the lowest part of your wall is where you will be cutting across the top, so don't ignore low areas. ⓓ

Note: As the form gets taller, you may realize it is flaring out too far. The solution is darting (see page 61)! As you build your skills, you'll need less darting, but don't be afraid to use multiple darts when you're starting out. Don't ever dart the corners, though.

Cut off the top evenly using a cheese cutter and a cut-off/measuring stick or ruler. ⓔ Now let your form set up a bit before adding the flange. You want the wall to be firm enough so that you can attach the flange without distorting the shape.

When your clay is ready, score a line around the form about ½ inch from the top on the interior wall. I try to give myself ½ to ¾ inch above the flange, and the scoring is about ½ inch thick.

Roll out a uniform coil, slightly thinner than the coils you used to build the form—about the thickness of your finger is good. The coil should be long enough to wrap around the interior of your casserole dish. Once the coil is the desired length, gently pinch it into a soft prism shape with your fingers and thumb. Score the side that was on the tabletop, and moisten with a damp brush.

Attach the coil, starting mid-wall. Use your thumb to press the coil into the wall, with your other fingers on the outside of the casserole dish acting as a backstop to preserve the shape of your form. Make another pass with your fingers pushing on the underside of the flange coil. If you have the room, you can also use a rib to do this.

When the attachment is nice and firm, work on the outside of the form with a rib to make sure you haven't distorted it. Next use a rib with a corner to clean and flatten the top seam of the flange where the lid will sit. Remember, you don't have to do this in a single pass. You can work your way around several times.

Using a cheese cutter or a craft knife, cut the interior edge of the flange to about ½ inch. ⓕ Before we move on, let's also address the lip. (In this case it's the area above the flange inside and out.) Using a cheese cutter, take off the corners of the interior and exterior edges. ⓖ Let the form sit until it reaches a soft-leather-hard stage.

Once the casserole dish has set, use drywall sandpaper or a firm (damp but not wet) sponge to take away the sharp edge of the freshly cut flange. Not having any sharp edges on your flange will help keep your flange intact over time, as sharp edges tend to chip.

To make the lid we'll be using the second slab in a soft leather-hard state. Take the measurements of the top of your casserole dish and cut the slab about 2 inches longer in length and width. This will help you when draping the slab to form the lid and give you enough clay for some play on all sides.

Drape the slab over your casserole dish. Use a soft plastic rib to work the lid gently into the form. The goal is to create a lid with a bit of a curve to it. Don't push too hard and create a giant domed top, though. Let gravity do most of the work.

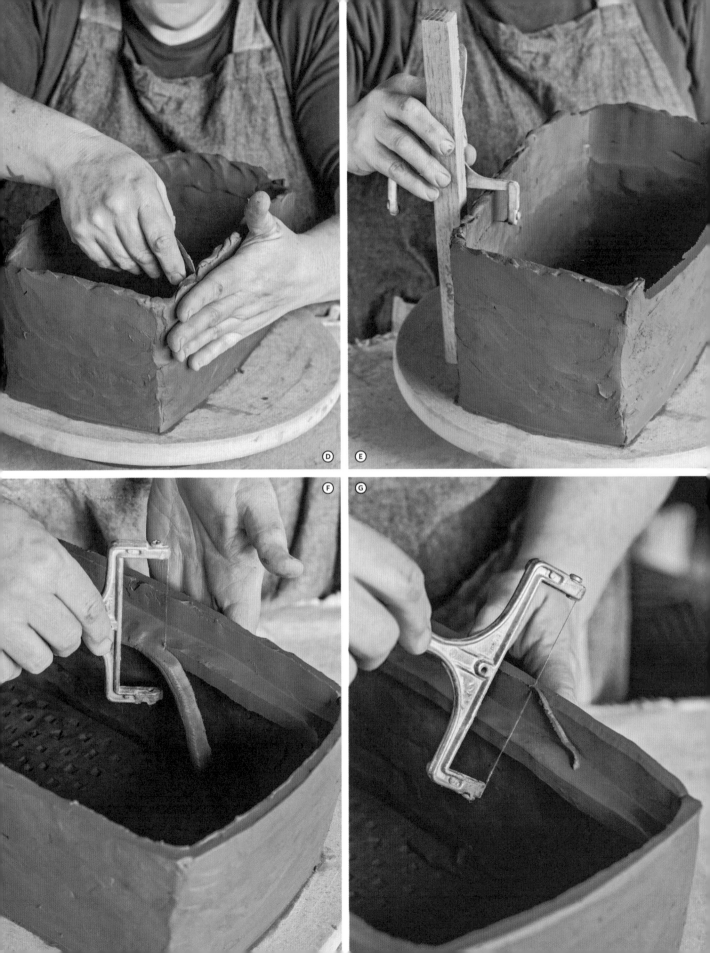

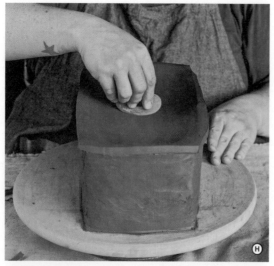

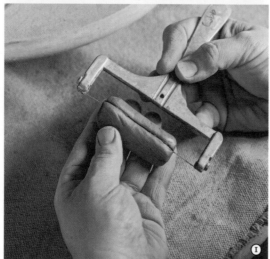

Work the edges of the slab onto the casserole dish, defining the outside edge of the dish onto the slab, so there is a clear indentation. Once the edges are creased you may also find a bit of air resistance when you start to rib. That's okay. Ⓗ When you have a decent curve, use a cheese cutter to cut off the excess slab, right up to the outside wall of the dish.

Let everything sit, wrapped in plastic, for a full day. The moisture from the slab will dampen the casserole dish, and the lid will stiffen up at the same time. You will need to uncover the lid and monitor its drying the next day. When pulling the lid off, it should be leather hard—you don't want it to be flexible or easily bent. If you take it off and it starts to flatten out, replace and let it firm up further.

If you want to work on the handles and knob now, you can. You can also wait and make them the next day.

Regarding the handles and knob, I will teach how to make the ones shown here, but feel free to explore your own ideas. It is important that handles and knobs do the job they're designed for, but it is your creativity that can put the "fun" in functional!

To create the handles in this project, make a coil about 2 inches long and just thicker than your finger. Cut the coil in half. Ⓘ Shape the handles so each has a wide base that tapers to a narrower edge at the top. Ⓙ About 1 inch from the top of the wall, score the body of the casserole dish where the handles will go. Score the handles and wet the scored areas with water or slip. Attach the handles, using one hand inside the pot to prevent any distortion. Continue to shape and refine the handles. ⓀⓁ

When your lid is ready, take it off the casserole dish. Treat it gently because it will "remember" any torqueing or manhandling. Use a craft knife to cut along the mark made by the top of your dish. This is the starting point for fitting your lid into your form. Place the lid right side up so that it's resting on the dish. It won't fit inside to the flange yet, but you will be able to see where it is hitting on the lip of the form. Use this as a guide for where you need

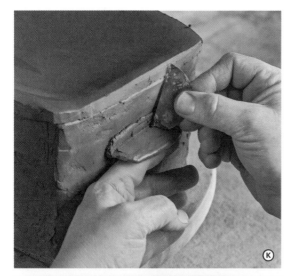

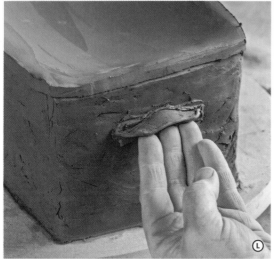

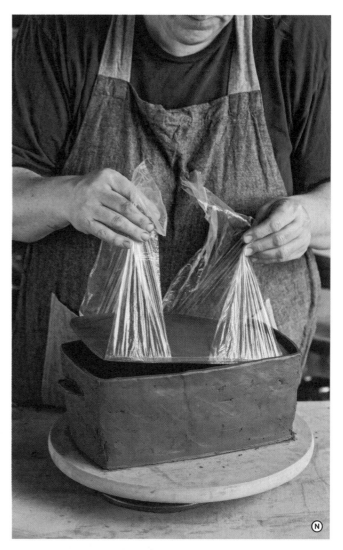

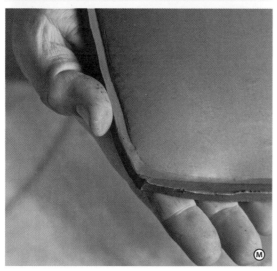

to shear off clay so that the lid will fit. Ⓜ Use strips cut from a plastic bag between the dish and the lid once the lid fits inside. This will help you lift the lid as you continue the refining process. Ⓝ

I typically sur-form the corners first, making a couple of passes, then check to see how the lid fits. I repeat the process, noting wherever the lid isn't fitting. As you refine, check often to prevent the lid from getting too small. If this happens, you'll have to drape a new slab and start over.

SCALE

As I've mentioned, most of the projects in this book are midsize, as they're easier to work with than oversize pieces or miniatures. Once you have the skills, though, working on very large or small pieces can be fun and rewarding.

You can approach scale in a couple of different ways. Scaling up can often be intimidating. But the most important part of your practice is making. If you find yourself wanting to scale up but keep finding excuses to not build big, look closely at that resistance. Define the stumbling blocks. What are you scared of?

Here are my tips for getting started on a project, big or little:

Make a plan. Large-scale work can require additional tools, and moving your piece can be tricky. Building small, like building large, can also require special tools and planning.

Sometimes we don't have the confidence or skills to build what we have imagined. So start small, then go large. Build a maquette—a small scale model—to help flesh out the idea and troubleshoot any problems that may arise during the making process.

Understanding function is important; however, functionality can be a deterrent in the beginning. Don't get so caught up in "will it work?" that you talk yourself out of making something that inspires you. Research can also be crucial in developing functional objects. Check out images online, go to your local functional ceramics gallery, or visit a museum. These are wonderful resources for beginners!

We live in a world that often seems to think bigger is better. Yet small work can often make a huge impact. There is a fragility that can be attractive when you build small. It also gives you opportunity for repetition and rhythm when making multiple forms.

To create the knob for your lid, I recommend making a few varieties using the methods in the handles section, such as pinched, coiled, or pulled (see page 51). Several knob shapes can work well with any given form, and only through experimentation will you find the right one to match yours. On page 116, you can see a few options that work on my form. ⓞⓅⓞⓇⓈ A cautionary note: Pay attention to the total height of your piece. If you make a very tall knob on a tall casserole dish, you may have trouble fitting your piece between oven racks. Attach the handle of your choice to the casserole lid, scoring and moistening it well.

The last step is to finish the bottom. Remove the lid, turn the casserole dish over, and roll the bottom edge by hand. ⓣ Let your finished piece dry slowly with the lid in place. Sur-form the lid as needed if it is a little too tight before firing the casserole dish, again with the lid in place.

HARD SLAB

So far all the slab projects in this book call for soft slabs. Many of the same steps in soft-slab building will apply to hard-slab building; however, there will be a few important considerations to help avoid cracking or warping. I recommend mastering the soft slab before moving to hard slab. The two processes can work together quite well.

Hard-slab building is all about working with clay in that small window between workable and too dry. Mastering this will open up the possibility of creating forms with very clean corners and angles, forms that are much more rigid than the other projects in this book. Hard-slab building is not only a very versatile way to build functional forms, it's also a skill that will allow you to branch out into the sculptural realm. It is a liberating building method and a technical challenge at the same time. You must understand the connection points and the importance of scoring. Careful consideration of the clay body is also essential. If you have a fussy clay, it will need more babying. I would recommend a clay that has strong greenware strength and a wide range of flexibility for hand building.

HARD-SLAB TIPS

In this section, I am going to outline the important steps of building with hard slabs no matter the form or template you choose.

First, slab preparation is very important. It's critical to work with the clay when it is ready and catching the clay when the workability is at its largest window. Prepare at least two or three slabs (depending on the size of slabs you make and the size of your project), and let them dry to the proper consistency: The clay should be stiff but still have some flexibility. This is difficult to explain with words or even in a photo, but as a test you can bend a corner of the slab. If it folds over and onto itself, it is too soft. If it bends about halfway, then breaks, it is about right.

When you're cutting hard slabs, whether using a template or cutting freeform, use a sharp blade to make the cuts and bevel the edges where they will connect to other hard slabs. The beveling on footprints needs to match the beveling on the bottom of walls and the beveling on the sides of walls needs to match the beveling on adjoining walls. ① While you want to have plenty of clay slabs in the right state, it doesn't pay to cut out all of the pieces for a project at the same time. The forms do not go together like a jigsaw puzzle (the clay will remind you who's boss!). You can cut more than one piece at a time, but always leave yourself room for making adjustments when beveling.

At first, beveling can be confusing, so it helps to focus on one piece of the wall and one connection at a time. Leave a bit of extra clay to work with. Mistakes in beveling happen often, and mastering the technique takes a while to learn. Also, increasing surface area at the point of connection is an advantage in beveling, but you still need to score generously and wet one side before connecting two hard slabs.

At each connection between the walls and between the walls and the floor, add a small soft coil of clay. Compress it, first with your fingertip, then with a rib with a right angle. ②③ This will help reinforce the connection. Be careful to use only a small amount of clay to fill in the seams; do not lay a fat coil over the top of the seam to hide it! This can lead to excessive cracking.

If you want a sloped connection, meaning a more rounded interior transition between the walls and the floor versus a right-angle transition, this can be created after the entire wall is complete.

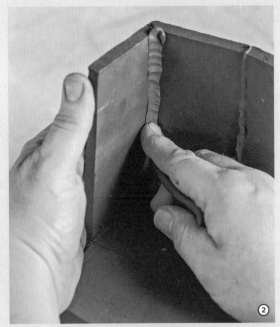

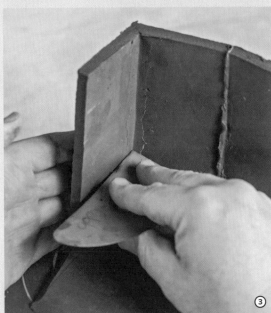

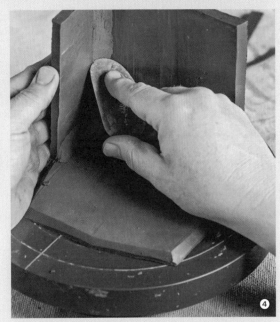

Add a larger coil, being sure to score where the connection will be, and compress the clay well with a rib that has a rounded edge. ④

After all connections are made, let your form rest under plastic to allow those connections to become firm while the whole form reaches a uniform state. Spray it gently with some water, wrap it, and set it aside for twelve to twenty-four hours. This is a good stopping point if you are working in multiples or before you move on to form a lid. In short, you can pick up here the next day no matter what!

HARD-SLAB BOX WITH CAPPED LID

To get the hang of hard slabs, let's dive into a straightforward box project. Capped-lid boxes were my introduction into the realm of hard-slab construction and got me hooked on this method of building. The most important thing in this project is the connections. Compression is key. If you do take on a smaller, larger, or more complex box form, keep this in mind.

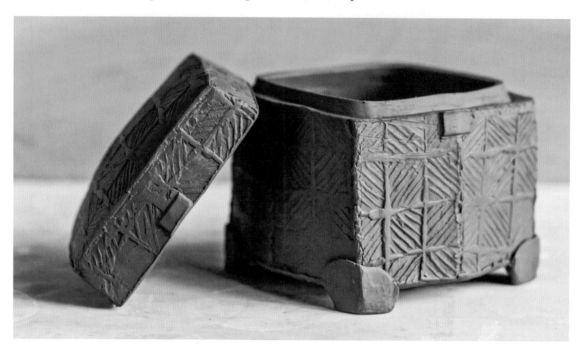

TOOLS AND MATERIALS

4–6 pounds of clay, prepared as follows:

Slab 1: 7 x 7 x ¼ inches, for footprint
(let dry to leather hard)

Slabs 2 and 3: 5 x 21 x ¼ inches, for walls
(let dry to leather hard)

Slab 4: 7 x 7 x ¼ inches, for lid
(cover to keep soft)

Template (page 197)

Basic toolkit (page 23)

Drywall sandpaper

INSTRUCTIONS

With your slabs prepared and in the right state (leather hard for all but the lid), begin assembly by beveling the outside edge of the footprint slab. It's also a good idea to mark the corners on your footprint—it will help indicate where and how you'll cut your side walls. Now you'll work your way around the box, cutting, beveling, and attaching the wall sections.

Cut your large wall slabs down into sizes that you can easily handle. Then hold a section up to the footprint and cut your first wall section to match the footprint. Ⓐ Leave a little extra clay on each side, as you will bevel not only the edge of the wall that will connect to the floor but also the edges of the walls that will connect to other walls. Score all

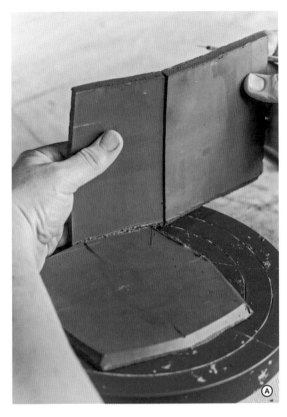

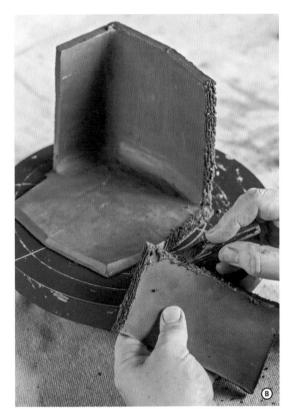

the beveled edges well, wet the beveled edge that will attach to the footprint, and attach the wall to the footprint.

Cut, bevel, and attach the second wall in the same manner, making sure the beveled edge on one side will match the beveled edge of the first wall. Attach the second wall to the footprint and the first wall, scoring all points of attachment and wetting one side of each connection. ⓑ Continue to attach the rest of the walls one at a time. Gravity will help you if you taper your walls slightly toward the center of the form. This process will help keep your attachments together and make your box more structurally sound. ⓒ

Depending on the strength of your clay, you may need to wrap your form and let it set up before moving on to leveling the walls. Check the walls: Are the connections set, or do they need a few minutes to stiffen?

It is not unusual to have some variation in the height of the wall. If the form is sturdy and the

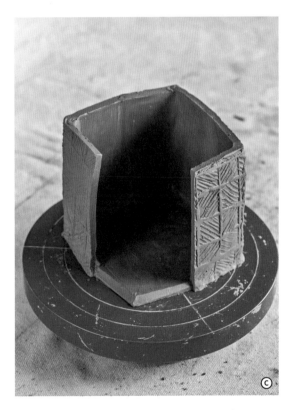

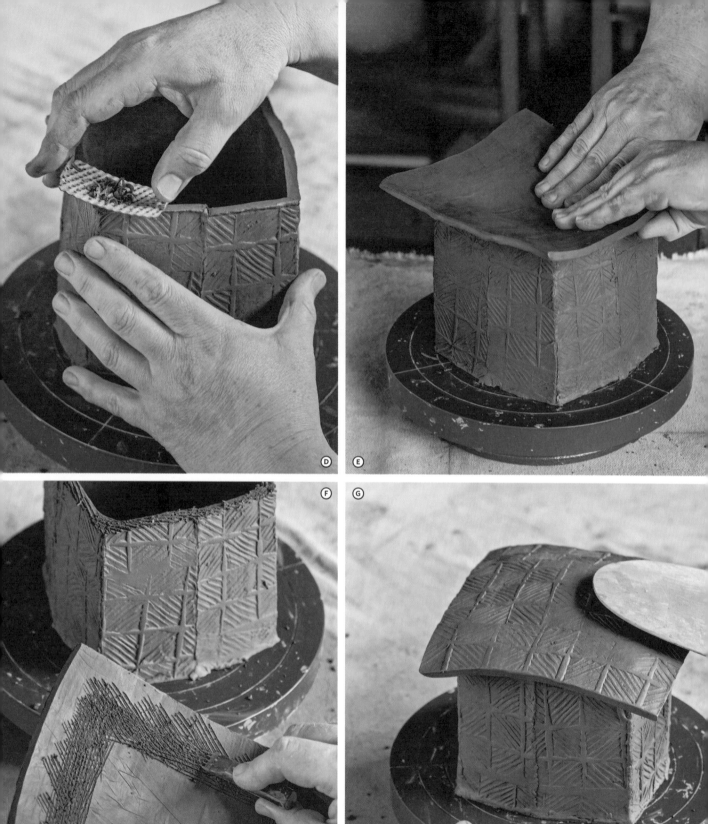

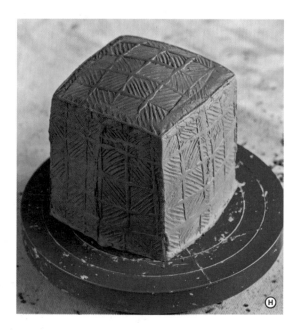

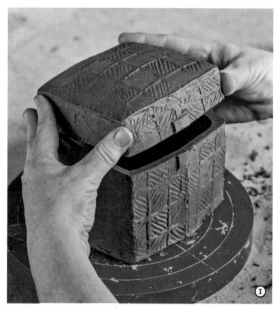

connections are firm, use a sur-form to level the wall height. Ⓓ If the form is too soft or feels too fragile for a sur-form, use a craft knife to cut the wall height evenly. Break out the ruler, and make a line around the form so you don't cut off too much.

Once the box is leather hard and the walls are the same height, take the soft slab set aside for the top and gently drape it over the top of the box. Create a slight convex curve to the form by ribbing or bending the slab into the box. Ⓔ Wrap the form in plastic with the draped slab in place, and leave the pieces together overnight. This will help their states equalize.

The next day remove the plastic and wait until the top is ready to handle. It should not lose its shape when you pick it up. Once it's sturdy enough, gently pull the draped slab off the box.

Flip the lid upside down on the box, and mark with a needle tool where the outside wall hits the lid; this will give you a guide for scoring. Take the lid off, score generously around the mark you just made, and set the lid aside. Ⓕ Score the top edge of the wall in a downward motion toward the outside of the wall, which is where the lid will attach. Wet the top of the wall and attach the lid. Use a paddle to gently compress the attachment, working your way around the box. Ⓖ

To test if the attachment is solid, carefully lift the piece by the overhanging clay of the lid. Did it come off? If so, rescore, rewet, and reattach. Make sure your attachment is solid! Once the top is attached, cut away any overhanging clay directly to the wall. The lid you just made is a part of the box now. Cut the excess lid slab accordingly (straight) and sur-form the walls, and rib to make the seam disappear. Use your texture tool to fully erase the seam. Ⓗ

You may have noticed that your piece resembles a doorstop, a fully enclosed box with no opening. Now it's time to make the lid. Using a ruler, mark all around the form where you want the lid to be. A good general rule is at least 1 inch from the top because you will need space to fit the flange. Using a sharp knife, cut straight into the form, and slowly make your way around it.

Note: Start your cut mid-wall, not at a corner. Even with the guide, you may need to adjust your cut, and that is easier to do on a flat surface.

Before pulling off the lid, make a small notch on the lid and the bottom to remind yourself how the box fits together. Ⓘ You will erase these marks

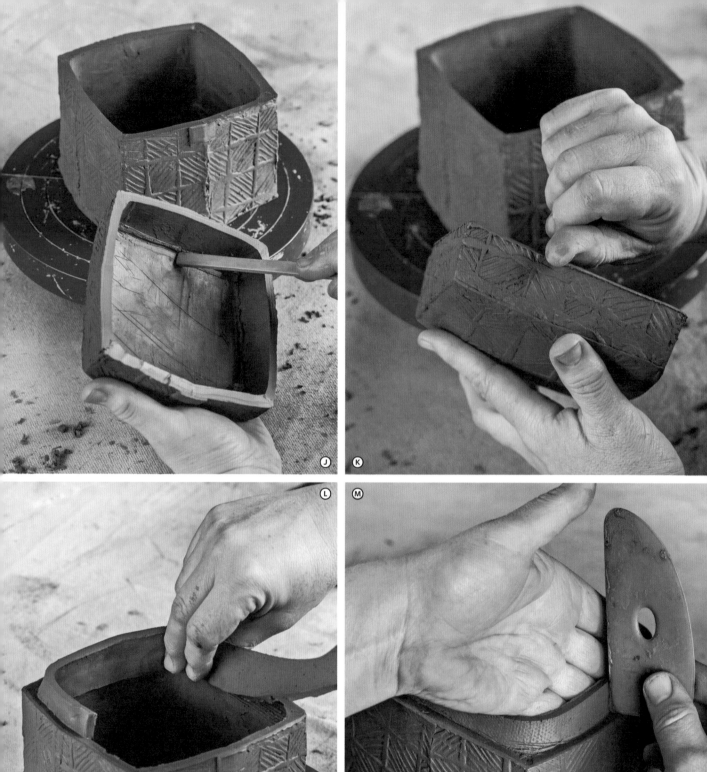
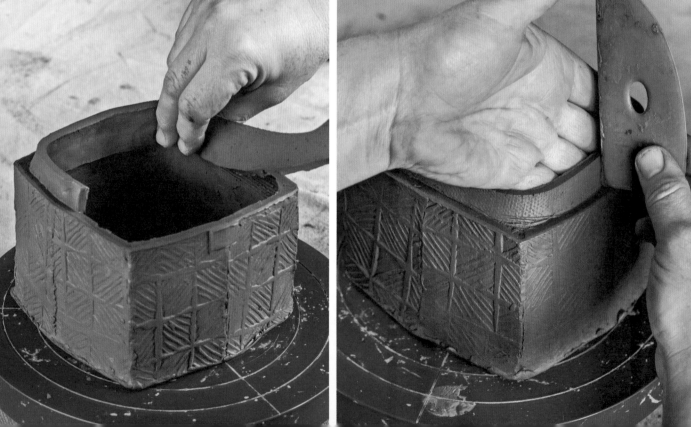

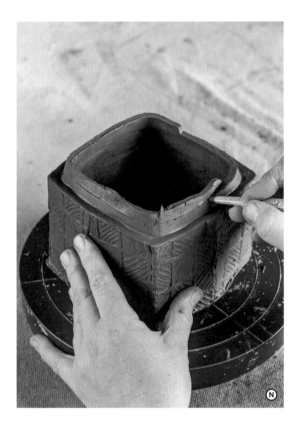

once you are finished building the box. Now take off the lid.

Clean the lid's inside seam. I also compress the corner seam with a rib, but depending on the wall thickness and how much cleanup is necessary, you can also backfill the seam with a small coil. ⓙ Use caution if you add a coil; remember, this will be sitting over a flange, so be mindful of the space you are taking up (the flange will need some of this space). Roll over the outside edge gently to create a small burr line that will give a bit of shadow when the lid is resting on the flange. ⓚ On the inside wall, use the cheese cutter to take away the sharp corner. Then set the lid to the side.

Get ready for the flange by rolling the outside of the wall with your thumbnail. Now for the tricky part: Using a ruler as a guide, cut a strip from a prepared *soft* slab that's about 1 inch wide and long enough to encircle your box. The thickness should be about the thickness of your wall or a just a bit thinner. Score

and moisten about ½ inch down on the strip of clay. Score the top ½ inch inside wall of the box. Attach the soft-slab strip to the wall, starting mid-wall again, and use your thumb to secure the attachment as you go. ⓛ Keep the fingers of your hand on the outside of the box to backstop the pressure you are applying inside. You don't want to distort your box.

Using your hand or a wood knife, shore up the interior attachment. Pay close attention to the corners and the seam of the flange, as this is where the form is most likely to crack. I like to meld the soft slab into the wall of the form, making the seam disappear.

Now address the outside wall and flange attachment. Using a rib with a sharp corner, compress where the flange and the wall meet. ⓜ Taper your flange wall so that it leans toward the inside of the form. This will help ensure that the lid slides over the flange. To clean the flange, cut away all but about ¼ inch of the flange wall. There is no need to have an overly tall flange; it can actually increase the chance of the lid not seating well and the potential for breakage. Using a craft knife, cut the flange down evenly. ⓝ Use a cheese cutter to remove the sharp corners on the flange. Since the clay has set up and is leather hard, you can go back over the flange edge with a bit of drywall sandpaper.

Now is the moment of truth: Test to see if the lid fits. Gently put the lid on the box, making sure to line up your notches. If you feel resistance, check where the pieces are catching and adjust the form or clean away any extra clay. Small adjustments to the box should still be easy to make if it is leather hard.

It's a good idea to key your box—that is, indicate which side is the front. I usually key with glaze, but there are many ways to key a form. Simply add some type of decorative element.

Now on to the feet. For this step, you'll want your box to be leather hard so you can handle it without distorting it. Roll a coil that's about 1 inch thick and 4 inches long, then cut it into four equal sections. Pinch them into a pyramid shape, a rough version of what the final feet will look like. You'll

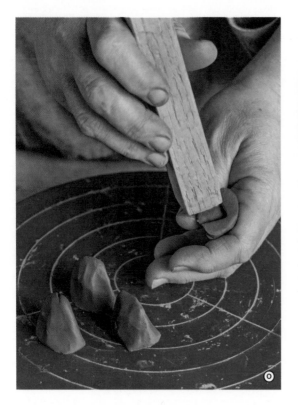

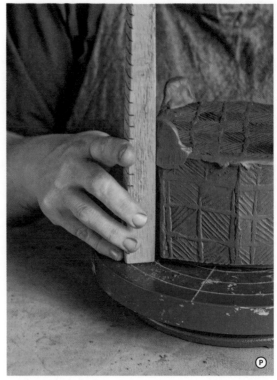

continue to refine them once they're attached to the box. Use a ruler or similar tool to indent corners into the feet (these are where your box will nest on the feet). Ⓞ Take the lid off the box, flip the box over, and attach (score and moisten one side) the feet to the four corners. (The flange of the box should be strong enough to support the weight of the box. If necessary, rest the box on soft foam.) Use a stick to make sure the feet are in line with the form of the box, creating a corner on the foot that matches the box and shoring up the attachment. Ⓟ Shape and refine the feet as desired, then use a cheese cutter and measuring stick to cut the feet off evenly. Clean up the feet, using your finger to soften any sharp edges. Let the feet firm up to leather hard before turning the box over to sit on the feet.

Dry the box slowly with the lid on. Check periodically to make sure the lid comes off easily. Use drywall sandpaper to adjust the piece if needed. It is important that the box and lid are dried, bisque fired, and glaze fired together. If they are fired separately, the forms may warp in different directions and no longer fit together properly. But be mindful when glazing not to glaze your box and lid so that they become stuck together!

MOLDS

In the hand-building world, artists often use molds to form their pieces. Molds can be made of almost anything, and most studios have dedicated plaster, clay, and wood molds around somewhere—even if only on an out-of-the-way dusty shelf. Molds can be simple or very complicated in construction, temporary (such as paper) or permanent.

Molds are a wonderful way to make parts to combine or multiples of a form. They work well as a base form for larger objects because you can add slabs or coils to create a more complicated object. As your pieces develop and your skills improve, keep molds in your back pocket as an option to help you build more complex designs.

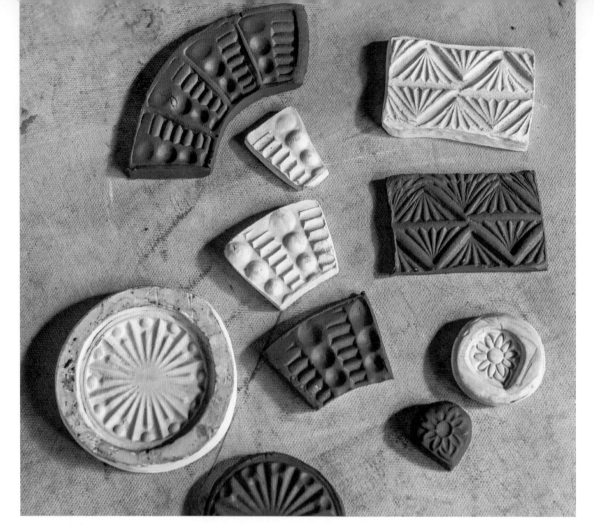

PRESS MOLDS

A press mold is a mold designed so that soft clay can be pressed directly into it to achieve a shape or texture. Press molds are great to have, but large ones are usually a shared studio tool. Some potters use press molds that are equilateral, creating two halves of an object and then combining the halves to make the final object. Press molds are helpful when producing architectural forms and other forms with hard edges as well as when you want something you can reproduce. Although teaching how to make large press molds is beyond the scope of this book, you can easily make small press molds for sprigs, which are decorative elements added to forms.

TOOLS AND MATERIALS

1–2 pounds clay

Basic toolkit (page 23)

3-D objects (to make impressions of)

INSTRUCTIONS

Make a clay slab, and cut it so that there's roughly 1 inch of clay around the object you want to use for an impression. The slab should be ½ to ¾ inch thick, so that the impression has at least ¼ to ½ inch of clay behind it.

Stamp into the wet clay, making sure to create a good impression. Remember, the devil is in the details: Clean up any edges that are sharp to avoid hurting yourself and to prevent chipping the mold later. Let the clay dry, then bisque fire it.

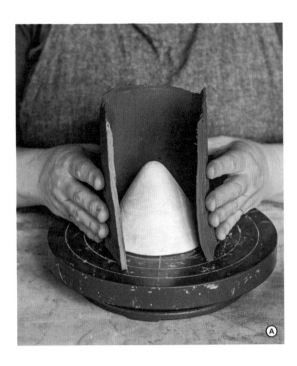

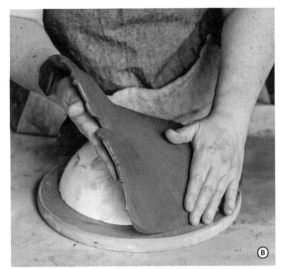

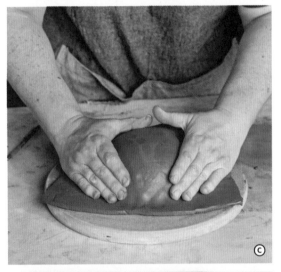

DRAPE/HUMP AND WRAP MOLDS

A wrap mold is the type of mold I use most often for cup forms. Wrap molds are also great for creating small pieces of an object or making multiples for sets. They make it easy to come up with simple shapes to play with. Working with wet to soft leather-hard clay, you can wrap the mold and work the seams easily, backstopping against the mold itself, then pull the mold out and finish the object. Done! Ⓐ

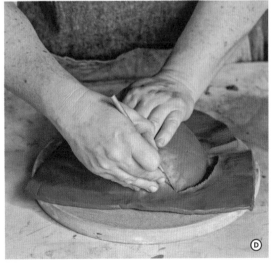

A drape mold, also known as a hump mold, is a convex form designed for draping clay over it. An advantage to working with a drape mold is that you can easily add feet or handles to the outer surface of the clay while it's on the mold. Chances are your studio has a shelf full of plaster drape molds, and you can experiment with those shapes. Basically you want to place a clay slab over the top of the mold, press the clay to form a firm attachment to the mold, then trim the clay as desired. Ⓑ Ⓒ Ⓓ Don't have a plaster mold? Read on for a way to try the drape-mold technique with newspaper and tape instead.

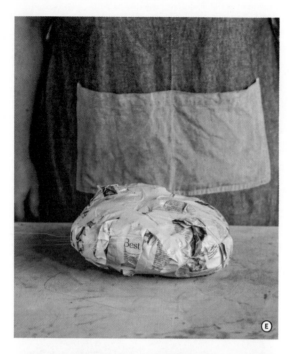

MAKE A PAPER MOLD

If you don't have access to a plaster mold or if you want to test a shape before making a mold out of clay, make a temporary mold. The quickest way to make a drape mold for one-time use is with paper and tape! I love this method, as it allows for some really interesting and spontaneous form development. One reason to workshop drape molds with materials like this is the angle of the mold is very important. If you are making a plate, for instance, the curve of the plate is difficult to gauge in the beginning. So before making a drape mold out of clay and bisque firing it, it is a very good idea to make a few paper molds to find the angle that suits your aesthetic.

Start by balling up some newspaper. The balls will act as a filler for the center of the mold. Start to slowly bind the newspaper together with the tape, and use more paper to wrap up the wadded-up balls. Build the mold to the desired shape. Note that the paper should be dense and able to absorb the moisture of the clay as well as withstand the weight of the clay. Ⓔ

Drape the clay slab over the top, and see what shape you get. Modify your mold from there! Ⓕ

When you're happy with your temporary newspaper mold, use clay to replicate its shape. Build up the clay, then use a sur-form and ribs to refine the shape. Let the clay mold set up to leather hard, then hollow it out, leaving the clay ½ to ¾ inch thick. After you bisque fire the clay, you'll have a reusable mold to make plates.

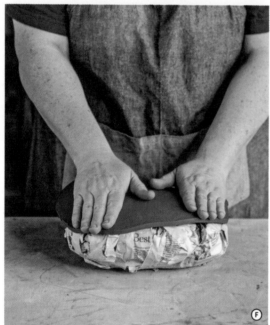

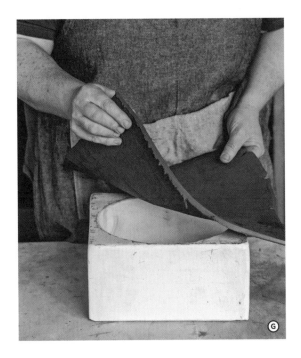

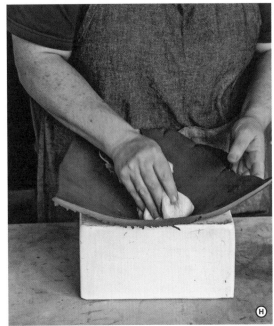

SLUMP MOLDS

The slump mold is the opposite of a drape mold: It's a shallow concave form that clay is laid into. As with drape molds, attaching clay to the surface of a concave plaster mold is relatively easy. Ⓖ Instead of my fingers, I often use a tamping tool, or a bag of sand, to apply pressure to the clay and create a uniform surface without leaving fingerprints. Ⓗ For a project built using a slump mold, see page 135.

One big advantage of the slump mold is that there is less worrying about shrinkage. Since the clay is shrinking inside of—rather than around—a supported form, there's generally no cracking. You can also build with different techniques inside a slump mold. For example, why not let a slump mold support a coiled pot?

CASTING

Casting molds out of plaster is a great way to learn about molds and forms, and if you take a mold-making class, you are sure to leave with some useful new tools. However, slip casting is not easy. It requires many design considerations and is technically challenging. If you are interested in slip casting, try press molds first so that you can test design ideas in a low-tech way. Then read up on slip casting and maybe take a class dedicated to the process. Keep in mind that making plaster molds is tricky in a shared studio, because plaster and clay don't mix. This is why I'd rather create bisque molds for most projects, especially if I'm still working out the ideas.

Kate Maury | Using Molds

How did you get your start in clay?

I took classes at the University of Iowa, where Clary Illian was replacing a professor on sabbatical. I was learning to throw on the wheel and wanted a more thorough understanding of utilitarian wares. Clary recommended the Kansas City Art Institute for the structured program I was looking for. I applied to that program and began to work with Ken Ferguson, Victor Babu, and George Timock. Everything about it was demanding. You had to be dedicated due to how challenging it was on many levels. I called it the boot camp of clay programs, but upon completing the degree, you were well prepared for any graduate program.

How does your current body of work use molds?

I repurpose hobby craft molds, traditionally used in slip casting, as press molds for sprig making. Using parts of a mold that has high relief allows me to quickly press a variety of textured shapes when constructing small forms or embellishing surfaces on larger hand-built pieces. I love the repetition of a motif, visual rhythms on a form, and textural elements built through sprig application. A dynamic language between form and surface can easily be attained, and sprig application promotes visual density, patterning with a multitude of textures.

I often press and shape dozens of sprigs and store them in damp boxes until the moment I assemble them to make or decorate a piece. Due to the number of damp shapes stored, I can easily improvise with repeated patterns, curvilinear movement that contours a form, or dimensional motifs on a surface.

How did you get started down this path?

When I decided to change from wheel throwing to hand building, a friend from a local clay company offered me access to its hobby/craft plaster molds. I simply reacted and improvised with these

Sororal Twins. Kate Maury. Slab, cast, and prig.

molds and found a much-needed new avenue in approaching my work. I would find myself chuckling a lot at the beginning, realizing that a mold of Santa's beard gives some great sprigs in forming candle parts. It was comedic in a way.

Once my new work was exhibited, people started dropping molds off at my studio. Part of this new working method was saying yes to change and responding to what I was given. My donated molds are now stacked so high I rarely make my own.

What are some of your best practices or tips for working with molds?

Don't look at a mold as simply the object it can make when cast but for its potential for textures, patterns, and shapes. Curvilinear sprigs can be strategically placed on forms to promote

Dessert Plates. Kate Maury. Slab and sprig.

Candy Bowl. Kate Maury. Slab and sprig.

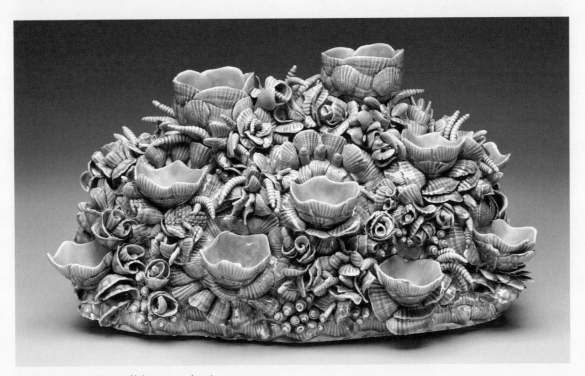

Truffle Bush. Kate Maury. Slab, cast, and sprig.

movement. Patterned sprigs can establish static patterns as well as a foreground and background on surfaces.

Hunt for molds with high or medium relief and dynamic curves or textures. These are the best for visual impact as they create lively surfaces and can be manipulated without losing definition.

High-relief sprigs look better than low-relief sprigs when glazed, and pooling glazes are simply stunning.

As far as application goes, be aware of the thickness of sprigs, how pliable they are, and trim them with an X-ACTO blade so they don't look like a cookie cutout. I recommend keeping a number of

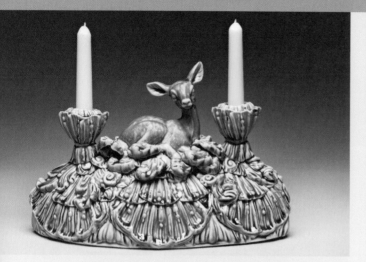

Meadow Hill. Kate Maury. Slab, cast, and sprig.

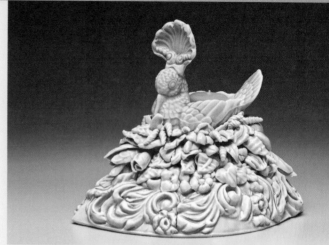

Crowned Bird. Kate Maury. Slab and sprig.

"humidors," or damp boxes, for your sprigs as well! Mine are plastic containers with snap lids with a dampened slab of cast plaster in the bottom. I find this is the best way to store sprigs for future use.

What important lessons have you learned in your process?

Say yes to change! Accept that the unknown is a good place to be when making. Revel in it. If you always have an idea of outcome and accept only narrow parameters of what is "good" or "bad," the making process will be a horrid experience. Know your craft, but follow the fun. If I'm not enjoying the process, I know it's time to change the process.

John Gill once recommended that I ask an open-ended question while working so the investigation would continue without judgment. It took me years to finally understand how to apply this basic concept to my art-making practice.

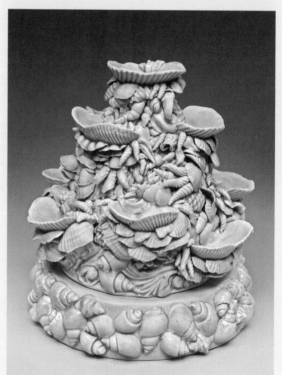

Oyster Server. Kate Maury. Slab and sprig.

 All photos courtesy of the artist.

SLUMP-MOLD PLATE

Plates are wonderful objects for the exploration of surface and subtle variations of form. The first of the two plate projects in this chapter is a sandwich-size plate. I just love these smaller plates. They're fun to make and very useful to have in the cabinet! Even when making small plates, it's important to remember that clay has a memory. You need to continually tell your clay that it's a plate and not a slab.

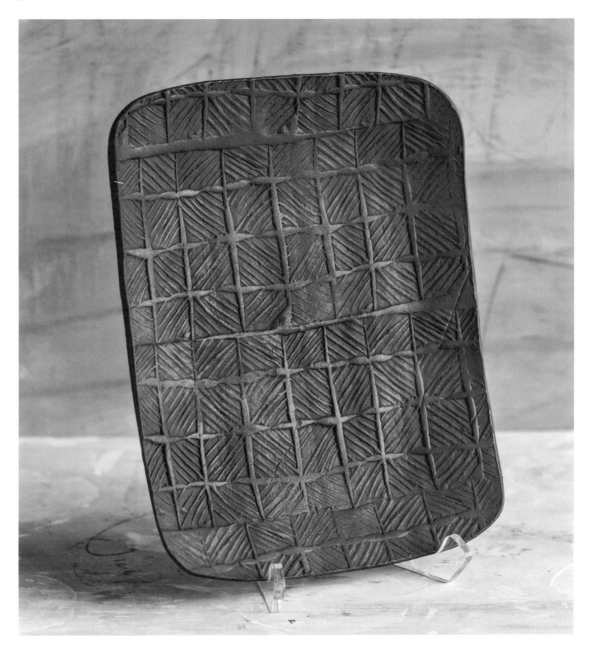

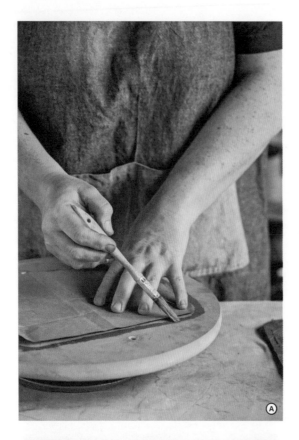

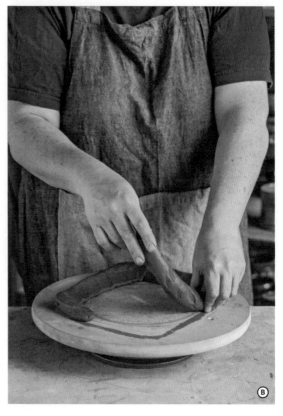

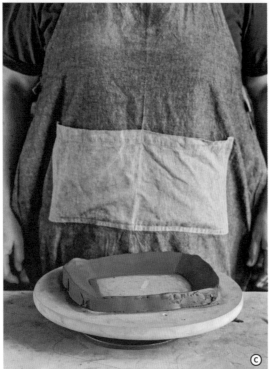

TOOLS AND MATERIALS

2–3 pounds of clay, prepared as follows:

 Slab: 9 x 9 x ¼ inches, for plate

Extra clay for coil

Template (page 198)

Basic toolkit (page 23)

Texture tools/roulettes (optional)

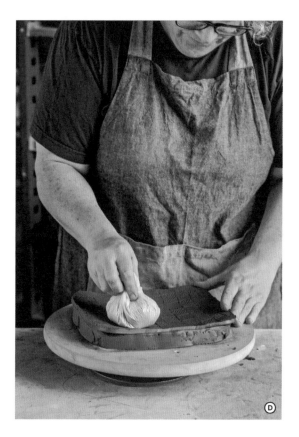

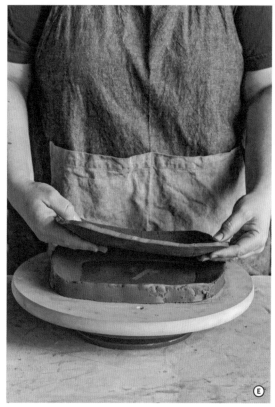

Prepare your slab, applying texture to one side (which will most likely be the top) if desired. Using your template, cut out the shape of your plate. Stay on the safe side, and cut the plate slightly larger than the template.

Roll out a coil that's about 1½ inches thick. It needs to be long enough to completely encircle the rim of the plate. Place it on a ware board, using the template to guide the shape. Another way to do this is to outline your template on the ware board in water. Ⓐ Ⓑ

The coil will eventually serve as a slump mold for the plate, so use your palm and work the coil downward on the board until the clay has a slight taper toward the middle. Give yourself at least three passes to refine the angle. Use a rib to finish setting the angle before moving on. Ⓒ

Gently lift the clay slab and drape it over the slump mold on the ware board. Use a tamping

tool, such as a sock with sand in it, or rib the slab to gently shape the plate. I recommend gently patting the clay with the sand-filled sock because this will maintain the texture of your surface instead of erase it the way a rib will. Ⓓ Be careful to maintain the desired shape. Let the plate set up to leather hard before continuing.

Once your plate is leather hard and won't lose its shape when handled, remove the plate from the slump mold. Ⓔ Supporting the plate with one hand, use a sur-form to remove any sharp edges. Use a rib or a similar tool to refine the curve on the bottom side of the plate. Make sure the lip is rounded a bit as well. I finish the lip at this point, leaving the foot for last.

To add a foot, start by flipping the plate over onto a piece of soft foam or another surface that will provide gentle support. Lightly draw the shape of the foot on the bottom of the plate. You can use

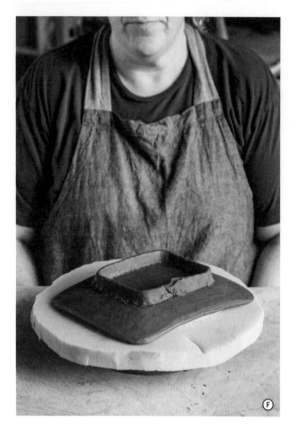

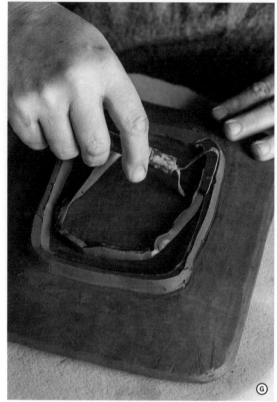

a template or a freehand sketch for this. Once you have the foot drawn, make a coil that will fit around the entire circumference of the foot. The size of the coil should be appropriate for the size or your plate: Larger plates will need a larger, and often thicker. coil. (A foot on an object is not only for physical support but also for visual balance.) Score both the bottom of the plate and the coil. Wet the coil, and attach it to the plate. Holding the coil, start at one end and pinch the coil onto the bottom of the plate. Continue to attach the coil around the plate, then score and attach the ends of the coils where they meet. ⒡ Now clean up the seam, inside and out, and shape the foot. Use a sharp knife or cheese cutter to cut the foot to an even height, then use a chamois or a sponge to make a nice smooth foot. ⒢ If you wet the foot with a damp sponge or chamois, keep in mind that it will need additional time to set up. Before you turn the plate over, wait until the foot is firm enough to avoid becoming deformed or marked. Once you rest the plate on its foot, double check the balance of the plate and levelness of the foot. Adjust as needed.

DRAPE-MOLD PLATE

There is a spontaneous and subtly casual feel to a slab plate. That said, I think it's a project that teaches how sometimes the simplest things are quite difficult to master. When you work on this project, shape is important. You'll find shaping will be more intuitive as the plate becomes more refined. Consider the lift of the plate off the table as well as the thickness and sturdiness of the slab. Understanding these factors will contribute to the success of this plate. My other advice is to make several of these plates. Working in repetition with an intuitive form will help you begin to envision better solutions.

TOOLS AND MATERIALS

3–4 pounds of clay, prepared as follows:
 Slab 1: 12 x 12 x ¼ inches, for wall
Template (page 198)
Basic toolkit (page 23)

INSTRUCTIONS

Create a temporary paper mold as discussed on page 130. The goal for this project is an 8- to 11-inch plate, so although the mold is larger taller than needed here, the eventual depth will be just an inch or so. We're making a plate, not a bowl.

Prepare the slab for the plate. Apply texture to one side (which will most likely be the top) if desired. Using your mold as a guide, cut out a slab that will fit over the mold, leaving some extra clay all around. Drape the slab over the mold. Depending on the mold shape and the size of your slab, you may need to trim the slab further. Don't let the clay rest on the tabletop! Cut it just slightly larger than the desired shape of the plate. Rib or paddle the shape gently over the form to compress the clay, and then let it set up until leather hard. Ⓐ

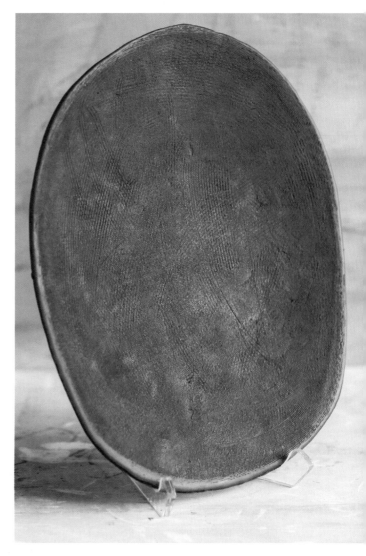

Before finishing the bottom of the plate, you may need to remove marks left by the newspaper. I rib the inside and outside to remove such marks—a serrated rib followed by a rib can also work if there are deep grooves. ⓑ I also use a rib on the lip.

To finish your plate like this one, which does not have any clay added for a foot, flip the plate over and determine how it will sit. Gently scrape the plate on a rough tabletop or floor. This should give you a good indication of where the plate already hits the table. ⓒ Flip the plate, support the plate from the underside (top) inside with one hand, and paddle around the scrape mark to increase the surface area where the plate will touch the table—I'd recommend a footprint of about ⅓ the diameter of your plate. You can also use a sur-form tool if you need to remove more clay. Just be careful not to remove too much at once. Instead, repeat this process until there is a large enough footprint on the plate. At that point, rib away any marks left by the sur-form.

Let the plate dry slowly on its foot, lightly draped with plastic. Check it as it dries to make sure it's not warping and that your footprint remains consistent in size.

GALLERY

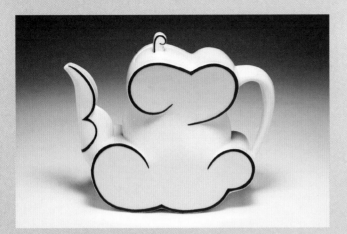

Cloud Teapot. Sam Chung. Slab construction with templates. *Photo courtesy of the artist.*

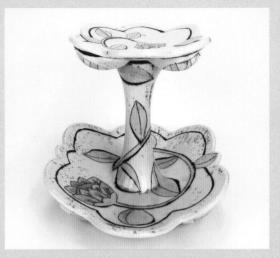

Tiered Server. Chandra DeBuse. Slab construction. *Photo courtesy of the artist.*

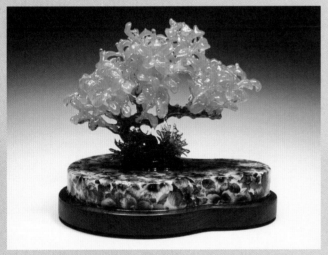

Bon Mot. Rain Harris. Press-molded slab. *Photo courtesy of the artist.*

Selling Copy. Chris Dufala. Hand-built with press-molded and extruded elements. *Photo courtesy of the artist.*

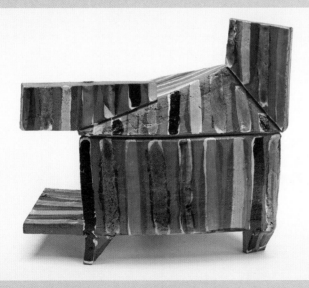

Lidded Box. Mike Helke. Hard-slab construction. *Photo courtesy of the artist.*

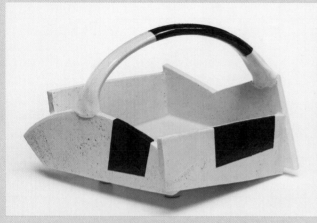

Tray, Lidded Box. Mike Helke. Hard-slab construction. *Photo courtesy of the artist.*

Nesting Bowl Set. Joe Pintz. Slab construction with bisque molds. *Photo courtesy of the artist.*

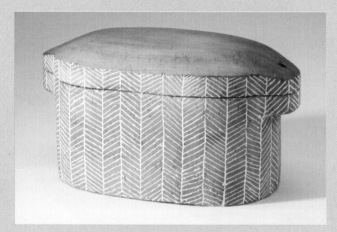

Chevron Box. Joe Pintz. Hand-built earthenware with terra sigillata. *Photo courtesy of the artist.*

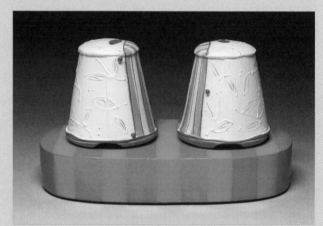

Floral Salt & Pepper Set with Brick. Liz Slot Summerfield. Slab construction. *Photo courtesy of the artist.*

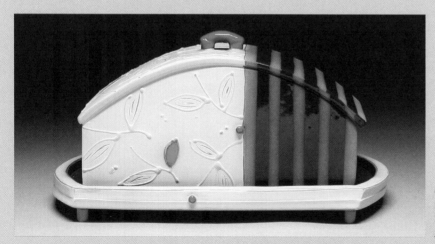

Floral Butter Dish.
Liz Slot Summerfield.
Slab construction.
Photo courtesy of the artist.

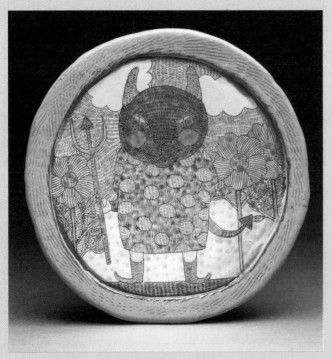

Devil Cat, Small Plate. Shoko Teruyama. Slab construction.
Photo courtesy of the artist.

Iron Jar. Holly Walker. Coil and slab construction.
Photo courtesy of the artist.

Palette Color. Holly Walker. Coil and slab construction.
Photo courtesy of the artist.

Anamorphosis. Anne Currier. Slab construction.
Photo courtesy of the artist.

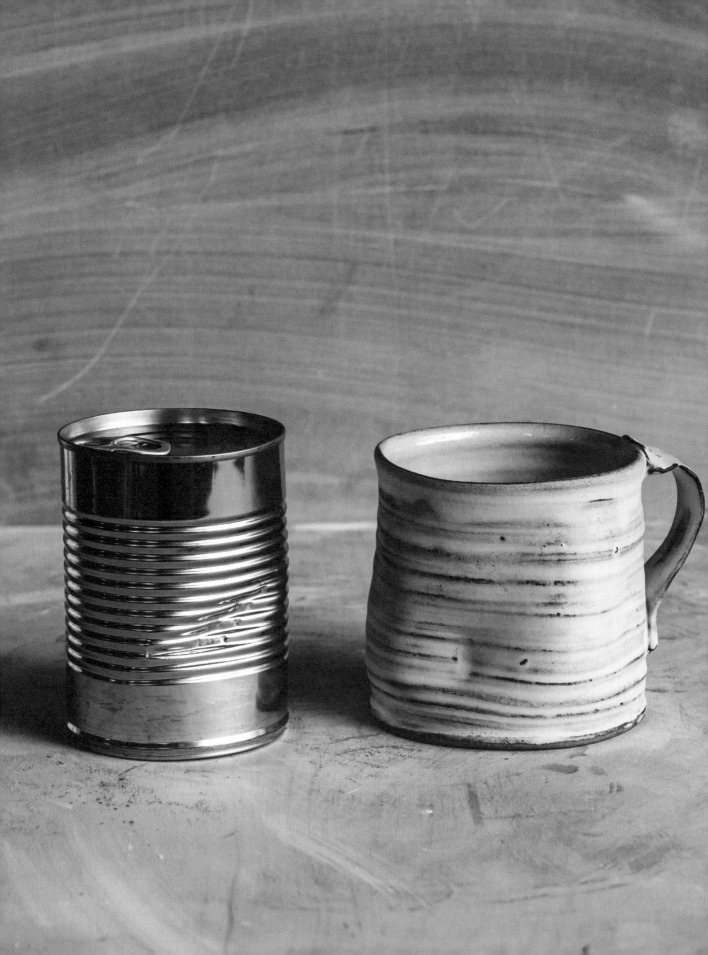

5 DEVELOPING CONTENT

FOR BEGINNERS, or even intermediate potters, it's normal to spend a lot of time developing physical skills and pushing content to the back burner. Part of the likely reason is that there are so many new physical skills to develop with ceramics. It's easy to stay busy in the studio! Yet glossing over content often happens for another reason: many potters simply don't know where to begin.

I know some of you are thinking, "But I'm not skilled enough to think conceptually." I disagree! As with most skills, developing content requires practice. How much time you put in and how much you devote yourself to the practice will make a difference. Likewise, putting off conceptual work will eventually lead to an imbalance. Your making skills will outpace your skills in developing good content. This can cause greater discomfort, as you may feel more inadequate about thinking conceptually.

Learning to navigate this conceptual space and develop ideas you can verbalize is another part of your toolkit as an artist. It will make for a more fulfilling ceramic journey that satisfies and challenges you beyond the physical skills of building. Making original work instead of copying something out of a book or a picture online is an amazing feeling. A form that expresses your vision and that you have developed a relationship with is the ultimate goal of a creative exploration. So start small, and be brave. Nobody starts out with the greatest idea in the world. We all stumble.

One of my favorite mantras is "progress over perfection." Keep that in mind as you read this chapter—and, please, do not skip it!

STARTING YOUR JOURNEY WITH CONTENT

In our culture we tend to make art seem far removed from daily life. Some people believe you need a special degree to understand art! It's true that after years of education and countless trips to museums I can recall many times when I was fascinated, repulsed, or spiritually moved by art. Yet chances are that even if you've never been to art school and you went to a museum for the first time today, you would be moved by a piece of art in the same way. How can this be?

My theory is that successful art can grab you by the heart (or brain . . . whatever you want to call it!) because it communicates with you. You may like or dislike the message, but you are connecting with that piece of art. Unsuccessful art, on the other hand, is art you can walk right by. The maker has failed to connect with the viewer.

When you're a ceramic artist, the *content* of your work is what's ultimately responsible for this connection—or lack thereof—with your audience. Just as you develop the techniques and skills in the other chapters of this book, I believe that, as a maker, you must also think about the objects you will create. This chapter contains ideas for exploring this concept, and they will no doubt lead you down many different paths. I have found it's impossible to force an agenda when it comes to content. So grab your notebook, and read on! Take the first few steps on your journey with content.

FIND INSPIRATION

When starting out with content, there is no one-size-fits-all solution. You need to pick and choose what's interesting to you, then determine how it might relate to your work. This type of inspiration can be easy or hard to find from day to day. The amount of inspiration in the world can seem overwhelming at times, yet there are also days when it seems as though nothing inspires you.

So the first step is to pay attention. Ask yourself some meaningful questions: What am I drawn to? What are my favorite hobbies? What type of art do I connect to? What are my politics? What are my values? If you are already passionate about something in particular, you can follow these threads of interest. Share your thoughts and talk with friends about what you learned. Write about it in your sketchbook.

What if nothing calls to you immediately? Don't worry: That is normal. One way to jump-start the process is by taking photos. Not so long ago, telling students to buy a camera and photograph what caught their eye was a somewhat radical idea. Now we all have phones that double as cameras! Start using your phone (or a camera) to capture objects that speak to you as you go about your day. Build an image bank of inspiration! Create folders for different types of images or print and organize them in a variety of ways. The simple act of noticing what speaks to you is a wonderful place to start. From there, it's not such a big leap to narrow down your sources of inspiration and choose something you want to reflect in your work.

I still do this as part of my creative practice. If over the course of a few months I find that I have twenty-five to fifty similar photos, I start to dive deeper into the form or the surface that's captivating me. Why am I drawn to that object? What emotion does it evoke? By considering the objects in this way I can develop themes that interest me, which is a starting point for new content in my work.

How do you translate this inspiration to your own work? That is something I cannot answer for you! The answer depends on your imagination.

When I look back through my photos and find I have developed a small obsession for a form or surface (left), eventually there will be a subtle relationship to my work (right).

There are loads of forms that interest me. Boxcars and lunchboxes become inspiration for lidded jars and boxes.

If you struggle with inspiration for handles, start looking around: they are everywhere!

Paying attention to surfaces is an essential part developing your own glaze and surface treatments. Finding something that lights a spark for you, whether it's a color or texture, can help you set a clear goal for your work.

Throughout the year, my forms are inspired by the changing seasons. Summertime calls for tea tumblers and ice cream bowls, winter means casserole dishes and mugs, and I greet spring with bud vases.

You will have to work like an interpreter, compiling information from the world and then filtering it in your own language. Concentrate on this role as a communicator. There is the literal translation of your inspiration. For example, if you are interested in shovels, make a shovel. This sounds easy, but it is often not as simple as it seems. Then there's the not-so-literal translation of compiling images and then defining what it is about the objects in them that compels you. This can be a feeling or a look. You will often need to do a bit of work to define what the connections are as well as incorporate them into your own work. Attempt both ways of working: One may feel more comfortable or more challenging. Keep in mind that the way to the core of an idea is through the exploration of it. Your first attempt will probably fail. Try again!

See pages 147 and 148 for a few examples of how inspirational photos have been translated into my work.

SET YOUR INTENTION

Just as important as finding inspiration is setting your intention. I first heard this in a ceramic workshop with Doug Casebeer, though if you are into yoga, this may sound familiar: To set an intention is to set yourself up to act to make that intention happen.

The important part here is to set an intention with clarity. It's all too easy to start with too large a concept, which will get you nowhere fast. For example, "I want to make work about the environment." Okay, but which environment? The environment of your childhood? Or the rainforest? How do you make work about the rainforest? These are huge concepts with no actionable intention or goal.

Note: *A simple way to get started is to pick three words that you want your work to embody. This will take some time and maybe even require journaling a few pages of words that mean something to you. Once you have narrowed down to the three best words, post these words someplace in your studio where you will see them every time you work. Read them, think about them, and make your work. Don't try to make the words! Instead let your understanding of the concepts behind the words be a part of your mindful making.*

If I had you and your work in front of me, I would ask you to get more specific. How does your topic or theme relate to you? What do you want me, the viewer, to understand about the work (without reading an artist's statement)? What is the emotional content you connect to? Are you connecting with your audience with the same emotional content? Is the work evoking the emotion you want?

Sometimes we can't answer these questions ourselves, especially if we have worked for days, months, or years on a body of work. Yet determining the underlying emotion or idea is the foundation on which you will build your work. (This is the clarity of the intention you will be searching for.) That brings us to the next stage, connecting to an audience and getting feedback.

CONNECT TO AN AUDIENCE/ GET HONEST FEEDBACK

I don't believe in making work for an audience. First and foremost you should be making work for you! That said, thinking of an audience comes in handy when you start to evaluate the effectiveness of your message. By that I mean: Do the people who encounter your work "get it" or not?

Note: *Often we, as makers, have a drive to share our work with and make a connection to an audience. In some cases, when the work you are developing is about changing people or trying to get people to think about a topic, it may be very important to define whom you believe your audience to be.*

(continued on page 154)

THE IMPORTANCE OF SKETCHING

Sketching doesn't come naturally to everyone. It doesn't help that there is little in this world as intimidating for an artist as an empty sketchbook! But feeling as though you don't have good ideas or having a book with pages upon pages of subpar sketches is something everyone goes through in the beginning. It's important to get going now so that, when you do come up with good ideas, you are in the habit of writing them down.

Even if making work gives me new ideas, I have found I often can't stop midway through a project to make a new form or to change the form to fit a new idea. In these moments, a sketchbook helps me to jot down the idea for future work so that I can focus on the project at hand. Without a sketchbook, those new ideas might just disappear!

Sketching is helpful for other reasons. Collaboration or getting advice from more experienced makers is much easier when you're used to sketching. When students tell me what they want to build, I can't see what's happening in their head. I usually need them to draw what they have in mind so that I can help them plan. Sketching is also a wonderful way to keep track of your own journey. I often look back at sketchbooks from years ago. When I flip through them, I can see a progress that I wasn't aware of in the moment.

I know many gifted illustrators who share their daily practice of sketching online. I will never be as skilled as they are! My notebooks aren't pretty at all—that is no longer my goal. They are filled with everyday notes about things I need to get done, quick sketches of forms I want to revisit, or even notes from a lecture I attended. I date my pages and entries, and keep my current notebook in my bag. That way if I find myself with empty time, I can write down a thought or doodle (I am a huge doodler!).

This is never what I imagined my notebooks would be filled with when I started keeping them. I imagined something more glamorous. Yet I consider my notebooks a success since they don't sit empty, and they are useful to my work. In short: Find what works for you! Make it fun, and make it a habit. Don't be intimidated by the empty pages; fill them up.

Peter Christian Johnson
Computer Modeling

How did you get your start in clay?

I was a science major who stumbled into art toward the end of my education. I was excited by the challenge of learning the wheel, and I was drawn to the quantifiable nature of skill development. Is it taller? Is it thinner? Is the curve better? Is the foot cleaner? This structure and focus on technique appealed to my science background and experience in construction. Of course I soon learned that skill development can get you only so far.

What types of objects are you drawn to making and why?

Over the last ten years I have focused more on architectural and industrial forms. The why is an important part and something I am constantly trying to better understand. One simple answer is that it is what I know. As a kid I wasn't interested in art any more than the average child, but I did watch my father build things with his hands, including our home. Eventually, in my early teens, I began working for his small construction company. The more complicated answer is that I am interested in industrial and architectural forms because they are clearly human endeavors or manmade objects. Therefore they have the ability to talk about the human experience or human potential. Through weathering, slumping, or collapsing these forms, I am then able to allude to our own finiteness, our failure, and, hopefully, ultimately the beauty in brokenness.

What is your process for developing a new piece? How much planning and staging is required and how do you use computer modeling?

I do a decent amount of planning these days. In the case of my recent body of work that references Gothic cathedrals, I spent a good amount of time finding historic blueprints, researching how the

Extruded Parts Ready for Assembly. Peter Christian Johnson. I usually spend a full day extruding parts. I keep them in a plastic container with 1 inch of plaster that has been saturated with water, which keeps them leather hard for months.

original buildings were constructed, understanding the symbolism of each area within the building, and learning how many generations were required to complete the task of construction. I then used the computer to model abstracted versions of the cathedrals I was most drawn to, using the historic blueprints as a reference. It was important to me that I didn't create a miniature version of the original but, instead, created a sculpture that referenced its source. The computer-modeling process provides a number of advantages to my process. For one, it allows me to troubleshoot how I will actually build the sculpture. I try to model it on the computer in a way that approximates how I might build it in my studio, and usually this leads to exposing problems I need to solve in order to make it in clay. Second, the computer allows me to rotate the model in virtual space,

Parts for Construction. Peter Christian Johnson. Small vertical sections; each piece is attached with a small amount of stick-up slip.

Using Blueprint to Build. Peter Christian Johnson. This illustrates how I build from the blueprint.

allowing me to better critique its formal properties, judging the sculpture's potential before I begin to build it. Last, it allows me to measure elements within my model and to print paper blueprints that aid in the construction process.

Could you address how you build your forms from many pieces?

I have been extruding the components of my sculptures and have made a number of dies to aid in the process. I was pretty skeptical about art made with an extruder and had to talk myself into using it. (In the 1990s pottery magazines were filled with bad extruded art.) In the end it is just another tool that can be used in a variety of ways. As a general rule I think you don't want your audience to think about how the thing was made. If people look at particular work and think, "Oh, those parts are extruded," then you have created a distraction. I use an extruder because it is the fastest and most effective way to make the parts I need. My recent pieces are made of three thousand to four thousand pieces, and I can't think of another way of making the components more efficiently. But again, if you are thinking about the extruder when you are looking at my work, then I am probably doing something wrong.

All photos courtesy of the artist.

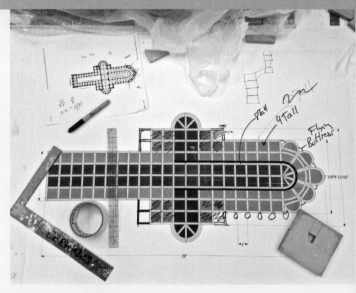

Preparing Blueprint. Peter Christian Johnson. This is the planning stage; before building I review the blueprint, looking for adjustments that may be necessary.

Leather Hard on Blueprint. Peter Christian Johnson. This illustrates building on blueprint. I create a blueprint from my computer model and use it as a map to lay my first few courses of extrusions.

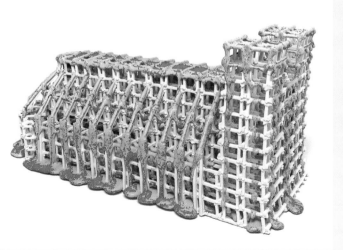

Preludes, from *Poise* exhibition. Peter Christian Johnson. Extruded and assembled parts using blueprints from a 3-D model.

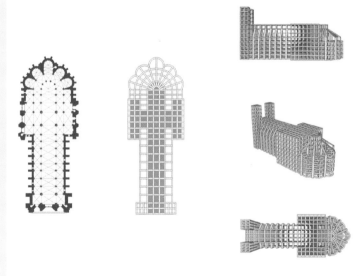

Reims Blueprint. Peter Christian Johnson. Laser-printed blueprint for exhibition. Sometimes I exhibit blueprints with the sculptures.

Getting feedback can be a tough process. First, I would suggest you start by being a strong critic of your own work. I don't mean you should tear yourself and your work down or create roadblocks that hinder your progress. (I have seen too many people who confuse criticism with perfectionism. They are the people who build something that everyone around them loves while they themselves see only every flaw and destroy a piece before it is even completed.) There is a fine line between being objectively critical and critically self-defeating. Don't trash everything you make because it isn't good enough! You are building your skills. If you never work through the whole process, you will never grow and develop those very important finishing skills. Pay attention to what you are learning with each new form or process, and be honest about its success relative to your skills.

Next find a few people who will tell you the truth. Often when we work in a community studio we are surrounded by fellow potters. It may be tempting to ask them what they think, but the truth is that their feedback is often not critical or objective enough to help you move forward. Instead find people whom you trust to be honest—you should respect them and know that they have a critical eye and can be objective.

It is important to pursue this step only once you are ready for critical feedback. Sometimes the truth can hurt, especially when work that you have put your heart into is being critiqued. You must be ready to hear someone else's opinion. Try to put on a different, more objective, hat when discussing your work. Step away from being the maker, and don't be immediately defensive. Practice listening, taking notes, and collecting your thoughts. Then practice talking about your work.

STAY MOTIVATED

Motivation is very personal. When my obsession with clay started, I scheduled my clay classes first thing in the morning. I knew myself well enough to know history or statistics wouldn't have made me want to get out of bed. Playing with clay was literally my motivation for waking up each day during my college years. Yet as time goes on, ceramics is like anything else: I have to make getting to the studio a priority.

If you begin to struggle with getting to the studio or being motivated to make work, an honest conversation could be in order. What is keeping you away? Sometimes we have legitimate reasons: health, family, or work. Don't beat yourself up! I had a mentor comment once that time outside the studio is sometimes more important than time inside the studio. How we feed our creativity, restore our energy, and honor the things that are important to us allows us to return to the studio fresh and renewed. If it's the middle of the month and you haven't been to the studio yet, it's okay! Find other ways to act on your creative impulses instead. Pick up that sketchbook, write down your thoughts, make lists of ideas, etc. When you get back to the studio you will have a place to start!

When you don't know where to start, it's all too easy to wander around the studio, talk to people, and avoid working. One trick I learned is to develop a few studio rituals. (After an absence, the first thing I do is weigh out a bag of 1-pound balls of clay, then I sit down and throw mugs.) What is great about this is threefold. First, it gets mugs made! Second, it gets me back into the rhythm of the studio because I will need to address the feet and handles of those mugs. Those are built-in reasons to return to the studio the next day. There's work to do! Third, making mugs lets my mind wander. As I am sitting at the wheel throwing cylinders, I start to think about what I want to do next. I find myself making a list of the objects I'll make after the mugs.

Investigate some rituals of your own! What do you make that is fun? What is your meditative object? What will get you started?

MY JOURNEY WITH CONTENT

Some might argue that there is nothing new under the sun. Some days I agree with that statement, and other days I don't. But I will say that the idea was comforting as I began to develop my own content.

When I started out in ceramics, I would make a mug, bowl, or a casserole dish. Those objects had use beyond my agenda or ego; it was not important to know my motivations in those days. I was busy skill building and almost belligerent about the importance of being connected to the handmade. Making pots was a rebellious act for me.

Remember, I didn't want to be an artist with a capital *A*. I wanted to be a potter with a lowercase *p* (which at the time was *very* different from an "Artist" to me). I was surrounded by other makers in a community studio, looking at ceramics magazines and going to galleries that sold functional work. Over time my quest as a maker began to change. For example, I started paying attention to the various decisions potters made in their work. What solutions did they have to the various questions that, say, a mug posed? I started to wonder how to make a

mug that was more *me* rather than a mug that was a poor imitation of a mug made by someone else. The act of collecting pots, then using those handmade creations, also played a role in my development. I started to pay attention to the details of a piece and began to form my own ideas about function and content. This in turn affected my studio practice—I began striving to make mugs that communicated more than the need to hold coffee.

Definitions change and grow with our development and understanding. Today I am comfortable with any type of label, be it "potter" or "artist," because I understand my motivations. The labels don't matter as much as my desire to make. Some of that may sound silly or not make sense at all, but what I am trying to say is that the path to content is circuitous. There is no guarantee that if you do A, then B will naturally follow. I believe striving to develop content is striving to make your work uniquely your own. And that is why it is so important. The result of the journey, wherever it leads, will help you find your voice.

AVOID STUMBLING BLOCKS

All this talk of content is often lost on someone deep in the skill-building part of their journey. It was lost on me for years during my development. But I always had the desire to make better work. So take heart! While I push people to start thinking of content early, it may not make sense for you yet. And that is okay. I have discovered the road to satisfying content is long and winding. When you reach the point

of desiring more from your work, remember that developing content may be the next skill you should work on. That said, it's entirely possible you're ready to work on content but you've hit another stumbling block. Here are three common barriers:

The desire to make: You may recognize the saying "my hands are itchy" as something makers say

STORYTELLING AND EMOTIONAL CONTENT

All content development involves some amount of exposing a vulnerable side of ourselves as humans and as makers. Yet nothing exposes the maker as much as telling his or her own story.

Once you start putting your own narrative into your work, it goes out into the world and invites comment. If you are not ready to discuss and explore these vulnerabilities, be careful. This step has the potential to be incredibly disheartening and ultimately damaging to your content development.

However, if you are ready and can take a small step away from your emotional connection to the content, developing your narrative can be extremely powerful and create new connections between your work and your audience. This is because there is great power in vulnerability.

If you're ready to explore those feelings—and ways people can misinterpret your story—start small. Find one or two people whom you trust as you start to explore this process, and use them as sounding boards. Let them help you develop your ability as a narrator. Be honest with yourself and your emotional health. It is also perfectly acceptable to make work that you never share with an audience. Sometimes the meaning it has for you alone is enough.

when their hands have been idle too long. Something about the physical process of making is so seductive to some of us that it makes it nearly impossible to spend time away from our making and dedicate time to the cerebral work of developing content. Remember, though, at some point you should devote time to thinking about your work because it will enrich the time you spend making it.

Being overly critical: Your inner critic may tell you that what you are thinking is dumb. This happens to everyone. So when you catch yourself disregarding an idea for no other reason than self-doubt, stop yourself! If you are passionate about cats, lemons, or clowns, so be it. Follow your passion! Although art may never be your job, you are nevertheless giving it your time and that is valuable. Your practice should be filled with the experimentations that will inspire you and enrich your studio time. Don't dismiss the subjects that excite you; investigate them. You never know where that investigation might lead.

Not acting on an idea: Maybe you think an idea is not bad but that it's not fully formed. Or maybe you have a great idea but think you don't have the skills yet to pull it off. If this sounds like something you're doing, keep in mind that your idea is not the last one you will ever have. Maybe it will work, and maybe it won't, but at some point you need to try it. In fact, the act of attempting to execute an idea is often a great source of further inspiration. Taking an abstract idea and turning it into a three-dimensional object is a difficult step, but it's the only step that will truly bring you closer to your vision.

Zemer Peled | Content and Inspiration

How did you get your start in clay?

When I was twenty, I began going to art therapy, and the therapist was using clay, among other materials, in the sessions. This is what sparked my interest in the material, and after that I started to take evening classes. A year later I applied and went to Bezalel Academy of Arts and Design in Jerusalem. Working with clay has saved my life.

What led you to discover the method of building you use?

I was researching ways to create different textures in clay and looking specifically for a way to contrast the softness of the clay with the sharpness of form. Some of this inspiration came from the softness of feathers and the flowing waves of fabric. I spent a long time exploring, experimenting, and playing around in the studio. I was interested in creating textures that I had not seen before and yet something that was very natural.

What is your process for developing a new body of work?

The process usually starts with the clay and not knowing the end result. Experimentation plays a huge role in the development of my work and how I find new forms, colors, and so on. Inspiration comes while playing with the material and discovering new ways of working. Suddenly I'll just see something, and that moment inspires a new body of work.

Do you research or sketch?

It depends on the project. Typically I don't sketch, but I do research things that inspire me. For example, if a piece is inspired by nature, I will go out and observe the object firsthand. Recently the Joshua tree has been a large inspiration, so I have made several trips to Joshua Tree National Park to see

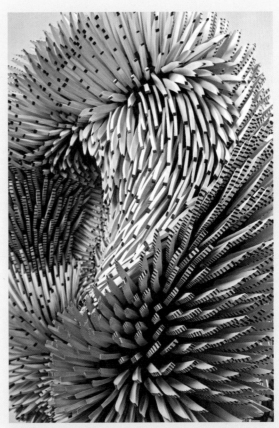

Under the Arch. Zemer Peled. Assembled.

the tree up close and to experience its surroundings. Other pieces have been inspired by historic ceramic collections, one example being Japanese blue and white porcelain. For the last project I did, I took inspiration directly from my surroundings, which in that case were the tropical colors and textures of Hawaii. Certain pieces are site-specific, and for that I don't sketch or research. Instead I take the pieces that I have made in the studio, then go into the space, where I can be spontaneous with the installation. I enjoy working with the space and the lighting to create a unique experience that can't be replicated.

What important lessons have you learned in your process?

The most important lesson I've learned is to keep playing: discoveries with clay come through games, play, and experimentation.

What is your favorite thing about the method you use?

I love breaking the shards—it's the liberating act of the breaking and the reassembly that is very beautiful. It is like a kind of dance to put the pieces back together, with all of the broken parts coming together to create something whole.

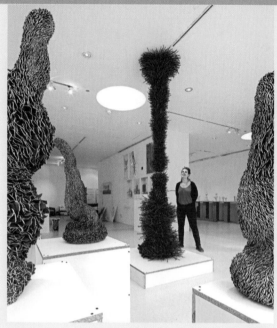

I am walking in a forest of shards. Zemer Peled. Assembled.

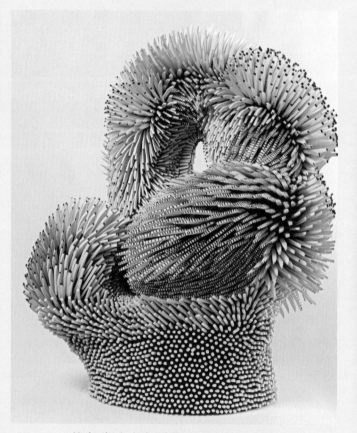

Under the Arch, detail. Zemer Peled. Assembled.

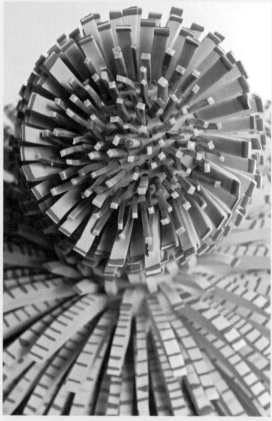

Untitled. Zemer Peled. Assembled.

All photos courtesy of the artist.

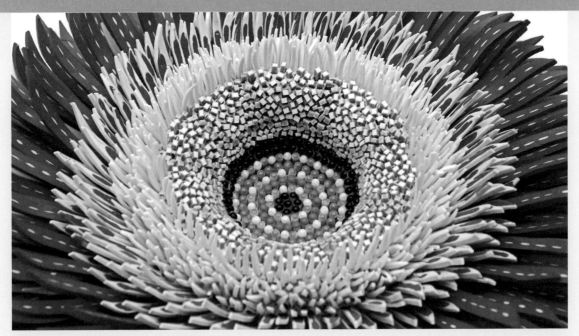

Bunch of Shards. Zemer Peled. Assembled.

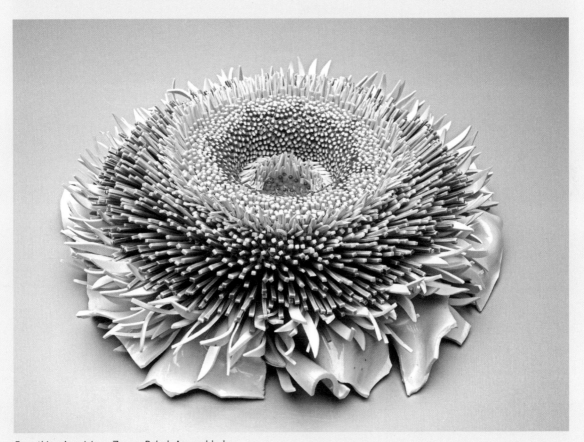

Everything Auspicious. Zemer Peled. Assembled.

GALLERY

Collection of Tableware. Ingrid Bathe. Coil and pinch construction. *Photo courtesy of Stacey Cramp Photography.*

Anamorphosis Diptych (Rust). Anne Currier. Slab construction. *Photo courtesy of the artist.*

Node, details. Nathan Craven. Extruded ceramic. *Photo courtesy of the artist.*

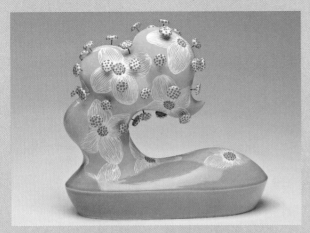

Her Labor. Erin Furimsky. Coil and sculpture.
Photo courtesy of the artist.

Teapot. Joe Pintz. Slab construction.
Photo courtesy of the artist.

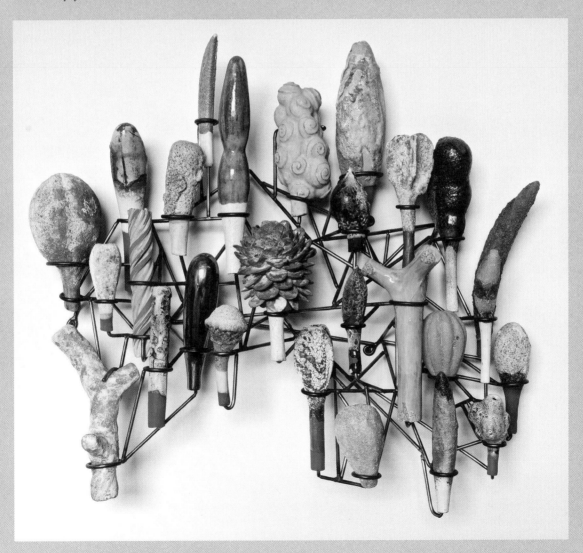

Panel Composition, Yellow Cluster. David Hicks.
Mixed media. *Photo courtesy of the artist.*

Tahu 2180; Revolt Series. Coil construction.
Photo courtesy of the artist.

LEFT: *Diver*. Kensuke Yamada. Coil and pinch construction.
Photo courtesy of the artist.

Spice Set with Tote.
Liz Slot Summerfield.
Slab construction.
Photo courtesy of the artist.

Follow. Alessandro Gallo. Hand-sculpted.
Photo courtesy of the artist.

Mother's Little Helper. Chris Dufala. Slab-built with press-molded and extruded elements. *Photo courtesy of the artist.*

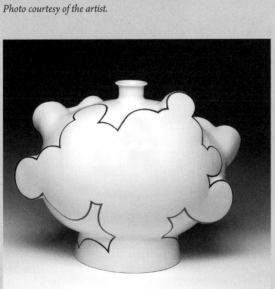

Cloud Bottle. Sam Chung. Wheel-thrown, cut and altered with slab construction. *Photo courtesy of the artist.*

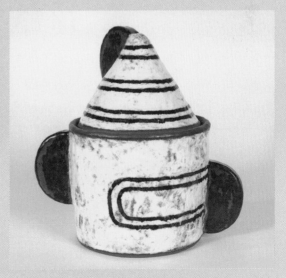

Circuit Jar. Holly Walker. Slab and coil construction. *Photo courtesy of the artist.*

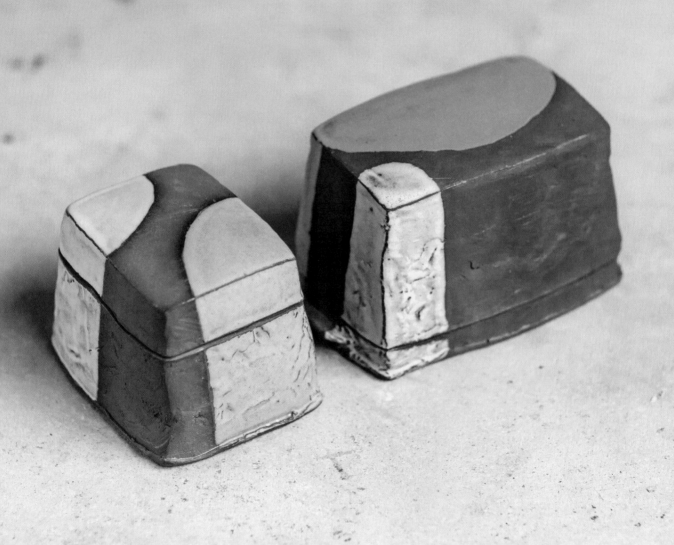

6 DECORATING AND FINISHING

WHEN YOU CONSIDER your favorite pieces by other ceramic artists, you'll realize that much of what you respond to in their work is related to their surface treatment and attention to detail when finishing. Despite this, many beginning potters devote little time to learning about finishing techniques compared with the time they spend creating forms. While such techniques can seem intimidating, lack of experience in this area will ultimately lead to ruined work.

Glazing may be the first thing that comes to mind when you think of decorating ceramics. But there are many ways to decorate your projects well before glazing, and they will help you build complexity in your surfaces. Since glazing techniques and recipes really deserve their own book (see page 203 for some recommendations), in this chapter I will cover my favorite non-glaze finishing techniques so that you can start to think about decoration as a process that can occur at many stages during your projects. We'll discuss adding texture to pots at the greenware stage and techniques like carving and stamping as well as ways to add depth with slip and underglaze.

Before we dive in, let me give you an example of how I decided to treat my own surfaces, as you see on the left and throughout the book. Believe it or not, I found my inspiration in a picture of a beat-up oil drum! That photo started my investigation into layering slips and clear glazes as well as saturated color glazes with post-firing distressing (in my case, with a sandblaster). While I'd like to say it all came together quickly, it actually took years of testing. So don't be discouraged if you're not immediately happy with your surfaces. Experiment, research, and see where that leads you. When all else fails, look to the world outside of clay for additional color and surface inspiration!

ADDING TEXTURE

Greenware decoration is all about adding interest to your piece before you're finished making it. Generally you'll be using various methods for building up surface complexity, either by adding elements or making marks on the clay (including not only impressions but also slip decoration or *mishima*-style decoration). The section that follows includes a few ideas for exploration, but know that there are whole books about surface decoration and many variations on these techniques. This should be merely the beginning of a long journey of skill building.

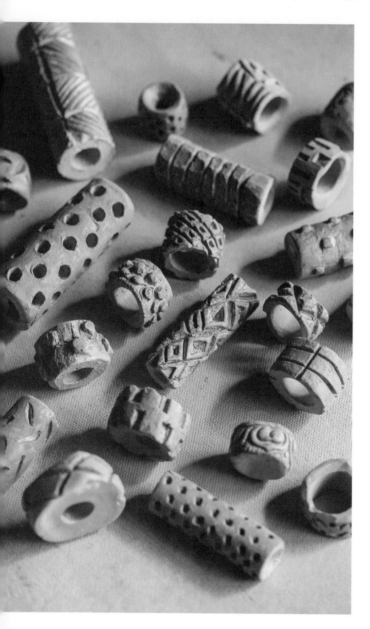

Texture is applied in so many ways that some of them may at first not be obvious. For example, texture development hinges on how you choose to build. Is your form pinched? Is it ribbed? Do you want the surface to be smooth or rough? Texture is an aesthetic choice that begins with the very nature of how you form and combine pieces. Developing the surface of clay objects is easy and a challenge at the same time: Clay is so soft and malleable that it will do what you want, so the difficult part is figuring out what you want in the first place. Ideally you should start with an idea about what you want the final product to look like. That said, you should also keep an open mind so your work can move in new directions!

Replicating an effect can also be a huge challenge. In my own work the surface I am interested in has been compared to a stucco effect. What I want are high points for the glaze to break over and low points for it to pool. I use red clay and bright glazes to help achieve this. The reason I coil build and rib is to develop the surface texture. Hard-slab building would not lend itself to creating that type of surface. Also, I am looking for a softer effect; if I am making a box, it is an interpretation of a box that is gentle and not rigid. Coil building and ribbing as well as the rhythm of my making are ways in which I work toward that effect. Now, after years of practice, it is something I do instinctually. My hands feel and my eyes see where I need more buildup of surface. But in the beginning it was a conscious effort.

STAMPS AND ROULETTES

A stamp can be an implement with a single motif on it, such as a store-bought stamp with the image of a flower, or a large surface of plaster carved with designs that you can roll a slab on. The idea is the same no matter the scale: you are making an impression in soft clay. Carving a stamp is as simple as using a tool to cut into leather-hard clay. I recommend tracing your image onto the clay first and then carving. Look for any rough spots or burrs that result from your carving, and remove them. Test the stamp by making impressions in soft clay. Ⓐ Refine the design as needed, then bisque fire the stamp.

Roulettes are great tools. A roulette is a wheel-like device with designs cut into the surface so that, when the device is rolled on soft clay, it leaves a repeating pattern. Think of it as a rolling stamp. Ⓑ Roulettes can be made from almost anything—I've seen wood and stone roulettes—but when you're working with clay, plaster and bisqueware roulettes make sense and work well. (Uncoated wood can work too, as long as the surface of the pattern will release the clay cleanly.) These materials draw moisture, so they will eventually become saturated and need to dry out. (You will begin to tear the clay with your stamps and roulettes if they are wet.)

When you wash your stamps and roulettes, let them dry for a full day before using them again. To clean them, rub them with a bit of sandpaper to eliminate excess clay buildup or try a dry brush to remove any clay dust from the crevices.

Making Roulettes

There are plenty of ready-made stamps and roulettes on the market these days. But making your own will give you the most personal design options—and often be much cheaper as well.

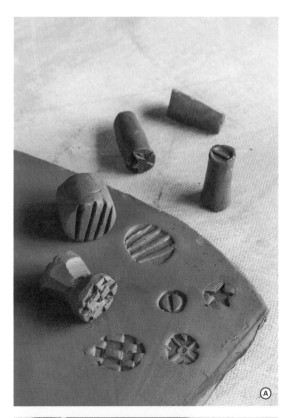

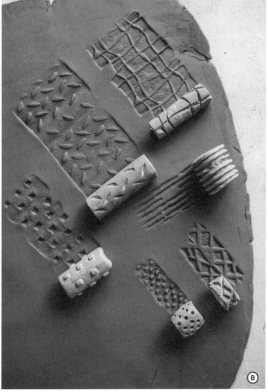

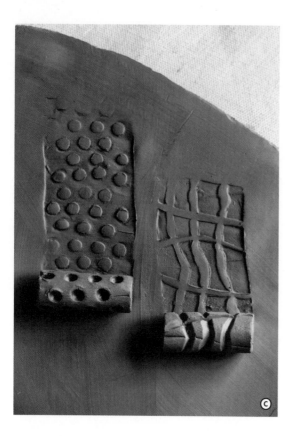

Use a drill bit or a dowel to hollow out the center of the coil and clean up any rough edges. This hollow center allows the roulettes to dry evenly and quickly. For the finger-size roulettes, it also allows for an easy grip as I roll (a place for my fingers to rest as I roll the roulette). Let the roulettes dry to leather hard before moving on.

Now the fun part: Carving various designs! Test your designs by rolling them on soft clay. Ⓒ Refine them as needed, then bisque fire them. If you make a mistake or hate the look of a roulette, discard it. Out of a batch of ten to twenty roulettes, I'll keep only three to five of them if I'm lucky.

Play with your interpretations of textures, repeating patterns or singular motifs. Try combinations with multiple roulettes and see how they work with your clay and with your slips or glazes. You will be surprised which patterns you keep, and hopefully you will elaborate on those when you make your next batch.

INSTRUCTIONS

Begin by rolling out a coil 1 to 1½ inches thick. Then cut it into segments roughly the width of your palm (3 to 4 inches) and/or the width of your finger (about 1 inch). I tend to make five to twenty roulettes in one sitting.

Note: I make two sizes of roulettes as described above. The reason for this is to make sure I am able to backstop while I am applying the texture. I use the palm-size roulette when pressing down on a slab. With the finger-width roulette, I'm backstopping my finger on the opposite side of the texture (finger-clay-roulette) so I can get a decent impression without warping the form (like a cup wall). Feel free to follow along and make these sizes, or experiment with other sizes.

CARVING

As I mentioned on page 45, *carving* is the word potters use to describe the process of removing bits clay from the surface of a form. Carving can be highly decorative or functional. Many potters use carving to enhance their pot's surface in tandem with glazes—creating ridges or valleys where glaze breaks or pools. You can carve the exterior or interior of a pot and carve deeply or shallowly. Your carvings can even be filled with a colored slip (see page 171). If you apply slip that is a different color from your clay, you can carve through it and create a high-contrast pattern.

Carving is like drawing in some ways, so if you already enjoy drawing, you will take quickly to this technique. There are many tools for carving, both designed for the purpose and improvised. There is no one perfect solution, but much will be decided by the tool you use and the effect you want to achieve:

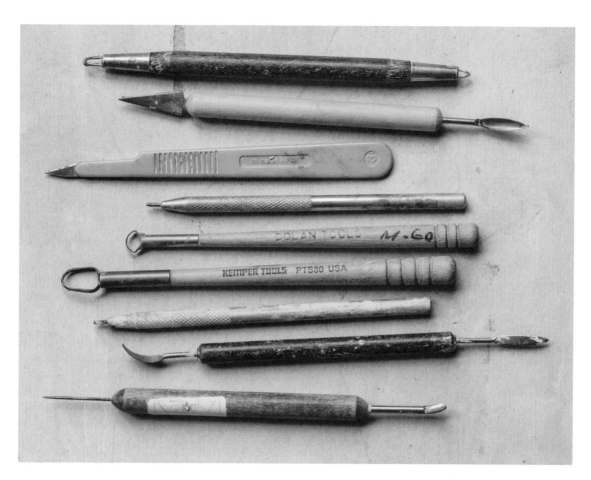

Experiment with different carving tools to find the ones that work best for you.

Sur-form: Use this tool to shave clay in an efficient and rapid manner once it's leather hard. A sur-form does leave a particular texture, but you can leave it or rib it away.

Trimming tools: Loop tools and similar trimming tools are used most often for trimming a foot on a pot. But they are also wonderful for reductive sculpting, removing clay to reveal the desired shape. If you carve into clay at various stages of leather hard, you can leave an incredible range of gestural marks. Of course you can also clean up impressions left by your tools and refine the marks.

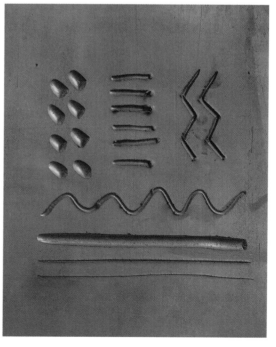

REDUCTIVE CUTTING

One of my undergraduate teachers, Robert Brady, once showed my class an interesting use for a bag of clay that had become too hard to throw. Instead of reconditioning and recycling it, he cut the clay block into quarters from the top down. He then treated each of those four blocks of leather-hard clay as an individual canvas, whittling away at the surface with a fettling knife. He created some amazingly graceful figurative forms from those blocks!

I mention this not only because it's an extreme example of what you can do with carving but also as a reminder that sometimes the most interesting objects we make come from unexpected circumstances. Don't be afraid to play and experiment. At every state of clay interesting things can happen. Some may inspire and interest you, others you may dismiss immediately. But my advice is to be adventurous!

What can you make from a solid block of clay?

Fettling knife/X-ACTO blade: Use this tool on leather-hard clay to cut away unwanted clay or carve clean, sharp lines.

Ribs: Ribs are handy for altering the surface of your clay. They can smooth or rough up a surface, depending on the edges of the rib and how you use it. I will cut or shape ribs to meet my specific needs, often as reductive devices.

Fingers: If you're working with soft clay, you can use your fingers to indent the surface and/or remove clay. Just be careful when trying to clean up lines or burrs, as fingers can cause some serious smudging!

Miscellaneous carving tools: Scan your surroundings for sharp implements. You never know what will make an interesting mark. One of my favorite tools for drawing on clay is a cheap mechanical pencil. It creates a fine, sharp line, and you can "resharpen" the pencil easily.

Besides practice, carving will require some investigation into what type of design or pattern you might be interested in making. On page 169 you'll find some examples of carved patterns.

SLIP TECHNIQUES

Slips are wonderful and versatile when it comes to application options. Most studios will have slips available in basic colors: white, black, blue, and an earthenware-style red are common. Slips are also easy to make and store in small, sealable containers. There are a couple of basic recipes on page 192 that work on a variety of clays and at different temperatures.

As a general rule, slip is applied during the greenware stage. Layers can be built up, then drawn through or added to. If slips are left exposed rather than glazed, they are usually dry and rough to the touch after the final firing. For functional ware, this is not so appealing, but it could work for a sculpture surface. When creating functional pieces, keep in mind that slips can change dramatically under glazes, depending on the chemistry of the glaze. A glaze could intensify colors or completely melt the slip and make it appear nonexistent. Make sure you test before you cover your masterpiece in both slip and glaze.

When applying slip you will be rehydrating the clay your object is made with, adding water to whatever state of wetness/dryness the work is in. Generally I recommend applying slip to leather-hard work. Even then, if you're applying slip that's too thick, you can easily oversaturate your work if the clay is on the soft side of leather hard. (At a workshop, I once dipped a series of mugs with freshly attached handles in slip, and set them out to dry. Five minutes later all of the handles had fallen off, and several of the mugs collapsed under the pressure of the slip/water content. Lesson learned!)

While you don't want your work to be too wet when you apply slip, I would caution you against the use of slip on bone-dry work. Bone-dry work and slip will lead to the complete and utter destruction of a piece very quickly. This is because

bone-dry work will crack under the stress of expansion when it quickly reabsorbs moisture. Moisture causes shock and stress to the form.

Note: *Consider the state of your slip as well as the state of your clay. Remember, slip is liquid clay and, as such, its water content can vary as the slip sits. Moisture is always evaporating, changing the thickness of slip.*

Aesthetically, have some fun! Slips are a great way to change your clay canvas. For example, using a dark slip over light stoneware can create a much different look and showcase a particular glaze. Likewise, by using a light slip over a dark clay, you can create a new surface to draw though and reveal the dark clay underneath. The process of drawing through slip to revel the clay below is called *sgraffito*. And unlike glaze, slip gives you a good idea about the color you will end up with once it's fired.

BRUSHING SLIP

There are so many brushes available out there. If you are going to use slip, my suggestion is to try a variety of brush types (buy the cheap ones first) and test how they work. It's worth noting that most slips (glazes and waxes too) are hard on brushes, so be sure to care for them well. Clean them promptly after use, then let them dry. Don't leave them sitting in rinse water overnight! This is the quickest way to destroy a brush.

When you've selected your brush and you're ready to apply your slip, I recommend pouring some of the slip into a smaller container. This will help protect against accidental cross contamination if you're using multiple colors. In a smaller container you can change the consistency of the slip (thinning it down with water or thickening it by letting water evaporate).

When you're ready to decorate, start with a wet brush. Slip or underglaze will be drawn into

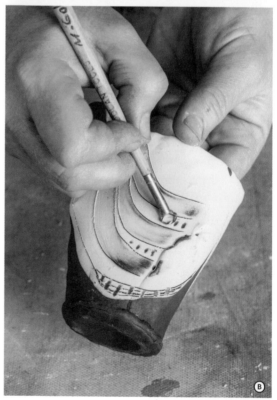

the brush better if it is already moist. Work with one color at a time, starting with the lightest and working toward the darkest. Ⓐ Clean your brushes thoroughly between color changes. Make sure to let your slips set before you apply another coat—just like paint, slips will mix together when they're wet, muddying their colors.

Once you have slip on the surface of your piece, you can carve through it to create designs. Experiment with other tools, such as those used for making sewing patterns or other implements, to increase surface complexity. Ⓑ

DIPPING OR POURING SLIP

Dipping or pouring slip produces very different effects from brushing slips. Generally one dipped or poured coat is thicker than one that is brushed. There is a variety of tools for pouring: spoons, ladles, measuring cups, homemade pourers, even your hand. Pouring is a very gestural and intuitive application method. It embraces the spontaneity of motion and the force of gravity against a stationary object (the clay).

When you're ready to dip or pour, make sure the slip is the right consistency. You want it somewhere between heavy cream and half-and-half, depending on your goal. The thicker the slip, the more it will saturate your piece, so use caution and be quick! Your clay state is important as well—you'll generally want it to be leather hard.

If you're dipping, set up a container that's deep enough for your object. If you're pouring, get your tools ready before you begin, including a splash pan to capture excess slip.

Last but not least, figure out how you will hold your object while dipping or pouring. It is often hard to handle a leather-hard piece. Knowing how you will hold it, as well as how and where you will set it down after applying slip, will save you a costly error. If you are pouring slip over a large object, try

STORE THOSE SLIPS!

For slip, using containers that can be sealed and reopened easily is a must. I prefer plastic containers because they have a long shelf life and they seal better than most repurposed food containers. Some potters use glass jars, but I don't like them—mainly because if you drop one on the floor, you have slip and shards of glass everywhere.

When storing multiple slips, always label the color, including the slip recipe and/or colorants, on the containers. Your labels should be on the bottom and the lid of the container, so you know which lid goes with which bottom. Also, the labels will inevitably get wet, so cover them with tape or use water-resistant tags.

If you're using studio slips, return any excess slip to the main studio container only if you haven't contaminated it or watered it down significantly. Also, make sure you are putting the slips back in the correct containers. *Don't be a slip contaminator!*

setting up a system to avoid placing the bottom of the object in a pool of slip. For example, resting your piece on two sticks laid across a large splash pan works well to keep the piece elevated and out of harm's way.

MISHIMA

Now that we've learned about carving and slip, let's put them together! *Mishima* is an interesting greenware decoration technique in which you'll carve lines into leather-hard clay with a sharp implement, then fill those lines with colored slip. The result is that you'll enhance the lines with color.

To get started, look on the Internet for imagery you are interested in, print it out, and trace it onto your form. The easiest way to do this is to place the printed paper over your form (the clay should be soft leather hard to leather hard) and use a ballpoint pen to outline the image. As long as you press hard enough and the clay is not too hard, you'll leave a slight indention in the clay under the paper.

Now carve the pattern or design into the clay using a sharp bladed tool. At this point do not brush away any burrs you create. You can try different mark-making tools, such as a No. 2 pencil, a mechanical pencil, a needle tool, an X-ACTO knife, a woodcut knife, and so on.

Let the clay reach almost bone dry, when you can use a soft bristle brush to remove any burrs. They should just brush off easily if they're completely dry.

To inlay your carved lines with color, apply slip to the bone-dry clay. (Yes, I know what I said about bone-dry clay and slip! But with this process, we'll be applying slip to the design only.) Paint the slip over the carved lines. You'll notice the dry clay will really pull the mixture from your brush. Cover your entire design, and let it dry.

Wipe away the excess slip (what is on the surface of your piece, not in the line) with a damp sponge, or scrape it away with a rib. Bisque fire your form as usual.

Flower Brick. Piece built by Sunshine Cobb and illustrative *mishima* by Richard Peterson—collaboration. *Photo courtesy of the artist.*

Chris Pickett | Texture and Finishing

How did you get your start in clay?

As with many who work in our field, clay was something I stumbled upon. I was originally an engineering major when I started college. Growing up I had always enjoyed drawing, and when I entered college, I filled all of my elective credits with art courses. I ended up taking every art course offered, one of which was ceramics. I often hear of people who fell in love with clay from the moment they touched the material. I didn't fall in love with clay at first sight; rather, we casually dated until it just made perfect sense that we should be together. We've been going steady ever since.

Your work is heavy on pattern and color. Can you talk about the imagery and textures that inspire you?

There are a number of things that influence the form, color, and surface imagery in my work. My pots are about comfort, and there are several areas I look to that address that topic.

Many different cultures consider the vessel a metaphor for the body. I use the soft volumes of the body in my work to reference the comfort of touch and physical intimacy. Pots are intimate objects that we regularly touch and at times press to our lips. Their use makes them the perfect vehicle to address the comforts of intimacy. Soft matte glazes and generous volumes provide a tactile experience, allowing the vessel to serve as a proxy for the body.

I reference toys as a link to the comforts of childhood experiences. Toy designs are often stripped down to form and color. Complex shapes are often simplified and accented with bright primary and secondary colors. The Fisher-Price Little People toys are a perfect example. The shape of the human body is reduced to a sphere placed atop a cylinder and accented with line and color. Often in my work I adopt a similar strategy. Soft basic

Spring Vase. Chris Pickett. Soft-slab construction, drop mold, template/low-relief stencil, press mold, manipulated aluminum wire. *Spring Vase* references the Bead Maze toy and the nostalgia of childhood.

volumes highlighted by small accents of bright color allude to these playful designs.

Other toys I use as inspiration are the Lite-Brite and the Bead Maze. The Lite-Brite is a toy that uses colored pegs pressed through black paper into a light box to create colorful designs made up of small illuminated circles. I use low-relief surface designs painted with underglaze to achieve a similar aesthetic and nostalgic tone. Similarly I incorporate portions of the Bead Maze toy into another form. The Bead Maze is made up of several meandering wires with colorful beads that travel along the wires. I adopt a portion of this toy design to serve as the handle of a vase form. A coiled aluminum armature with a press molded clay bead serves as a reminder of my childhood.

Midcentury furniture is a point of reference when considering the comforts of domestic spaces. Many midcentury designs for the home have a close relationship to toy design. A good example is the George Nelson Ball Clock. Twelve colored beads attached to wire rods serve as the numbers of the clock. This feature inspired the handles of my Low Vase design. I also draw on midcentury fabrics for inspiration. The Ray Eames classic Atomic fabric pattern is a playful design, which I associate with the optimism of the era and the comfort of the domestic landscape. I merged this fabric pattern with a dot array motif to create the low-relief design on my Atomic Serving Bowl. This imagery is a nod to the midcentury era and to the value of personal domestic spaces.

What important lessons have you learned in your process?

There are a few lessons I have learned over the years. Time has taught me that tools are just tools, no more, no less. Use every tool at your disposal to say what you want to say. Don't let the tool dictate what you make; rather, use any tool available that helps you articulate your ideas.

The most important advice I could give anyone is to simply show up every day. There is no substitute for time spent with the material. If you keep plugging away and pay attention, good things will happen. Someone once told me, "Chris, there are two kinds of artist in this world. Some people are naturally talented, and then there are people like you who just work really hard." At the time it felt like a backhanded compliment. With the benefit of hindsight, I'll gladly accept it.

Atomic Serving Bowl. Chris Pickett. Soft-slab construction, compound drop mold, template/low-relief stencil. This pillowed form incorporates the Ray Eames fabric pattern as a nod to the midcentury era and personal domestic spaces.

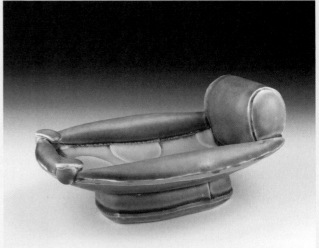

Chaise Lounge Tray. Chris Pickett. Soft-slab construction, drop mold, compound drop mold, template/low-relief stencil. *Chaise Lounge Tray* references the furniture piece and personal domestic spaces.

All photos courtesy of the artist.

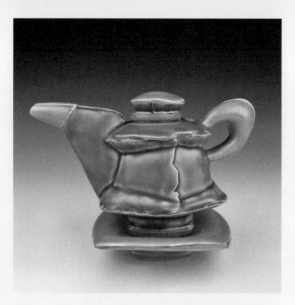

Oil Can. Chris Pickett. Soft-slab construction, drop mold, compound drop mold, template/low-relief stencil. The small accents of bright colors is a strategy inspired by toy design.

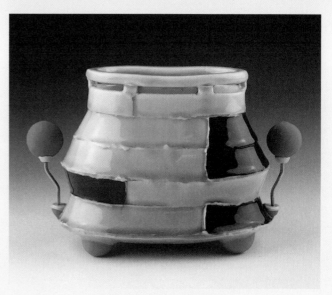

Low Vase. Chris Pickett. Soft-slab construction, drop mold, template, press mold, manipulated aluminum wire. *Low Vase* is inspired by the George Nelson Ball Clock design.

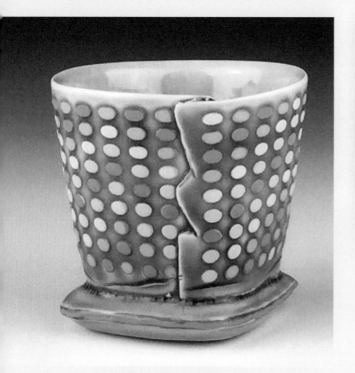

Chevron Rocks Glass. Chris Pickett. Soft-slab construction, drop mold, compound drop mold, template/low-relief stencil. The surface decoration of this piece is inspired by the Lite Brite toy from my childhood.

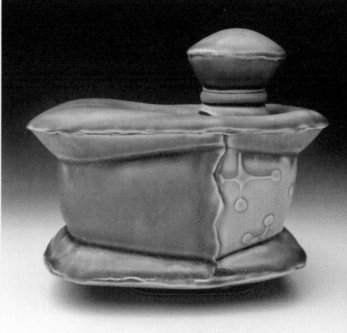

Liquor Bottle. Chris Pickett. Soft-slab construction, drop mold, compound drop mold, template/low-relief stencil.

GLAZES AND UNDERGLAZE

Underglaze is somewhat similar to slip, so I won't spend too much time on it here. In fact, underglaze can be used the same way as slip is at the greenware stage. However, it can also be used over bisqueware. Commercial underglazes are formulated for application on clay at either stage. The saturated color of underglazes can be incredibly intense. (If you've ever been to a paint-your-own-pottery studio, then you know what I mean. Almost all of those studios rely on underglazes.)

Underglaze is effective for producing a more painterly decoration. It can even be used for screen-printing patterns to create color transfers for greenware. Still, as the name implies, it is meant to be used in conjunction with glaze, which will seal and finish the piece.

Note: *When I use underglazes on bisqueware, I like to sinter (fire to 700 degrees Fahrenheit) the underglaze onto the bisqueware or bisque fire it again before applying glaze. This keeps the underglaze from acting as a resist to the glaze.*

Test your underglazes with various glazes because, as with slips, glazes can change the intensity of colors. (The chemical reaction between a glaze and an underglaze during the final firing will affect the outcome.) While some glazes will add intensity, others will be opaque and render the underglaze almost invisible. Even something that appears straightforward is worth testing. All clear glazes do not fire the same way, and temperature will influence the color intensity of underglazes. Take notes to record your combinations and firing methods.

For inspiration on how far you can take underglazes, see page 194.

Unlike underglaze, glaze is essentially a mix of materials that melts when heated to form a glass. It can get crazy complicated, depending on your aesthetic goals, but let's talk about a few basics.

First, you'll need to know what temperature you are firing to. Even when working in a communal studio where the firing is done for you, it's good practice to know how hot the kiln gets.

There are three main temperature ranges in ceramics: Low fire (generally cones 04–06), midrange (generally cones 5–7), and high fire (generally cones 8–11). So what is a cone? "Cone" refers to the specific temperature range that takes into account temperature and time. Think of it in terms of food. When you're roasting, you can roast something fast at 450 degrees or for a long time at 200 degrees. The results will be different, but whatever you are roasting will be thoroughly cooked eventually.

In ceramics, we use pyrometric cones that are made to melt gradually to indicate specific temperature ranges in the kiln. This helps gauge how hot our work is when it's being fired. This matters in the vitrification of clay and the melting of glaze. When we fire a kiln, we often use cone packs indicating a specific series of temperatures (usually three cones, with one that melts at the target temperature, one at a higher temperature, and one at a lower temperature) to monitor the firing. An example of a cone pack for a midrange firing would be cones 5, 6, and 7.

You may or may not have a choice of firing temperature, depending on your kiln access, but if you do have a choice, there are some serious creative and practical considerations.

Let's address the creative considerations first, as the color of clay and glaze is dramatically affected by temperature. Low to midrange temperatures are more conducive to bright colors (most often electric fired in oxidation (simply a gain of oxygen), though

there is also the possibility of low-temperature atmospheric firing such as *raku*, pit firing, or black box firing (these are reduction low-fire processes) ... but these are for decorative ceramics, not for functional work). Higher temperatures, in electric kilns or in gas kilns (which also can be fired in reduction (simply a reduction of oxygen) are conducive to a richness in the clay-glaze barrier. High temperatures also open up additional options, such as atmospheric firings using wood or salt or gas-fired soda.

Clay strength and vitrification are important practical matters. One reason I prefer to fire at mid-range is the strength of the clay at those temperatures compared to the strength at low-fire range. Most clays are vitrified, meaning they are watertight, at their advertised temperature, but that can vary. "Vitrified" doesn't mean impenetrable or even strong. Anyone who has used an earthenware pot and then a stoneware pot can feel the difference in the density of those fired clays, which makes earthenware casserole dishes wonderful to cook with and stoneware mugs wonderful to drink hot coffee out of. Although I do love earthenware, when I make functional wares for sale, it is important to me that they are strong and can survive normal wear and tear. You'll need to decide what the important factors are in your work and adjust accordingly.

The first glazes you'll have access to are likely to be those at your community studio. This is a great way to start, because you can ask your studio manager about the glazes if anything is unclear. You'll also probably see a lot of your studio mates' work coming out of the kiln with the same glazes. I encourage you to explore alternative firing methods, such as *raku*, if you can. Every studio is different and has its perks and limitations. Once you are ready, you can start to adventure outside these boundaries, finding new studios to work in or setting up your own. But don't look over the fence too quickly. The grass is always greener on the other side, so don't be concerned in the beginning if you don't have the perfect green glaze!

A common complaint from students is that they hate glazing. If you spend 95 percent of your time making and only 5 percent of your time learning to glaze, it's no wonder the results you're getting are unsatisfactory. The only way to get better at the finishing processes is to practice. Now is also a good time to go back to the section on surface treatment in this chapter. Remember, the surface of your clay and the glazes you apply must work together to create the finished pieces that you desire.

Whether you are new to glazing or have done it for years, I recommend avid note taking. You will want to be able to repeat successful results. Too many times I have been brought a pot and asked, "What glaze is this?" How would I know? Even if you can identify a glaze, you'll want to know how thickly or thinly you applied it, and whether it might have reacted with any underglazes or other glazes or the clay body itself.

POURING OR DIPPING GLAZE

Pouring or dipping is the most straightforward way to apply glaze. It's usually the introduction to glaze application in ceramics classes. My recommendation is to get an in-person demonstration before you glaze a pot. In this section, I will provide some guidelines, including things to look for and things to avoid. Still, nothing is a substitute for a hands-on tutorial.

Before you start glazing, your work should be bisque fired, clean, and free of dust and debris. Use a damp sponge to wipe the work if it has been gathering dust on a shelf. Don't saturate your work in the process. The absorbent nature of bisqueware is what helps glaze adhere to it, so if you get the work too wet, you will need to let it dry before glazing.

Wax any areas where you do not want glaze, such as the foot of your pot, then let the wax dry fully. Ⓐ Be careful not to get wax on your pot where you do want glaze. You'll have to bisque fire the pot again to burn the wax off!

Don't open the glaze bucket yet. First, come up with a plan for glazing. Prepare a clean space for your work, lay down newspaper, and have a sponge handy—glaze is drippy and messy. Gather your pouring implements, such as ladles or measuring cups. Or grab the glazing tongs. Have a bucket of clean water with a sponge available so you're ready to clean the bottoms of pots or any spills.

Now it's time to pick the glaze you'll be using. Prepare the glaze, stirring it to a uniform consistency. ⓑ Glaze consistency can vary greatly, depending on how a glaze is meant to be used. Also, if it has been sitting for an extended period, water might have evaporated to cause the glaze to become too thick. Generally, most glazes should be the consistency of paint. If you dip your hand into the glaze and pull your hand out, glaze should drip off your hand quickly but create a slight webbing effect between your fingers. If it is too thick or too thin, consult a studio manager or technician who can determine whether the glaze needs to be adjusted. It is important that one person oversees this. If everyone in the studio starts adjusting the glazes, the glazes will quickly become unusable!

If you're using tongs, place the tongs on the interior and exterior of the pot so that you have a firm grip on it. Otherwise, grab the piece near the bottom of the pot with your fingers. Now dip the piece, allowing the form to fill with glaze. This will be a quick, graceful plunge of the pot into the bucket. Once the pot is submerged, give it a little swish while you perform a short count, "One Mississippi, two Mississippi," then pull the form from the bucket. ⓒ (The count will vary, depending on the thickness of the form and the thickness of the glaze!) Gently shake off the excess glaze, letting it drip while it's still liquid. Then set your piece somewhere safe to dry completely. If you used tongs, gently release the piece so you don't scratch it. Some glazes will "heal" over the marks left by the tongs. Other glazes will require a small amount be applied to the marks. If you dipped by holding the

pot, you can fill the marks left by your fingers with glaze (by dabbing or brushing) or accept the process marks (my preference).

If you're using two colors of glaze, here's a general guideline for functional work: glaze the interior of the form first, then the outside. Use a measuring cup or ladle to fill the form about ½ to ¾ full. Then pour the glaze out, slowly turning the form to make sure the entire interior surface is coated with glaze. Let the excess glaze drip out entirely before flipping the pot back onto its foot. (This will help make sure that you don't have a large pool of glaze at the bottom of your pot, which can lead to major cracking issues.)

Depending on your glazing strategy, you may now need to clean up drips on the exterior of the form. Glaze thickness will reveal itself in the final firing. So if you have drips and layer more glaze over them, those spots with heavier glaze will be apparent. Let the work dry before applying additional glaze. Remember, water saturation will change how quickly the bisqueware absorbs the glaze.

Note: *The thickness of the glaze on your form is important. If you don't get enough glaze on the piece, it can vastly change the glaze outcome. And too much glaze can cause a variety of other problems. As a general rule, aim for the thickness of your glaze to equal the thickness of two credit cards. If you can't tell how much glaze is on the form, use a needle tool to scratch a little line in the glaze to check. Dab a touch of glaze over the scratched mark to make sure it is covered.*

When you've already glazed the interior of a piece in one color and you're ready to glaze the exterior a different color, pouring will help keep the two colors somewhat separate. To do this, hold your ladle or measuring cup filled with glaze in one hand, hold your piece firmly in the other hand, and turn the form while pouring glaze over it in a steady stream.

Dipping is also an option, but this method will lead to more overlap between the two glazes. For

functional items such as cups and bowls, hold the form by the foot and dip it straight down into the glaze bucket so that you can keep air trapped inside the form while it is submerged. Dip the object up to the foot line for a couple of seconds before pulling it out. Ⓓ

When you're done glazing your piece, touch up any gaps in the glaze and remove any errant glaze. Make sure you leave at least a ¼-inch unglazed foot ring. This applies to all objects, not just functional ones. The bottom of the piece that sits on the kiln shelf must be completely free of glaze; otherwise, it will adhere to the shelf, which is worse than if you'd glued it. Even if you waxed the foot, run a sponge over the foot to wipe off any glaze remnants. Finally, clean the tools and counters, and replace the lids correctly on the glaze buckets.

BRUSHING GLAZE

While most studio glazes are poured or dipped, most commercial glazes are formulated to be brushed on. You'll find directions specific to the glaze on its container. This makes sense because the amount you'll buy is generally pretty small. The glaze manufacturer will probably suggest three coats for a good application. While I have seen many people use commercial glaze with unsatisfactory results, I believe that it is typically due to user error. The thickness of the glaze is just as important in commercial glaze as it is with studio-mixed glaze. You must learn enough about the glaze to manage its application consistently.

Before you brush, the same setup rules for dipping and pouring apply here. You want a clean, dust-free piece of bisqueware and a clean work area. Only once you're organized should you begin to brush.

Dip the brush in the glaze, and make sure it's well loaded with glaze. It's important to coat your piece evenly. As the piece wicks the glaze away from your brush and the applied glaze starts to get chalky and dry, you will have to dip the brush in

the glaze again. The first coat will be thin, but you will not need complete coverage. Ⓔ Subsequent coats will make sure you have enough glaze on your piece.

Let the first coat dry completely before brushing on the second coat. You should able to apply a thicker coat this time. Again, when the glaze on the piece appears to get chalky and dry, reload the brush with glaze. Once you have completed the second coat, let it dry. It will take longer than the first coat to dry.

The third coat is your last chance to address any spots that seem thin or transparent. With most glazes, the clay body should not be visible through the glaze. Let the third coat dry, then move on to cleaning any unwanted glaze from the bottom of the pot.

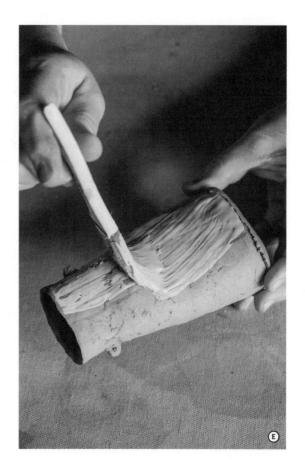

RESISTS

Resists prevent glaze, underglaze, or slip from adhering to your pot. They can be anything from paper (often used with slip) to wax (the most common resist for bisqueware). Resists can be applied during the greenware stage as a decoration or employed as a device to slow drying, especially in areas that may be weak or possibly dry too fast in relation the rest of the object (and break). But in this section we'll focus on resists for decoration.

PAPER AND TAPE

Paper and tape are very straightforward when used as resists. I recommend generic masking tape and newsprint but suggest you play with different types of paper and tape and see what works best for you. Just keep in mind that using paper and tape with slips and glazes is a one-shot deal. You're most likely going to ruin any stencils you create. Here are a few ideas for exploration.

Paper stencils: Cut out various shapes from paper, then spritz the paper with water until it's just moist enough to stick to a leather-hard piece. Use a soft rib to ensure the paper adheres to the clay surface—you don't want slip sneaking under the edges. Paint over the paper on your piece with slip, let it set up a bit (until the slip won't run), then peel the paper away. When the slip is no longer shiny, repeat with new cutouts and colors! Ⓐ Ⓑ

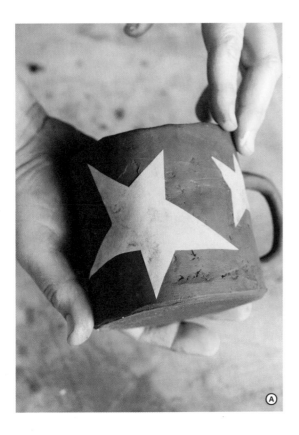

Ⓐ

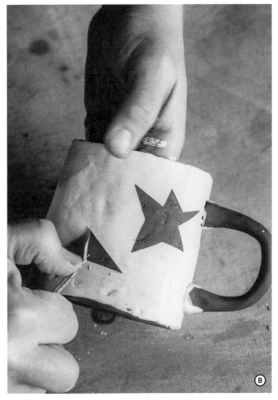

Ⓑ

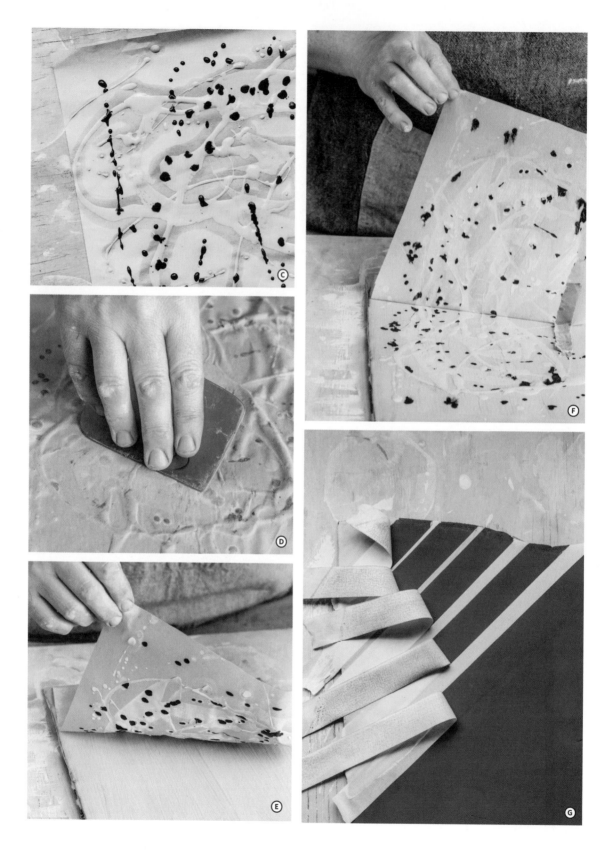

Paper slip transfers: Paint or drip multiple layers of slip on paper. Ⓒ While you let the slip set up until it's no longer shiny, brush a portion of your leather-hard object with a base slip. Ⓓ While the slip on your piece is still slightly tacky, mist the back of your paper with water. It should be damp but not wet. Place the paper, slip side down, onto the slip on your piece. Use a soft rib to rub and transfer the design from the paper to the form. Ⓔ Remove the paper and admire your slip design! Ⓕ

Tape resist: If you're into lines, use masking tape as a resist. It can be a little tricky to get tape to stick to leather-hard ware, but it should stick well to your bisqueware if it is free of dust. Cut patterns along the edges of a strip of tape or use the tape as is to make clean lines in your design. Paint or pour slip over the tape on leather-hard greenware, or paint or pour glaze over the tape on bisqueware. Once the slip or glaze is dry enough not to drip, peel away the tape to reveal the design. Ⓖ

WAX

Wax is a common item found in ceramic studios. It's most often used as a resist for bisqueware being prepared for glaze. Your studio may have oil-based wax, which tends to be heavier but is more resistant when you apply glaze. Water-based wax, on the other hand, tends to be a bit thinner. This is why some potters use it as a decorative tool at the leather-hard stage as well.

To use wax, first organize your workspace. Place newspaper or work on a table you can wipe down easily (no canvas). Use brushes that are designated for wax only. Transfer a small amount of wax to a small, stable container.

Now paint wax on your bisqueware where you want no glaze to stick, such as feet, lids, and lid seats (flanges). You should wax any place the piece will touch the kiln shelf as well.

You can be quite precise with wax, but it's also easy to unintentionally let wax get out of hand! Once

wax is on your form, it can be difficult to remove—often a piece must be bisque fired again to eliminate stray wax completely. So be careful. When you're ready to clean up, use hot water to wash your brush or, even better, have a cup of piping-hot water ready and place your brush in the cup as soon as you're done. This will melt the wax a bit and help keep your brush cleaner. Let the wax on your piece dry completely before you begin to glaze.

LIQUID LATEX

Why bother with latex instead of wax? It's temporary! By that, I mean it allows you to create resists that peel off so you can create multiple patterns with multiple layers of color.

Before using latex, dip your brush into Murphy's Oil Soap. This will help keep your brush from getting caked up. Then paint the latex on your piece, and let it dry. Apply the slip or glaze of your choice to your piece, and let that dry. Finally, peel off and discard the latex!

LACQUER/SHELLAC OR HARD WAX

Lacquer is primarily used on leather-hard work as a water resist. Hard wax is another option for this type of work, but you will need a hot plate and a pan dedicated to the wax.

To use these materials on bone-dry work, brush a design on your piece with the shellac or wax, then allow it to dry. Next use a damp sponge to gently wipe clay with no resist on it away. The lacquered or waxed sections should remain in place and will increasingly stand out in relief as you remove clay. This is a delicate process, and it takes some practice. It's possible to unintentionally rub off the lacquer or wax over time, so be gentle and patient. When you're done, clean your lacquer brush with denatured alcohol. Massage any lacquer out of the bristles, and let the brush dry. It will be stiff, but the next time you soak it in solvent, it should loosen up within thirty minutes.

Lindsay Oesterritter | Carving

How did you get your start in clay?

When I was preschool age, I made little globular animals that my dad and I sat in the sun to dry. And when I was in grade school, my brother and I took a community kids' class just down the street from our home. My mom still keeps some of the pieces made in that class on display in her china cabinet. However, it was not until taking an introductory class in college that I would consider I got my start in clay.

What led you to the carving you've used in your recent work?

I usually start my process by visualizing and sketching the object that I want to make, and then ask myself how I am going to make it. If it's a new form, I like to imagine making it in various ways: on the wheel, with coils, slabs, or molds, by carving, etc. When I think about each of these processes, I consider how the clay will behave, what the difficulties will be, and what process marks will be left behind.

Take the olive troughs, for example (see page 187). Beyond the form itself, I knew I wanted it to be heavy. I also wanted to see if I could make something that challenged the idea of the even wall, creating an interior shape that does not match the exterior shape. By carving the troughs, I was able to create almost the exact form again and again, but with much greater variety in mark making than if I used a press mold.

What important lessons have you learned in your process?

When working with thick walls and with forms that are long and thin, slow drying greatly reduces warping. I have adopted what I call the "towel dry." I drape a dry towel over the piece to slow down the drying. The towel still lets it dry, but I don't get the warping that can result from drying too

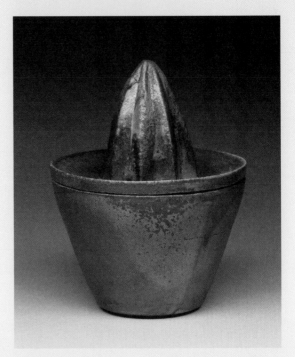

Juicer. Lindsay Oesterritter. Wheel-thrown, press mold, and slab. I was interested in designing a juicer that worked well and was beautiful.

fast. On that same note, if I have several olive troughs drying at the same time, I make sure there is plenty of room between them. Otherwise the moisture from the troughs nearby will affect the overall drying patterns too.

Touch your piece less. It sounds simple, but it takes a certain determination and patience. Don't fuss over something because then the whole thing will get lost.

How do you design your objects?

In high school I took three years of drafting. For a long time I thought I wanted to be an architect. This is beside the point but might explain why, to this day, I always start an idea in my sketchbook, sketching the object from all sides (top, bottom,

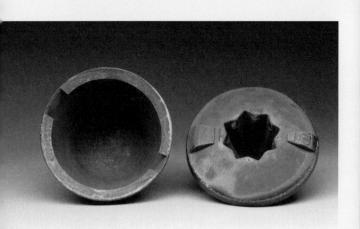

Juicer, detail. Lindsay Oesterritter. Wheel-thrown, press mold, and slab.

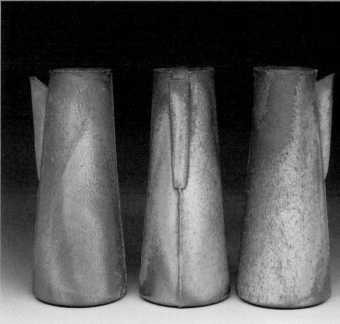

Pourers. Lindsay Oesterritter. Press mold and slab, cone 10. I make the pourers with a mold specifically for the seam that is a product of the press mold.

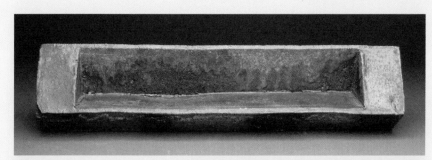

Olive Trough. Lindsay Oesterritter. Carved, cone 10.

Trough Use. Lindsay Oesterritter. Solid construction and reductively carved. Troughs serving tomatoes, cucumbers, crackers.

left, right, front, back) and in cross section. This helps me make initial decisions about proportion and line. After I get a general grasp on how the piece is going to look, I start on a to-scale paper template. Within the framework of how I want the piece to be used and handled, I work on the dimensions of the piece, again making a paper template for each dimension of the form. I use the paper template as a guide to outline the form on the clay and to know where to carve. I also use the template to make any other tools that would help guide the reductive process.

What are your thoughts about wood firing as a surface treatment?

One of the reasons I wood fire is it allows me to focus more on the form. When I decide on what hand-building technique I am going to use for a particular form, it is in large part because of the process marks that will be left behind to create the finished surface. I glaze very little, so the process marks combined with the wood-fired surface become the marks that decorate the surface. I strive to make work in a manner that is as straightforward as possible. What you see is what you get. In this truthfulness of process and simplicity of form, I hope to let the object and material speak for themselves. I aim to achieve depth through simplicity.

Trough Templates. Lindsay Oesterritter. This is the template that I use to outline and then carve the olive troughs.

Spout, work in progress. Lindsay Oesterritter. This is an image of me cutting out and shaping the spouts for the pourers.

KILNS AND FIRING SCHEDULES

We have come to firing! In the beginning firing is usually left to a kiln technician or studio manager. If you are interested in learning the ins and outs of firing, I highly recommend shadowing someone who has experience with firing a variety of kilns. Bisque firing and final firing electric kilns are pretty straightforward, but gas kilns can seem like a complete mystery.

When I wanted to learn to fire gas kilns to cone 10, I observed three different people—two of my instructors and the kiln tech at my university. There was no official class offered on firing kilns at my school, just lots of books to read about the process (which, when you have no practical experience, can be difficult to follow). Because I learn best through hands-on experience, I need to see how something is done and then try it myself. So I asked questions of my instructors and took notes and watched them fire kilns. To my dismay each teacher did it differently! It was crazy! I had figured there was one way, and that would be it. But I learned that firing high-temperature kilns can be an art, and a highly interpretive one, based on what you want the outcome to be. It is interpretive after you have copious notes and experience. One must see the actions taken during the firing process and correlate them with the results. Luckily I was allowed, with some handholding, to begin firing gas kilns, and I found a method I was comfortable with and that produced good results.

CONES AND FIRING TEMPERATURES

In the glaze section we discussed cones, temperature ranges, and how they impact clay colors and glazes. We defined the common firing range as low fire (cones 04–06), midrange (cones 5–7), and high fire (cones 8–11). The following will address how time and temperature (pyrometic cones) affect clay bodies during the firing process.

Pyrometric cones are the best way to ensure the quality of your firings.

I'm going to borrow from the Val Cushing workbook, from which I learned most of my firing guidelines when it comes to the basics of firing, and discuss what to watch for at certain temperatures. Hopefully this will help demystify the firing process and enable you to alter firing schedules with an awareness of what you are changing and why.

100 to 200 degrees Fahrenheit, slow climb and/or hold over three to four hours: Speeding through this first step is probably the most common way to cause problems with your firing. Holding the kiln, typically at about 180 to 200 degrees, allows the work inside to dry completely before it is exposed to higher temperatures. Ware will explode if the water remaining in the clay turns to steam too fast, so even if you don't hold as long as recommended, the work doesn't hit boiling before it is dry. If you're 100 percent confident that you're putting bone-dry work in the kiln, then you can hold at 200 degrees for only one or two hours instead.

Note: The way most electric kilns work is to ramp up every hour by whatever number of degrees is programmed. So for this first step, I would increase to 200 degrees Fahrenheit by 50 to 75 degrees an hour. This means it would take the kiln two to three hours to hit 200 degrees and then I'd have it hold that temperature for one to two hours.

200 to 1,100 degrees Fahrenheit over five hours: During this stage also, it pays to be conservative with the speed of your temperature climb. This will typically be the longest part of a firing. A couple of things happen. First, the chemical water burns out, and the clay becomes ceramic. (There is no going back after 600 degrees.) Quartz inversion, another important chemical reaction, also takes place. The important thing to remember is that, once the clay is subjected to this temperature range, it is no longer possible to break it down into a raw material that can be reworked.

Note: This temperature range is also when crystalline growth (structural growth in the clay during the firing process) can occur, which can be important to certain high-silica clay bodies and in atmospheric firings. It can lead to possible cracking if the kiln cools too slowly and too much crystalline growth has occurred (for example, cristobalite, a spiral cracking phenomenon).

1,100 to 1,940 degrees Fahrenheit over three to four hours: Now we're getting to the bisque range. After 1,100 degrees, the temperature can climb a bit more quickly to the final bisque temperature. The range for this can vary from the low end, cone 010, to the high end, cone 04. What temperature is desirable really depends on your clay. The lower temperatures like cone 010 leave the clay softer and more absorbent for glaze. Fired to higher temperatures like cone 04, the clay will be harder and slightly less absorbent. The standard final bisque temperature is between cones 04 and 06.

BISQUE-FIRING SCHEDULE TO CONES 04 THROUGH 06, ELECTRIC

If your kiln has preprogrammed settings for bisque firings, use them. I do! When bisque firing on a schedule that you're determining, it is a good idea to stick with a slow firing so that there's less chance of blowing stuff up. Here is a gentle firing schedule for low-fire work.

Degrees per Hour	Target Temperature	Notes
75°F	200°F	Work should be dry before firing. Between climbing and holding, the kiln should spend at least 4 hours at 200°F or below. It may require up to 8 hours if work is wetter or thicker than recommended.
220°F	1,100°F	Quartz conversion occurs.
250°F	1,850–1,940°F	Finish in the range of cones 06–04, depending on your clay. Kiln should shut off and cool naturally. Remove peeps (air-vent covers) after the kiln has cooled to below 900°F.

GLAZE-FIRING SCHEDULE TO CONES 04 THROUGH 9, ELECTRIC

This is a general firing schedule that can be adapted to suit your needs. For example, in my glaze firings, I usually fire to cone 3 and hold at that temperature for ten minutes. This seems to help my glazes settle and typically it melts the higher cone (cone 4). Remember, time and temperature work together to achieve a cone. Since any hold at high temperature will increase the cone, as little as a ten-minute hold can alter your firing and glazes. Employing strategies like this can improve some glazes, but you also risk turning a stable glaze into a melty mess. So be careful and test new ideas as safely as you can.

Degrees per Hour	Target Temperature	Notes
100°F	200°F	Hold for an hour as a precaution to dry any possible moisture in clay or glaze.
220°F	1,100°F	Quartz conversion occurs.
250°F	1,940–2200°F	Finish in the range of cones 04–9, depending on your clay and glaze. Kiln should shut off and cool naturally. Remove peeps after the kiln has cooled to below 1,000°F.

SLIP AND GLAZE RECIPES

Slip and glaze recipes can be found everywhere these days. Pretty much anything you have a question about, you can be sure there are people who have researched it extensively. There are whole books about red glazes and celadons! I have binders filled with copies of slip and glaze recipes I've used over the years.

It's wonderful that the ceramic community is, by and large, very generous when it comes to sharing information. There are some potters with proprietary glazes, but most love to talk about their recipes. As part of that tradition, I am sharing a few base slips that I have had success with. I am sharing some base glazes as well, though I must admit that I primarily use commercial glazes for my current body of work. Think of these recipes as a foundation to build on, and try mixing your own slips and glazes.

For some of the slip recipes below you'll notice that there's a base recipe that can be modified with oxides (colorants from natural elements), clays, or Mason stains for different colors. Mason stains are a commercial coloring material that makes it easy to create a rainbow of colors. Each Mason stain is very close to the color it will produce, so a pink stain will look pink and a blue stain will look blue. The intensity will vary, depending on your base and the percentage of stain to slip (adding 1 to 10 percent is the range widely used because once you hit 10 percent, it is often the most intense color you will get from a stain). Note that Mason stains will have a temperature range within which they will work well. Different colors will burn out at different temperatures. Getting intense yellows, oranges, and reds at cone 10, for instance, is very difficult.

Most recipes are provided in percentages that add up to 100. Any additional elements, like colorants, are treated as an extra percentage. That said, it's often the case that glazes and slips are passed around and tweaked in the process like a game of telephone. So it's not unusual for recipes to be correct even with numbers that don't add up to 100.

As a starting place, the recipes here are listed in grams. In my experience, a 100-gram batch makes for a fine amount to test. And no matter where you find your glaze recipe, I strongly encourage you to make a small batch and experiment with it! Glaze testing is one of the most important parts of the process. There's no faster way to ruin a great piece than to glaze it with a new glaze you've never tried.

Once you're ready to make a larger batch, simply multiply by 10 or even 100. Keep the math simple as you scale up!

LOW-FIRE SLIP

Cones 06 to 02

This is, as you might guess from the name, a low-fire slip. It is a straightforward white slip, which makes it a great base for adding color. Check a couple of the colorant suggestions included with the recipe, or branch out to Mason stains, testing 1 to 10 percent for different levels of color saturation.

25g	EPK
25g	Ball clay
20g	Frit 3124
5g	Talc
20g	Flint (silica)
5g	Zircopax

Colorants:

Tan	15% Rutile
Red	15% Red iron oxide
Grey	4% Iron chromate
Blue	1–3% Cobalt carbonate
Black	10% Black Mason stain

WHITE SLIP (BASE SLIP)

Cones 04 to 9

Here are a couple of other recipes for slip, but with a broader temperature range. Use the white slip as a basic white or as a base for adding colorant.

34.00g .. Kaolin
20.00g .. Ball clay
27.00g Potash feldspar
19.00g .. Flint (silica)
8.00g .. Zircopax
0.25g ... Soda ash
0.25g .. Sodium silicate

BLACK SLIP

Base Slip plus
80.00g ... Red art
5.00g Copper carbonate
3.00g Manganese carbonate
2.00g Cobalt carbonate
5.00g Red iron oxide

SUNSHINE'S LOW-FIRE CLEAR LINER GLAZE

Cones 01 to 4

This is a wonderful clear glaze that fits most clay bodies in its temperature range. There is little to no crazing (cracking of the glaze over the clay body), which makes it a good interior liner glaze for vases or cups.

49.00g Gerstley Borate
20.00g ... Kaolin
28.00g .. Flint (silica)
3.00g .. Alumina hydrate

BRIAN TAYLOR'S B1 CLEAR BASE

Cones 3 to 6

This is a nice clear base for midrange work. Like the slips, you can add 1 to 10 percent colorant to change the color or add depth.

25.50g ... Wollastonite
22.22g ... Frit 3195
18.89g .. Flint (silica)
16.67g Nepheline syenite
16.67g ... EPK

BRIAN TAYLOR'S SATIN BASE

Cones 3 to 6

This is a base glaze for midrange work with a different texture and look. It's neither clear nor opaque—it's more a cloudy clear. It will dull underglaze colors and provide a bit more dimension than a straightforward clear. To add colorants, test at 1 to 10 percent increments.

18.80g ... Wollastonite
18.80g ... Frit 3195
18.80g ... Flint
18.80g ... Neph sy
18.80g ... EPK
9.09g ... Zircopax

GALLERY

Untitled Mask. Robert Brady. Coil construction.
Photo courtesy of the artist.

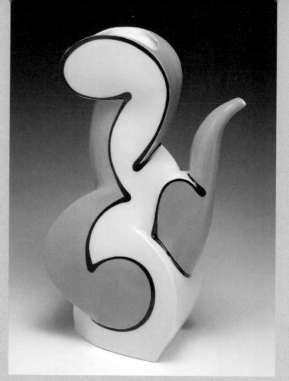

Ewer. Sam Chung. Slab construction with templates.
Photo courtesy of the artist.

Plates. Mike Helke. Slab construction. *Photo courtesy of the artist.*

Ombre Dust Furry. Linda Lopez.
Coil construction, colored porcelain.
Photo courtesy of Clemens Kois for Fisher Parrish Gallery.

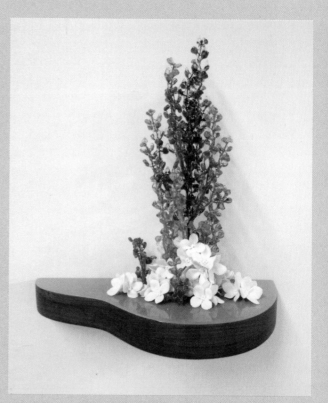

Vere Veridans. Rain Harris. Hand-formed porcelain flowers,
wall-mounted wood base, resin-dipped plastic plants.
Photo courtesy of the artist.

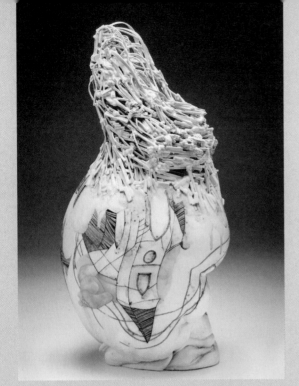

Giving Up the Ghost. Lauren Gallaspy. Pinch and coil construction with bone dry slip, cone 022 to 018 water-based china paint surface, multiple firings. *Photo courtesy of the artist.*

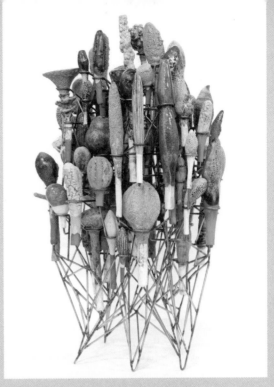

Cloud in Blue. David Hicks. Hand-sculpted. *Photo courtesy of the artist.*

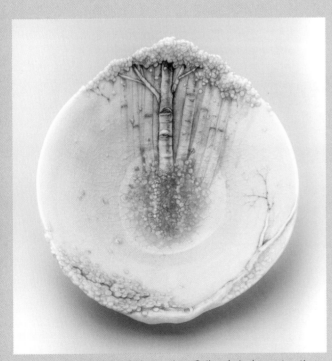

Forest with Pond. Heesoo Lee. Coil and pinch construction with additive elements. *Photo courtesy of the artist.*

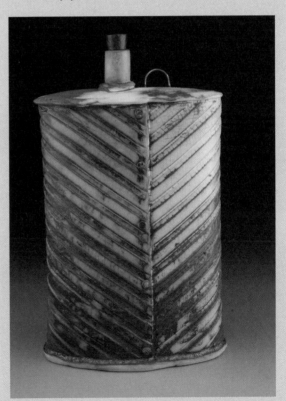

Blue Whiskey Bottle. Jeremy Randall. Slab construction with steel tacks and nichrome wire, textured red earthenware, terra sigilatta, glaze, and oxide washes. *Photo courtesy of the artist.*

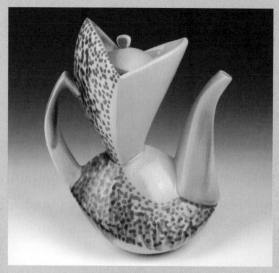

Teapot. Deborah Schartzkopf. Templates and bisque mold slab construction. *Photo courtesy of the artist.*

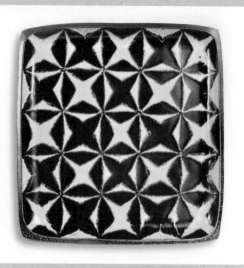

Star Platter. Courtney Martin. Slab and coil construction. *Photo courtesy of the artist.*

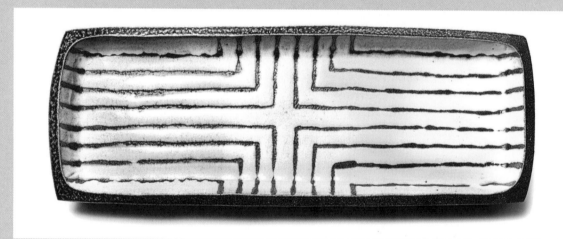

White Rectangular Platter. Courtney Martin. Slab and coil construction, latex resist. *Photo courtesy of the artist.*

Floral Pail with Brick. Liz Zlot Summerfield. Slab construction with wire, terra sigillata, underglaze, and glaze. *Photo courtesy of the artist.*

TEMPLATES

C. Solid Soft Slabs
Enlarge 133% (to approximately 6¾" x 12")

A. Coil-Built Box with an Inset Flange
Enlarge 133% (to approximately 8" x 5¼")

F. Hard-Slab Box with Capped Lid
Enlarge 133% (to approximately 9¼" x 9¼")

197

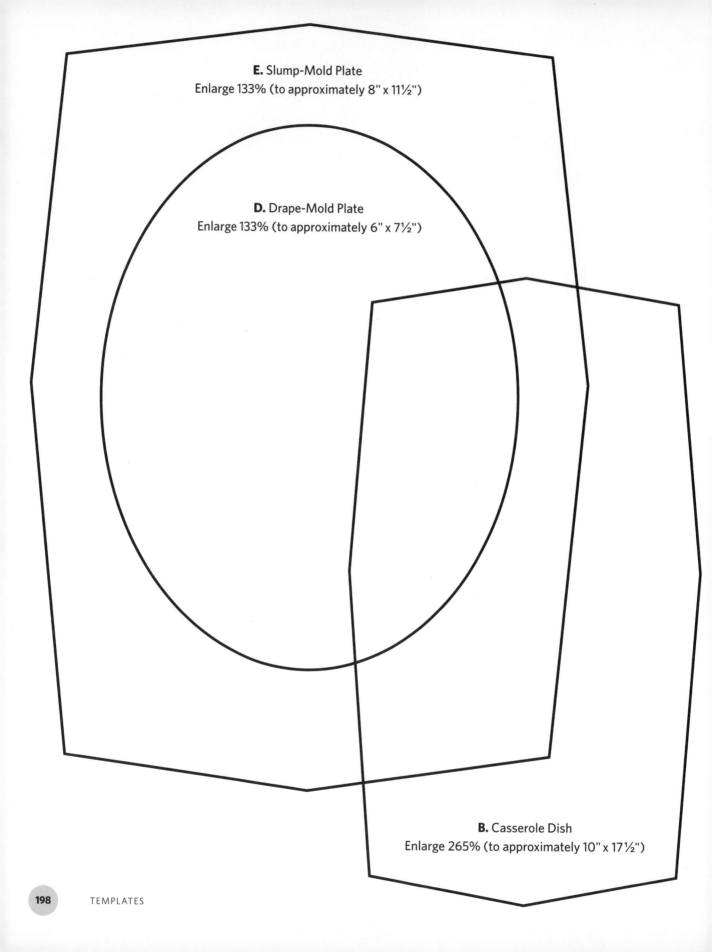

E. Slump-Mold Plate
Enlarge 133% (to approximately 8" x 11½")

D. Drape-Mold Plate
Enlarge 133% (to approximately 6" x 7½")

B. Casserole Dish
Enlarge 265% (to approximately 10" x 17½")

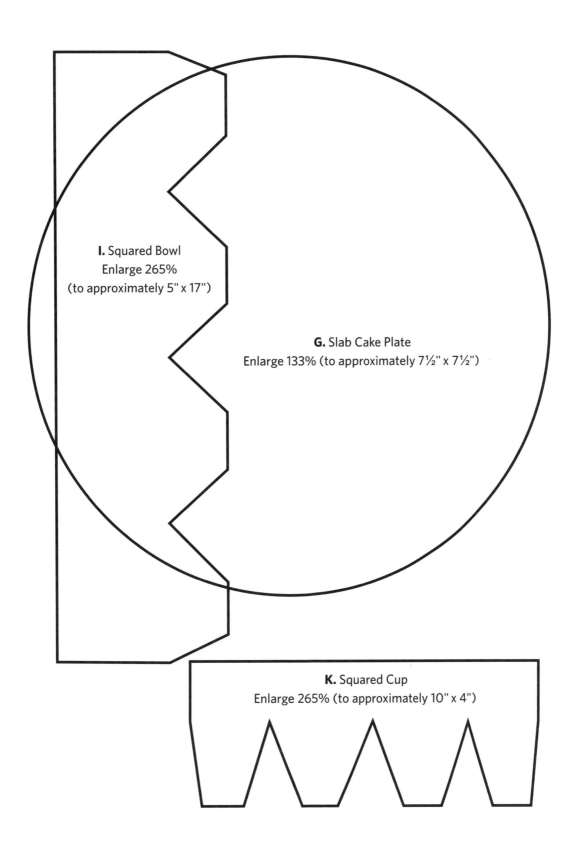

I. Squared Bowl
Enlarge 265%
(to approximately 5" x 17")

G. Slab Cake Plate
Enlarge 133% (to approximately 7½" x 7½")

K. Squared Cup
Enlarge 265% (to approximately 10" x 4")

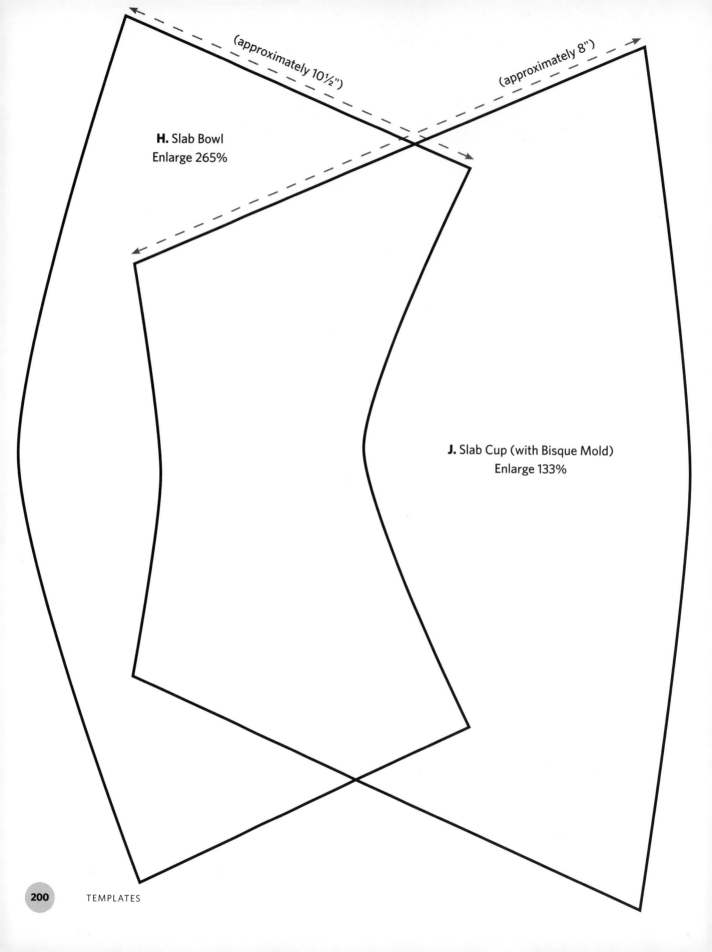

H. Slab Bowl
Enlarge 265%

(approximately 10½")

(approximately 8")

J. Slab Cup (with Bisque Mold)
Enlarge 133%

RESOURCES

ART CENTERS THAT OFFER CLASSES, GALLERIES, OR ARTIST-IN-RESIDENCE PROGRAMS

Anderson Ranch Arts Center—
Snowmass, CO
www.andersonranch.org

Appalachian Center for Craft—
Smithville, TN
www.tntech.edu/craftcenter

Archie Bray Foundation for the
Ceramic Arts—Helena, MT
www.archiebray.org

Armory Art Center—
West Palm Beach, FL
www.armoryart.org

Arrowmont School of Arts and
Crafts—Gatlinburg, TN
www.arrowmont.org

Art Center West—Roswell, GA
www.roswellclaycollective.com

Baltimore Clayworks—
Baltimore, MD
www.baltimoreclayworks.org

Carbondale Clay Center—
Carbondale, CO
www.carbondaleclay.org

Center for Craft Creativity and
Design—Asheville, NC
www.craftcreativitydesign.org

Clay Art Center—
Port Chester, NY
www.clayartcenter.org

Clay Arts Vegas—Las Vegas, NV
www.clayartsvegas.com

The Clay Studio—Philadelphia, PA
www.theclaystudio.org

The Clay Studio of Missoula—
Missoula, MT
www.theclaystudioofmissoula.org

Greenwich House Pottery—
New York, NY
www.greenwichhouse.org
/gh_pottery

Guldagergaard International
Ceramic Research Center—
Skælskør, Denmark
www.ceramic.dk

Harvard Ceramics—Alston, MA
www.ofa.fas.harvard.edu

Haystack Mountain School of
Crafts—Deer Isle, ME
www.haystack-mtn.org

John C. Campell Folk School—
Brasstown, NC
www.folkschool.org

Lill Street Art Center—
Chicago, IL www.lillstreet.com

Lux Center for the Arts—
Lincoln, NE www.luxcenter.org

Mendocino Art Center—
Mendocino, CA
www.mendocinoartcenter.org

Morean Center for Clay—
St. Petersburg, FL
www.moreancenterforclay.org

Mudflat Studio—Cambridge, MA
www.mudflat.org

Northern Clay Center—
Minneapolis, MN
www.northernclaycenter.org

Odyssey Center for Ceramic Arts—
Asheville, NC
www.odysseyceramicarts.com

Penland School of Crafts—
Penland, NC
www.penland.org

Pewabic Pottery—Detroit, MI
www.pewabic.org

Pottery Northwest—Seattle, WA
www.potterynorthwest.org

Pottery Workshop—
Various locations in China
www.potteryworkshop.com.cn

Red Star Studios—
Kansas City, MO
www.redstarstudios.org

Red Lodge Clay Center—
Red Lodge, MT
www.redlodgeclaycenter.com

Santa Fe Clay—Santa Fe, NM
www.santafeclay.com

Society for Contemporary Craft—
Pittsburg, PA
www.contemporarycraft.org

Watershed Center for the Ceramic
Arts—Newcastle, ME
www.watershedceramics.org

Wayne Art Center—Wayne, PA
www.wayneart.org

Worcester Center for Crafts—
Worcester, MA
www.worcestercraftcenter.org

MUSEUMS AND CENTERS FOR THE STUDY OF CERAMICS

Arizona State University Art
Museum Ceramic Research
Center—Tempe, AZ
www.asuartmuseum.asu.edu

Belger Arts Center
Kansas City, MO
www.belgerartscenter.org

Bellevue Arts Museum—
Bellevue, WA
www.bellevuearts.org

Chipstone Foundation—
Milwaukee, WI
www.chipstone.org

Crocker Art Museum—
Sacramento, CA
www.crockerartmuseum.org

Denver Art Museum—Denver, CO
www.denverartmuseum.org

DeYoung Museum—
San Francisco, CA
www.deyoung.famsf.org

Everson Museum of Art—
Syracuse, NY
www.everson.org

Freer Gallery of Art—
Smithsonian Institute,
Washington, DC
www.asia.si.edu

Fuller Craft Museum—
Brockton, MA
www.fullercraft.org

North Carolina Pottery
Center—Seagrove, NC
www.ncpotterycenter.org

Metropolitan Museum of Art—
New York, NY
www.metmuseum.org

Mingei International Museum—
San Diego, CA
www.mingei.org

Mint Museum—Charlotte, NC
www.mintmuseum.org

Museum of Fine Arts Boston—
Boston, MA
www.mfa.org

Museum of Fine Arts Houston—
Houston, TX
www.mfah.org

Museum of Arts and Design—
New York, NY
www.madmuseum.org

Nora Eccles Harrison Museum
of Art at Utah State University—
Logan, UT
www.artmuseum.usu.edu

Ohio Craft Museum—
Columbus, OH
www.ohiocraft.org

Philadelphia Museum of Art—
Philadelphia, PA
www.philamuseum.org

Renwick Gallery of the
Smithsonian American Art
Museum—Washington, DC
www.americanart.si.edu

San Angelo Museum of Fine Arts—
San Angelo, TX
www.samfa.org

Schein-Joseph International
Museum of Ceramic Art—
Alfred, NY
www.ceramicsmuseum.alfred.edu

Zanesville Museum of Art—
Zanesville, OH
www.zanesvilleart.org

GALLERIES THAT REPRESENT OR SHOW CERAMIC ARTISTS

18 Hands Gallery—Houston, TX
www.18handsgallery.com

Akar Design—Iowa City, IA
www.akardesign.com

American Museum of Ceramic
Art—Pomona, CA
www.amoca.org

Blue Spiral 1—Asheville, NC
www.bluespiral1.com

Charlie Cummings Gallery—
Gainesville, FL
www.claylink.com

Companion Gallery—
Humboldt, TN
www.companiongallery.com

Crimson Laurel Gallery—
Bakersville, NC
www.crimsonlaurelgallery.com

Dai Ichi Arts—New York, NY
www.daiichiarts.com

Dairy Barn Arts Center—
Athens, OH
www.dairybarn.org

Eutectic Gallery—Portland, OR
www.eutecticgallery.com

Ferrin Contemporary—
North Adams, MA
www.ferrincontemporary.com

Freehand Gallery—Los Angeles,
CA www.freehand.com

Gandee Gallery—Fabius, NY
www.gandeegallery.com

Harvey Meadows Gallery—
Aspen, CO
www.harveymeadows.com

Lacoste Gallery—Concord, MA
www.lacostegallery.com

Lark & Key Gallery—
Charlotte, NC
www.larkandkey.com

Mindy Solomon Gallery—
Miami, FL
www.mindysolomon.com

M. T. Burton Gallery—
Surf City, NJ
www.mtburtongallery.com

Mudfire Clay Works and Gallery—
Decatur, GA
www.mudfire.com

Nevica Project—Chicago, IL
www.thenevicaproject.com

Piedmont Craftsmen Gallery—
Winston-Salem, NC
www.piedmontcraftsmen.org

Pinch Goods—Northampton, MA
www.pinchgoods.com

Plinth Gallery—Denver, CO
www.plinthgallery.com

Pucker Gallery—Boston, MA
www.puckergallery.com

Schaller Gallery—St. Joseph, MI
www.schallergallery.com

Sherrie Gallerie—Columbus, OH
www.sherriegallerie.com

Sherry Leedy Contemporary Art—
Kansas City, MO
www.sherryleedy.com

Signature Shop—Atlanta, GA
www.thesignatureshop.com

Snyderman-Works Galleries—
Philadelphia, PA
www.snyderman-works.com

Trax Gallery—Berkeley, CA
www.traxgallery.com

PUBLICATIONS AND ARTIST RESOURCES

American Craft Magazine
www.craftcouncil.org/magazine

*Ceramics: Art and Perception|
Technical* www.mansfieldceramics.
com/product-category/magazine

Field Guide for Ceramic Artisans
www.juliagalloway.com/field-guide

Ceramic Arts Daily
www.ceramicartsdaily.org

Ceramics Monthly
www.ceramicartsdaily.org
/ceramics-monthly

Ceramic Review
www.ceramicreview.com

CFile
www.cfileonline.org

Clay Times
www.claytimes.com

Critical Craft Forum
www.criticalcraftforum.com

Craft in America
www.craftinamerica.org

The Journal of Australian Ceramics
www.australianceramics.com
/journal

New Ceramics
www.new-ceramics.com

Pottery Making Illustrated
www.ceramicartsdaily.org
/pottery-making-illustrated

The Rosenfield Collection
www.rosenfieldcollection.com

Studio Potter Journal
www.thestudiopotterjournal
.tumblr.com

ARTIST COLLECTIVES AND MEMBER ORGANIZATIONS

Art Axis
www.artaxis.org

National Council on Education for the Ceramics Arts
www.nceca.net

Objective Clay
www.objectiveclay.com

The Potter's Council
www.ceramicartsdaily.org
/potters-council

CERAMICS EQUIPMENT AND MATERIALS SUPPLIERS

Aardvark Clay—Santa Ana, CA
www.aardvarkclay.com

American Art and Clay Company—Indianapolis, IN
www.amaco.com

Archie Bray Clay Business
Helena, MT
www.archiebrayclay.com

Axner Pottery and Ceramic Supplies—Oviedo, FL
www.axner.com

Bailey Ceramic Supply—Kingston, NY
www.baileypottery.com

Big Ceramic Store—Sparks, NV
www.bigceramicstore.com

Blue Bird Manufacturing—Fort Collins, CO
www.bluebird-mfg.com

The Ceramic Shop—Philadelphia PA
www.theceramicshop.com

Clay King—Spartanburg, SC
www.clay-king.com

Clay Planet—Santa Clara, CA
www.clay-planet.com

Continental Clay Company—Denver, CO, and Minneapolis, MN
www.continentalclay.com

Crane Yard Clay—Kansas City, MO
www.kcclay.com

Highwater Clays—Asheville, NC
www.highwaterclays.com

Laguna Clay—City of Industry, CA
www.lagunaclay.com

L&L Kiln Manufacturing—Swedesboro, NJ
www.hotkilns.com

Mid-South Ceramic Supply Co.—Nashville, TN
www.midsouthceramics.com

New Mexico Clay—Albuquerque, NM
www.nmclay.com

Peter Pugger Mfg.—Ukiah, CA
www.peterpugger.com

Sheffield Pottery, Sheffield, MA
www.sheffield-pottery.com

Shimpo
www.shimpoceramics.com

Skutt Kilns
www.skutt.com

Soldner Clay Mixers by Muddy Elbow Mfg.—Newton, KS
www.soldnerequipment.com

Standard Ceramic Supply Company—Pittsburgh, PA
www.standardceramic.com

Venco
www.venco.com.au

RECOMMENDED READING

Ceramics, Philip Rawson and Wayne Higby

The Complete Guide to High-Fire Glazes: Glazing & Firing at Cone 10, John Britt

The Complete Guide to Mid-Range Glazes: Glazing & Firing at Cones 4–7, John Britt

The Craft and Art of Clay, Susan Peterson

Electric Kiln Ceramics: A Guide to Clays, Glazes, and Electric Kilns, Richard Zakin and Frederick Bartolovic

Functional Pottery: Form and Aesthetic in Pots of Purpose, Robin Hopper

Glaze: The Ultimate Ceramic Artist's Guide to Color and Glaze, Brian Taylor and Kate Doody

Graphic Clay: Ceramic Surfaces and Printed Image Transfer Techniques, Jason Bige Burnett

Mastering Cone 6 Glazes: Improving Durability, Fit and Aesthetics, John Hesselberth and Ron Roy

A Potter's Workbook, Clary Illian

Ten Thousand Years of Pottery, Emmanuel Cooper

INDEX

ACKNOWLEDGMENTS

In the beginning, I knew writing this book would be a challenge—that was part of the reason I took this project on. However, I had no idea about the extent to which it would challenge my brain, time, and studio practice. I am so grateful for this experience: it has stretched my abilities and given me an opportunity to contribute to the ceramic world in a way I never anticipated. In all challenging endeavors, though, we are rarely alone in our successes. I would like to thank a few special folks who helped me through this effort:

My mother, Chris Cott, for always being impressed when I had to get off the phone to talk with my editor! And of course for being supportive of the crazy life that I lead.

Feather Graham, I couldn't ask for a better sister or friend. Your support and encouragement are a gift, and I am forever grateful for having you in my life.

Ben Carter, thank you for recommending me for this project! It has been a wild ride, and I appreciate that you thought of me as a master hand builder.

Rich Peterson, forever my favorite cheerleader! Our friendship during these crazy times has been a beacon of light in the (sometimes dark) tunnel that is life!

Linda Easton, thank you for all the coffee shop gossip/work dates and the writing time spent side by side during this project and beyond! I cherish your support and encouragement.

Lindsey Meyers Carroll, what can I say? The things Lindsey knows! Thank you for all the talks and studio time spent wondering and musing about life's journey.

Giselle Hicks, for being my yoga buddy and anxiety-management consultant! We got this!

Thank you to my interns, Tilly Troelstrup and Patrick Crouch, who have rolled with the change in my studio time like champs and understood when I would take off to the coffee shop to get some writing done! A special shout out to Tilly for taking dictation when I worked on the project parts of the book!

Thank you to all of the amazing artists who contributed to this book. I appreciate the time you took to pull photos or flex your writing muscles. You and your work are forever an inspiration to me and others in the field of ceramics.

A special thanks to the many people with whom I connected during this project. To be met with your encouragement and support has kept me going! Thanks to the team at Voyageur Press for their support, Tim Robison for the photographs, and Gabriel Kline/Odyssey Clayworks for hosting the shoot.

Last but definitely not least, a huge thanks to Thom O'Hearn, my editor. Thank you for your encouragement and patience, and for making sure I don't sound like an idiot! I would have never had the courage to attempt a project like this without you on my side.

ABOUT THE AUTHOR

Sunshine Cobb is the owner of Sidecar Studios, a vibrant space for ceramic artists and creative community activities in Sacramento, California. A full-time studio artist who specializes in handmade functional pottery, she frequently travels the country as a lecturing and demonstrating artist. Sunshine has a BA in studio arts from California State University of Sacramento and an MFA in ceramics from Utah State University. She is the recipient of several honors in the field, including Emerging Artist Awards from the Windgate Fellowship and *Ceramics Monthly*. She has taught at Penland School of Crafts, Anderson Ranch Arts Center, Arrowmont School of Arts and Crafts, and Santa Fe Clay, and served as a long-term resident at the Archie Bray Foundation in Helena, Montana, from 2012 to 2014.

Utilizing traditional techniques, Sunshine's work embodies the importance of handmade pottery in an era of disposability. From the lingering memories of times, shapes, and experiences, she insists that her work remain functional—creating objects that find their way into our busy days, creating a connection between the maker and its user. Her work has received critical praise for its whimsical, rustic style and is consistently featured in national and international exhibitions.

With a strong social media following and online presence, Sunshine is proud to represent a new model for the functional potter. A leading advocate for functional art in modern living, she devotes time to growing the ceramics community locally and nationally. Sunshine frequently volunteers for local K–12 art programs and Sidecar Studios hosts an intern program for young artists seeking mentorship, space, and time to learn about the field they are seeking to enter.